Praise for *The A* *Reimagining Guided Experiences in Museums*

"The resource every museum educator dreams of is here! This is a one-stop guide to building impactful experiences in museums of all kinds. Claire's book unites several things that rarely go hand in hand: clear explanations for why we as educators owe people participatory, creative museum visits; concrete suggestions for how to make those happen and reflective exercises for our own self-improvement... a deluxe toolbox to deepen your practice, no matter what level you're at."

- Rachel Ropeik, Independent Educator, Facilitator, Experience Builder

"An excellent introduction to the 'how' and 'why' of effective practices in guiding museum discussions… But perhaps even more importantly, this book outlines effective practices that go beyond the tour… listening, establishing trust, collaboration and more. I look forward to using these ideas to help people lead all types of conversations, in galleries and beyond."

- Rebecca Shulman, Principal, Museum Questions Consulting

The Art Engager: Reimagining Guided Experiences in Museums is everything museum educators need to take their facilitation skills and connections with audiences to the next level... It is the perfect balance of practical ideas, grounded in Claire's extensive experience and research, coupled with well-crafted reflective opportunities. This book will make you a better facilitator

by developing questioning techniques, understanding when and how to share information, creating space for discussions and learning how to read your audience. I cannot wait to share this book with my team and other museum professionals and teachers."

- Dr Stephanie Smith, Learning Manager, Australian Museum of Democracy at Old Parliament House

"An essential book for the museum and heritage field. It demonstrates Claire's passion for engagement, collaboration, intentional information-sharing, facilitation, and much more. There are so many practical tips and techniques for museum educators here – this book is both a guidebook and toolkit in one. Read it!"

- Gundy van Dijk, Head of Education and Interpretation, Van Gogh Museum

"You'll easily fall in love with Claire's expertise and gentle nudges in this insightful offering – and rethink the way you engage in your practice in more ways than you expect."

- Jessica Vance, Educator and author of *Leading with a Lens of Inquiry*

"A treasure trove of insight and knowledge for museum educators. Bursting with practical exercises, downloadable materials and refreshing insights... this book is a companion that empowers educators to make every interaction with audiences count."

- Wencke Maderbacher, Head of Cultural Interaction and Education, Moesgaard Museum, ICOM CECA Board Member and Europe Coordinator

"The Thinking Museum® Approach can be used to elevate educator practice across all types of collections, sites and themes, helping us make our programmes more inclusive and engaging. This book is a must-read for everyone, offering insights to enhance and refine our approach, whether you're a newcomer or a seasoned professional in the field."

- Melissa Maynard, Consultant, Melissa Maynard Heritage Ltd

"Claire Bown's *The Art Engager* is an essential read for anyone looking to transform their museum visits into deeply engaging experiences. Masterfully combining theory and practice, Claire offers practical tips and actionable strategies that empower educators to foster close looking, inspire curiosity, and facilitate deep and purposeful dialogue. This insightful and empowering book is a game changer for those looking to elevate their teaching practice, or for anyone interested in creating a more meaningful connection with art."

- Mike Murawski, Consultant, Educator and author of *Museums as Agents of Change: A Guide to Becoming a Changemaker*

"Claire has done what few can do: bring transformative change to spaces that have long been experienced a certain way. From passive to active, from consumption to wonder, and from being given an experience to having an empowered experience, Claire is leading the engagement movement in museums. Mandatory reading for anyone wanting to nurture spaces of deep thinking, reflection, and joy, I am incredibly grateful *The Art Engager* has found a home on my bookshelf!"

- Trevor Mackenzie, Teacher, Author, Inquiry Consultant

THE ART ENGAGER

Reimagining guided experiences in museums

CLAIRE BOWN

THINKING MUSEUM®

ISBN paperback 978-9-09037-556-4
Typeset in Gill Sans & Palatino Linotype
www.thinkingmuseum.com

Self-publishing powered by
Amsterdam Academy Press
www.amsterdamacademy.com

Book cover design and artwork: Cigdem Guven, www.crocusfield.com
Author photo: Rudi Wells
Layout: Lisa Hall, www.lemonberry.com
Developmental Editor: Rebecca Blunden, www.exactlyediting.nl

To Richard, Samuel,
Lois and Kirsten,
with love,
always.

Contents

Acknowledgements

I'd like to start by thanking my husband, Richard, for his patience and encouragement throughout this process. You asked me to wait to write this book – although I was keen to write it a decade ago – and I'm grateful. The book I've written now is infused with the experience I've gained in working with this approach over the last 13 years and is all the better for it. So, for that and everything, thank you.

Writing a book requires spending a lot of time putting writing and reading first and everything else second. So I'm hugely grateful for the understanding and support of my children: Sam, Lois and Kirsten. My sisters too – Ali and Jo – you may be far away, but your words and encouragement have not gone unnoticed and have been so helpful.

Heartfelt thanks to my friends and colleagues at the Tropenmuseum where the Thinking Museum® Approach has its roots. A special thank you to Hans van de Bunte, Herman van Gessel and, especially, Gundy van Dijk for being receptive to my ideas, recognising the potential in them and for giving me the space to explore, experiment and iterate.

I'm also grateful to colleagues around the world who have given me their thoughtful suggestions for the book as a whole and for specific draft chapters. I want to extend special thanks to my beta readers: Gabrielle Grime, Melissa Maynard, Mary Ann Lancaster, Alexandra Bennett, Terry

Teufel, Björg Stefánsdóttir and Jessica Vance. And an extra mention to Jess for fielding all my questions about writing a book so generously and helpfully.

I am indebted to the members of the Thinking Museum® membership, and in particular, the founder members for inspiring me and contributing to my thinking. The membership started in 2020 as a result of my first online course ending and all the participants wanting to carry on 'being part of something'. We had 2 great years together exploring all of the practices, and many, many hours exploring art and objects online, for which I am incredibly grateful. All of those regular online sessions and classes on questions, facilitation, practice, coaching and more helped me to write this book.

I couldn't have done this without a great team behind me – thank you to the team at Amsterdam Academy Press who were able to give me exactly the right amount of help I needed to get this book edited, professionally laid out and beautifully designed. I am especially grateful to Hannah Huber, the founder of Amsterdam Academy, for her wonderful project management skills as well as to my editor, Rebecca Blunden, for her patience, dedication and thoughtful suggestions and responses.

I have read and benefitted from the work of many others over the years. Several are quoted in the book. I am grateful to Ron Ritchhart, Rika Burnham, Eliot Kai-Kee,

Olga Hubard, Warren Berger, Carl Honoré, Peter Cloth-ier – these are just a few of the many individuals whose contributions have shaped my practice and the writing in these pages.

Lastly, to you, the educator who has chosen to engage with this book. Thank you. Your decision to join me on this journey means a lot.

Introduction

B ack in 2011 I discovered that museum educators and guides were struggling to meet the demands of leading inquiry-based guided experiences with art and objects. They didn't know what questions to ask, how to get the group participating and how to share their knowledge in a way that engaged everyone to want to find out more.

At the same time, I found out that teachers weren't getting what they wanted from museum visits either. In a focus group with school teachers, they told me that they wanted guided programmes that engaged students fully with objects in the museum, encouraged deep observation, fostered group discussion, collaborative learning and (crucially) involved "less telling".

These two seemingly unconnected issues had something in common: engagement, or rather, the lack of it. Museum educators were struggling to fully capture the attention of their audiences, while teachers were finding museum programmes uninspiring for their students. There was an 'engagement deficit'.

This realisation inspired me to start designing an approach with engagement at its core, for educators to easily use on guided experiences. The Thinking Museum® Approach that this book explores offers a flexible structure for discovering museum and heritage collections, and their stories. It allows museum and heritage educators, guides,

docents and teachers to confidently design and facilitate discussion-based experiences with art and objects, for any audience.

The Thinking Museum® Approach is a way to engage audiences with what they are looking at, who they're with and where they are. It fosters meaningful connections: between educators and participants, amongst the participants themselves, and with the artwork or object being explored.

This book is your essential guide to confidently designing and leading engaging guided experiences around art and objects in museums, galleries and heritage organisations. I'm sharing simple, yet powerful principles and practical guidance, techniques and tools. You'll be able to use them to help any audience engage with museum collections.

You might be a museum educator working with a team or as a 'team-of-one', a heritage or tour guide, a volunteer, or a museum docent. You might be a learning practitioner or teacher in any sector of education who wants to incorporate (more) visual art or objects into your teaching. Or you might be a creative, entrepreneur, freelancer, art therapist, mindfulness practitioner or life coach who is looking for some new tools and techniques or a philosophy to underpin your practice.

If you're a museum educator who would like to transition from leading guided experiences using a traditional

walk-and-talk approach to using more interactive, inquiry-based strategies, then this book is for you. It's also for anyone who has some experience leading group discussions around art and objects but wants to enhance their skills and make inquiry-based methods work better for them.

Perhaps you're interested in finding out what happens when observation and noticing become the primary mode of discovery in your programmes and you want to integrate more close observation techniques into your practice. You might be keen to improve your facilitation skills or to understand how to create more opportunities for participation and interaction within a group. Or you might be intrigued to find out how you can share contextual information more intentionally with your participants to enhance their engagement.

Regardless of your role, where you're starting from, and your motivations for being here, *The Art Engager: Reimagining Guided Experiences in Museums* is filled with practical steps, helpful advice, tips and suggestions for creating engaging, participant-centred discussions with art and objects in the museum.

Part One of this book, *The Foundations*, explores the 3 Foundations at the heart of this approach. We will explore how observation and noticing, shared visual inquiry and personal discovery are the crucial ingredients for engagement on guided experiences. These three simple concepts

are the building blocks that support the Thinking Museum® Approach and make it effective.

In Part Two, *The Practices*, you'll discover the 8 Practices that are core to the approach: questioning, facilitation, multimodality, creating a community of collaboration, practice and coaching, reflective practice, intentional information and deliberate design. Each of these practices plays an important role in creating and sustaining engagement. It's the combination of these 8 practices that makes this such an effective method.

To conclude, I'll describe some final insights on the approach that I've gathered over many years and give you some practical advice for taking your own next steps.

What to expect from this book

This book is both a guidebook and a toolkit. In reading it you will come to understand the benefits of adopting the Thinking Museum® Approach and, importantly, how to get started.

To help you move from thinking to action, you'll find bite-sized inserts throughout the book that support your practice and learning. Use them to develop your self-awareness and practise your newly discovered skills.

Tips

Suggestions, ideas and questions that you can implement instantly into your own practice. These are taken from my own best practice and years of experience working with the Thinking Museum® Approach.

Step back & reflect

Questions that help you to explore your thoughts and ideas, and to reflect on your practice. You can write your answers down in a journal or simply think them through. It's important (for truly developing your practice) to pause and think about these questions before you move on to reading the next section.

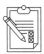

Exercises

The book includes various exercises to motivate you to take action and try things out for yourself. Through learning by doing, you will begin

to make progress and develop a sense of how this approach can be integrated into your own practice. Some exercises will work on particular skills, whilst others will challenge you to work a little beyond your comfort zone. Whilst all of the exercises are optional I encourage you to make use of them, as a deliberate and methodical approach to your practice is an essential part of the Thinking Museum® Approach.

Free downloads

Free resources for this book are available for download via the following link:

www.theartengager.com

You can read this book in different ways. You can opt to read it cover-to-cover, for a holistic understanding of the Thinking Museum® Approach and how to apply it. Or you might want to think first about your own biggest challenges when designing and facilitating inquiry-based art or object discussions, then prioritise reading the chapters which will help you specifically. Alternatively, you could read this book together with colleagues and discuss one chapter at a time, book club style. However

you choose to read this book, I hope you enjoy the process and can document what you are thinking and experimenting with as you go along. Once you've finished reading, look back at your thoughts and see how far you have come.

Before we begin, I'd like to share some key words, phrases and terms which are used frequently throughout this book:

Art

This book takes a broad-minded approach to art. For our purposes, art encompasses not only the visual arts (e.g. painting, drawing, sculpture, photography, printmaking, collage, installation art, street art, mixed media), but also objects and artefacts that are not typically associated with art. These include (but are not limited to) design objects, historical and heritage objects, everyday objects, functional objects with artistic value (e.g. ceramics, glassware, stained glass), and architecture and the built environment (e.g. landmarks and public art).

Community of inquiry

A community of inquiry is a place where two types of questions are valued, questions from yourself and questions from your participants. This means consistently asking thoughtful questions throughout your museum or gallery programmes, and creating a climate where participants feel encouraged and comfortable enough to ask

(you and each other) questions. It's the facilitator's role to nurture and champion this community of inquiry.

Community of collaboration

In engaging guided experiences, the museum educator plays a vital role in cultivating and supporting a community of collaboration. This community fosters shared discovery, idea-sharing, and mutual respect, valuing the contributions of each individual and acknowledging their perspectives. With the educator's support, a community of collaboration empowers groups to work collectively towards deciphering and understanding artworks or objects.

Facilitator

A facilitator is someone who supports and guides the learning and engagement on a guided experience in the Thinking Museum® Approach. They encourage participation, spark curiosity, foster connections among participants, and promote collaboration within the group. The facilitator ensures that all participants feel valued and understood, by actively listening to their perspectives and creating an inclusive environment.

Guided experiences

Guided experiences are designed and facilitated experiences around art and objects, taking place in (but not limited to) museums and galleries that are led by a facilitator, mediator, museum educator, docent or guide. Other locations are implied within this definition, such as heritage

organisations, historic houses and gardens, cultural organisations, and more. These experiences may include (but are not limited to) guided tours and educational programmes for all age groups and audiences.

Museum

Museums can vary in their focus, purpose and types of collections. In this book, museum and/or gallery is used throughout to denote art, history, natural history, science, archaeological, anthropological, ethnographic, technology, maritime, and children's museums, or any specialised museums that delve into a specific area of interest. Other types of cultural or heritage organisations are implied within this definition, such as historic houses and gardens, living history museums, open-air museums, heritage and memorial sites, and interpretive centres.

Museum educator

A museum educator in a museum is (amongst other things) responsible for developing and implementing programmes and activities for visitors. For the purposes of this book, the term museum educator is used to indicate the person responsible for designing and facilitating programmes around art and objects. This term includes not only museum educators, but also heritage educators, museum and heritage teachers, and museum docents and guides, as well as freelancers or independent individuals who facilitate guided experiences, such as guided tours and educational programmes related to art and objects.

Multimodal

Multimodal learning occurs when different modes or media of communication are used, in order to make meaning of something. To work multimodally involves using a variety of different modes to enrich the learning experience, instead of relying on a single mode of communication, such as words alone.

Participants

Instead of 'visitors', the term 'participants' is used throughout, to emphasise the active nature of taking part in a guided experience in a museum or gallery.

Participant-centred

A participant-centred guided experience in a museum or gallery is one that prioritises the active engagement and interaction of participants. It is designed to create meaningful and inclusive experiences, by placing the interests, needs, and perspectives of participants at the centre of the programme's design and facilitation.

Questioning Practice

A Questioning Practice is a structured yet flexible framework designed to guide the exploration of an artwork or object. These structured sets of questions or prompts are used to guide inquiry, stimulate critical thinking, and facilitate learning. Questioning Practices (QPs) have a dual purpose. They promote active engagement and enrich the participant experience by offering clear guidance and

support throughout the discovery process. They also provide educators with a clear and simple framework to guide their discussions, boosting their confidence in facilitating engaging interactions and inquiry conversations with participants. Questioning Practices are used intentionally and repeatedly over time – every time we use a questioning practice, we invest something of ourselves in it.

Reflection

Reflection is the general process of thinking about and evaluating your experiences, actions and decisions.

Reflective practice

Reflective practice is simply the art of thinking about or reflecting on what you do, in an intentional and systematic way.

Thinking Museum® Approach

The Thinking Museum® Approach is a flexible structure around which to explore museum and heritage collections and their stories on guided experiences. It is an approach which engages your audience, whoever they may be.

With plenty of helpful advice and practical steps for you to take, this book provides you with everything you need to create engaging inquiry-based discussions with art and objects in the museum. I really think the Thinking Museum® Approach is a game changer in the field of guided experiences in museums. I hope you think so too. So, let's get started!

PART ONE

THE
FOUNDATIONS

1
The 3
Foundations
for engagement

*"Build a strong foundation and
you can reach even the most unthinkable heights."*

– M J Moores

I've been actively developing the Thinking Museum® Approach through research and practice, and in the discussions I have facilitated with groups since 2011. My aims at the outset were simple: to address the concerns I heard from educators about designing and facilitating inquiry-based guided experiences, and to create a method that was effective, simple and practical, as well as being grounded in specific foundations and practices that create engagement.

This part of the book discusses the foundations of the approach – observation and noticing, shared visual inquiry, and personal discovery – and how they work together to create engagement. The 3 Foundations provide a solid framework that values active engagement, collaboration and individual agency in guided experiences in museums.

I teach from these foundations; they are the values and beliefs that shape my interactions with participants on the guided experiences I facilitate. About 15 years ago, while leading a guided tour, I found myself in the same place, at the same time, saying the same thing as the day before. It was unintentional, but it didn't feel good. It lacked engagement for me, and I doubt my participants found it engaging either. I was already working in a participative way, but somehow I had jumped to autopilot without realising it. This event prompted me to reflect on my practice and embark on a quest to develop an approach that would permanently deactivate autopilot mode.

I found out that I wanted to design and facilitate guided experiences that offered participants much more than just the knowledge in my head. I was drawn to creating experiences where connections and understanding were constructed *with* participants, and fostering spaces where we could discover relevance and meaning *together*. I wanted to share the journey of learning with the participants around me. These types of experiences, founded on observation and noticing, shared visual inquiry and personal discovery, *feel different*. They are rich with possibility and curiosity, buzzing with excitement, relevance, and personal and contextual meaning.

So whenever I feel lost, I return to the 3 Foundations. They act as a compass, guiding me back to true north. They also serve as a solid bedrock for everything within the approach, providing a clear understanding of where we're coming from. This is our stance – a solid foundation that keeps us grounded and guides every decision and action we take. The foundations remind us of our purpose and steer us forwards, defining our practice and shaping our approach to guided experiences.

Before delving into the practical aspects (the 'how') of any method, it's important to understand the underlying concepts and ideas behind it. And it's just as important to understand our own beliefs and values about our practice. Our beliefs shape our practice. In *The Art Engager* podcast episode in conversation with Ron Ritchhart, he shared insights from Alan Schoenfeld's research on teacher

decision-making.[1] Schoenfeld discovered that our plans only take us so far. They work well when everything goes as expected. However, when unexpected situations arise – like surprising questions or misconceptions – educators must make quick decisions. It's during these critical moments that our beliefs and values come into play. What we believe and how we see ourselves as educators strongly influence the approaches and techniques we use in the museum. These beliefs and values have a greater impact on our gallery teaching than our experience. But take heed, if you start implementing the 8 Practices in Part Two without fully understanding the significance of the 3 Foundations, it's the same as being on autopilot – you're merely going through the motions. The foundations are essential for effective teaching in a gallery setting.

Keeping these three principles in mind during the design and facilitation of your group experiences ensures that participant engagement remains consistent and meaningful. They help to create a strong sense of purpose and identity for your programmes, keeping you away from autopilot and guiding you towards active engagement with participants in everything you do.

As you read, reflect on your own guided experiences and consider if, when and how they provide opportunities for the 3 Foundations. Before exploring each of the foundations for engagement, we'll start by thinking about what engagement means.

What is engagement?

A few years back, I started *The Art Engager* podcast to showcase innovative methods of engaging with art, objects, and audiences in museum settings. Over time, the podcast has evolved into a rich library of solo and guest episodes aimed at helping listeners refine their skills, find inspiration, and learn new techniques. The podcast serves a dual purpose: to spotlight the remarkable programmes and projects created by museum educators for engaging audiences, and to bolster confidence in designing and leading inquiry-based guided experiences. The idea is that, through listening, we can take insights from each other and draw inspiration for our own practice in the museum. If I were to sum up the podcast in one word, it would be 'engagement'. But what does engagement mean, and why does it often seem lacking in guided experiences?

Engagement has been a buzzword in museum circles for the past decade or more. When we talk about engagement in the context of a museum, we are referring to the level of interest, attention and emotional connection that visitors have with the exhibitions, the objects and the stories that they tell. Within the context of guided experiences, engagement involves creating museum and gallery experiences that capture participants' imagination, curiosity and enthusiasm, and encourage them to think deeply and critically about the subject matter. Engagement, to me,

goes beyond connecting participants solely to art and objects; it's also about fostering connections between people too.

Participants may disengage during guided experiences for several reasons. Firstly, when visitors receive information passively, without any interaction or chance to ask questions, it can lead to disconnect and boredom. In the past, traditional guided experiences in museums and galleries have relied heavily on the one-way delivery of information from the guide to the visitors. These types of programmes may have a pre-prescribed script or route, and the guide may share facts, figures, stories and personal anecdotes. Traditional museum group programmes were often made to a one-size-fits-all recipe and did not always consider the individual needs, preferences, or interests of visitors. Visitors were passive observers, rather than active participants. This passivity was mainly due to a lack of interactivity and opportunities for participation, a lack of personal connection (to the guide, to others in the group, to the museum, to the objects) and information overload. This all had the potential to lead to disengagement, boredom and a general lack of interest in the objects and artworks on display, despite many of these experiences focusing on the highlights of the museum's collection.

In addition, the lack of a community of inquiry, where thoughtful questions are consistently asked throughout

the experience, and participants feel encouraged and comfortable enough to ask questions, further exacerbates disengagement in the museum. Absence of personal connections, both with the educator and among participants, can leave visitors feeling isolated. Information overload, limited flexibility, and accessibility issues can also overwhelm and exclude participants. Addressing all these factors is crucial for creating engaging guided experiences for everyone.

Engagement is at the centre of the Thinking Museum® Approach. The approach is built upon the 3 Foundations, which are designed to inherently drive engagement: observation and noticing, shared visual inquiry and personal discovery. Let's take a look at each of the foundations, one-by-one, and see how they shape and inform engagement in the design and facilitation of your guided experiences.

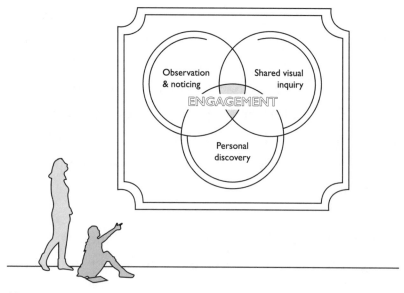

1. Observation and noticing

In today's world, we have become accustomed to superficial observation – we scan, we skim and we scroll. We check our phones or emails every few minutes. Studies suggest that our collective global attention span is narrowing due to the amount of information that is presented to us. Researchers at the Technical University of Denmark found that people now have more things to focus on, and that we often focus on things for short periods of time only.[2] Additionally, we often observe passively, missing out on a wide range of experiences that we simply don't notice.

And it's not entirely our fault either. We know we can't devote our attention to everything that we see. Our brains do a great job of filtering and processing information to make sense of the world around us. This automatic process, known as 'selective attention', allows us to make sense of what matters and helps us manage the vast amount of sensory input we encounter every day. However, this efficiency can also create a kind of visual 'tunnel vision', where we miss the subtleties and details that enrich our understanding of our surroundings.

In addition, our minds are constantly filtering and shaping the information we receive from the world around us, based on our experiences, beliefs, biases and expectations. These 'filters of expectation' as Bianca Bosker calls them,

can sometimes limit our ability to see things as they really are, as they predispose us to interpret incoming information in certain ways.[3]

Against this worrying backdrop of fleeting attention spans and superficial engagement, museums and galleries can offer moments for deep observation and careful noticing in a fast-paced world. But even here, it's easy to get distracted and try to see everything at top speed. Moreover, our senses are also bombarded with information from various sources, including objects, wall text, labels, sounds, lighting, temperature, and even the movements and behaviours of other visitors. In a museum or gallery, this means we might overlook intricate details in artworks or objects due to distractions, fatigue, time constraints, lack of interest in the subject matter, or simply not knowing where to focus our attention amidst the array of stimuli around us.

In our guided experiences, however, we can offer opportunities for participants to observe, notice, and deeply engage with art and objects. We can encourage and cultivate a heightened awareness and attention to detail, using all of the senses to connect with the objects on display. We can use these observations and insights as the basis for all discovery.

Observation and noticing on guided experiences

One of the most crucial moments for engagement in any

guided experience is when the group arrive at an artwork or object. From my observations, I've noticed a range of approaches among educators. Some immediately start talking, sharing detailed information about the artist, date, and title. Others ask questions right away. Some even start describing the artwork for the group. All of this happens before the group can settle in, catch their breath and notice details for themselves. In their eagerness to keep the experience on time or on task, educators may inadvertently skip over this crucial moment of observation.

This missed opportunity is important because it deprives participants of the chance to have their own initial encounter with the artwork or object. Instead of allowing the group to take a moment to absorb the visual details, textures, and overall feel of the piece, educators sometimes prioritise maintaining the flow of the programme, the significance of the object, or their own views, rather than the participants themselves. This impacts both engagement and participation.

Providing adequate space and time for participants to observe artworks shifts the emphasis to beginning the discussion with participant experience, rather than leading with context or dates. It allows participants to form their own impressions and for questions to emerge. This not only fosters a deeper connection between participants and the artwork, but also promotes engagement, curiosity, and participation.

As museum educators, we want to offer opportunities for our participants not just to see, but to deeply engage with the intricate details of objects and artworks using all of their senses on our guided experiences. Equally important, we are sharing techniques to help our participants notice fully, and confidently use their senses and minds to continue exploring artworks on their own after our visit together is over.

Observation and noticing as a first step

Observation and noticing have played a key role in the most engaging discussions I've facilitated with art and objects over the years. Without noticing details, there is no shared discovery.

Imagine being guided through a museum gallery by a museum educator for a moment. As you arrive at the first artwork, a painting, they invite you to pause and take a moment to observe it closely. You are encouraged to engage your senses fully: your ears tune into the quiet hum of the gallery, your nose catches faint scents, and your fingertips almost feel the textures depicted.

You focus your attention on the artwork in front of you. First your eyes move around the whole canvas, taking in the entirety of the piece. You then take a close look at the colours, textures and brushstrokes, zooming in on any small details that catch your interest. As you look, you start to label things you notice in your head and underline

any areas you'd like to return to later. Questions may start to bubble up too.

Gentle landscape sounds are played to complement the painting, while the educator also introduces a subtle scent that evokes the depicted environment. At this point you are all invited to start describing what you see and notice in the artwork. Together you start to build a fuller picture of what you're looking at. By doing this together you're actually seeing new details that you hadn't noticed before.

Two things are happening here. First, there is a period of looking when you first arrive at an object. This period of initial observation can take place in silence. It can be guided by the facilitator. Or, it can take place in pairs, noisily chatting together about what you see, sense and notice. We might stand still, or we might engage in movement, writing or drawing. As observation is such an important step in every discussion, it pays to invest time in thinking about how we are going to look when we arrive at an artwork or object. You can vary the way the group engages in this period of initial observation and noticing throughout your guided experience.

Secondly, the facilitator is asking everyone to describe what they notice. Taking time to observe out loud with everyone is an important part of the process. It literally lays the groundwork for deeper engagement and understanding of what we're looking at. Additionally, it serves

as an inclusive and accessible way of starting a discussion about an artwork or object. By starting with observation and describing details we create a 'level playing field' on which to start a discussion – everyone can take part and no prior knowledge is required. It is essentially a low-stakes way for participants to engage in discussion and sharing and allows your participants some time to ease into the experience at their own pace.

As we describe what we're seeing, we start to notice more details and to see what others are seeing too. The act of observing fires up curiosity and questions. It allows participants in guided experiences to see the whole picture and to notice parts they would ordinarily have missed.

By offering time to observe and describe, you are piquing the curiosity of the group. You are allowing them to notice the details for themselves. Questions will start to form in their head and they will be eager to find out more. Giving space for looking and sensing offers participants time to familiarise themselves with what they are looking at and to begin to process it. This careful observation may mean that they notice more than what immediately meets the eye. By encouraging participants to observe and describe the details of an artwork or object carefully, you lay the foundation for deeper interpretation and critical thinking. Objects do not share all their secrets at first glance, and different layers of meaning and nuance are revealed during sustained observation and noticing.

As adults, we're often uncomfortable with the act of observation, perhaps not seeing its immediate value, preferring instead to skip straight to analysis, interpretation and evaluation. Consequently, as we grow older, we inadvertently train ourselves out of the habit of noticing.

When we spend time observing and describing an artwork or object as part of a guided experience, we are effectively drawing a line between observation and interpretation, demarcating that they are different steps, with interpretation reached only after careful observation has occurred.

Spending time noticing the details and describing the physical characteristics and visual elements, encourages participants to push beyond any hasty interpretations and quick assumptions they might make, such as "I don't like it" or "I don't get it". It may even require participants to sit in discomfort and confusion for a while, whilst their brain catches up with what their eyes are seeing. Starting by articulating what we notice allows us to slow down, go beyond our initial impressions and linger in the observing.

It is a shared group process too. Although we may or may not begin with silent, individual looking, in the Thinking Museum® Approach, we collectively describe our observations without any interpretation. We say what we 'see' before we say what we 'think'. In the museum space, everyone brings their own (literal) perspective to the discussion, which creates opportunities for us all to see more.

Observation in a museum may show up in various forms as well. Different 'modes of looking', such as *close looking, deep looking, mindful looking and slow looking,* offer a variety of pathways for engaging with visual stimuli and deepening our understanding of what we're looking at. While there may be subtle nuances or emphasis in each term, they generally refer to similar approaches to engaging with visual art or objects, approaches which prioritise careful observation. The goal is to move beyond superficial glances and foster a deeper connection by encouraging viewers to examine details.

Close looking shares similarities with close reading, particularly in its emphasis on the careful and detailed examination of a subject. It is sometimes similar to 'visual analysis' and involves the observation of visual elements, such as form, colour, texture, and composition. At other times, it can refer to looking at specific details or areas in greater depth, and to zooming in and out to deconstruct and reconstruct what we're looking at.

Deep looking also goes beyond surface-level observations. It involves inferring meaning from what you see, as well as providing visual evidence to support your observations. Equally, deep looking could be likened to 'observation as experience': immersing yourself in the present moment and allowing the artwork to evoke a range of sensations, emotions, and insights. 'Looking Deeply' is a concept often associated with the teachings of Zen

Master Thich Nhat Hanh, a renowned Vietnamese Buddhist monk, author, and peace activist.

Similar to deep looking is *mindful looking*: the process of slowing down and looking at an artwork or object from the perspective of mindfulness. Mindful looking involves observing with full awareness, attention, and non-judgement. It typically couples guided looking exercises or activities with short meditation or breathwork practices.

Finally, I've written about *slow looking* in depth on my website and talked about it frequently on my podcast, *The Art Engager*. For me, slow looking is a practice, mindset and approach involving the study of something with intention and attention. It is not simply about the duration or pace of the observation, but the belief that all discovery originates in looking. As a mode of looking, slow looking requires us to be present, patient and willing to immerse ourselves in the act of observation.

While modes of looking may intersect, subtle differences exist in terms of proximity, duration, depth, and pace. These distinctions contribute to varied experiences and insights during the observation process, but present in each of them is a desire to intentionally go beyond superficial observation, and activate participation and engagement with the artwork or object.

You can employ various modes or techniques to observe and notice, but the process should never be rushed, skimmed over or skipped. The Thinking Museum® Approach uses observation and description as a means of discovery. The aim is always to push beyond first impressions and see what spending time in observation brings up from, and for, the group. Before you can do that, you need to ensure that your own observational skills are up to scratch. Once you've honed your own powers of observation and got comfortable with the idea of observation and noticing as an essential part of the process, you can then turn your attention to developing this skill with the groups you are working with in the museum.

2. Shared visual inquiry

The Covid-19 pandemic underlined the importance of our need for community and connection. Humans are simply not built to be alone all of the time or to feel disconnected from others. Neuroscientist Matthew Lieberman says that our brains are wired for reaching out and connecting with others.[4] We are social creatures.

Additionally, we now know that time spent engaging in social interactions plays a crucial role in maintaining our mental and emotional well-being. When we take part in meaningful social exchanges, various parts of our brain light up, indicating increased neural activity. This

activation is linked to improved cognitive function and emotional regulation.[5] Spending time with others and engaging socially may also help to boost cognitive reserve, mental resilience and offset stress. *In Your Brain on Art: How the Arts Transform Us*, Susan Magsamen and Ivy Ross liken fostering social connections to exercise for the brain.[6]

Museums are spaces for connection and belonging. They are also places for people to come together. In a broad sense, they provide opportunities for individuals to engage with art, culture, and history while also facilitating interactions with others who share similar interests. Guided experiences in museums offer structured opportunities for visitors to engage with art and objects while also facilitating social interaction and learning. These experiences can encourage dialogue and collaboration among participants, fostering a sense of community and shared discovery.

And yet, all too often, guided experiences fall short. Even in the early 21st century, you still come across programmes that are predominately lecture-based, with little or no opportunity for participants to actively engage or interact with the programme leader, let alone each other. Likewise, guides on guided tours may not effectively facilitate discussions or encourage participation around artworks and objects, resulting in passive experiences for visitors. They may practice 'performative participation', where questions are asked but are limited in nature, promoting

recall of information or leading participants towards what the educator would like to share only. Guided experiences may not always resonate with participants, and may not feel relevant, personal or meaningful to them or their lives, leading to disinterest and a lack of connection.

In developing The Thinking Museum® Approach over the last decade, my goal has been to create a practical framework for educators while also fostering a sense of belonging and participation for the participants. For the duration of their museum visit, the group works together to explore various artworks or objects. This process of discovery becomes a shared experience that makes us feel a part of something.

No museum or gallery programme should ever leave you feeling disconnected, disengaged, or passive. In addition, engaging museum experiences can make a lasting and impactful contribution to our social well-being, by nurturing connections and fostering a sense of community that lasts beyond the visit. Guided experiences in museums can actively encourage a community of collective and collaborative inquiry through the second foundation for engagement: shared visual inquiry.

Shared visual inquiry involves creating a space where participants can connect and engage with each other, engage with the artwork or object, and explore the meaning and significance of what they're looking at together. However,

this doesn't happen spontaneously; you need to consciously and intentionally create the environment and conditions for it to happen.

Shared inquiry relies on several key ingredients in order to thrive. First of all, creating a comfortable environment is paramount for fostering participation; individuals are unlikely to engage if they don't feel psychologically safe and free to share. If you've ever been to an event where you had to endure awkward icebreaker activities aimed at fostering introductions among participants, then you'll understand exactly what I mean. We need to feel 'socially comfortable' in order to engage in a social setting. We are particularly suspicious of anything that might cause us what Matthew Lieberman aptly calls "social pain".[7]

When we create a welcoming and inviting space, and actively build trust and rapport with participants, they are more than happy to engage in a shared process of exploration and learning, working together to construct meaning and deepen understanding.

It is delightful to observe a group discovering an artwork or object together, building on each other's ideas, and sparking new insights. Cooperation is one of the things that sets humans apart from the rest of the animal kingdom and it's something we do often. But why are we motivated to collaborate and work together? In simple terms, people cooperate when they believe they'll benefit from

working together. This idea, called 'reciprocal altruism', means that individuals collaborate because they are expecting mutual gains. In museum guided experiences, this happens when participants share their insights and perspectives. Participants collaborate with the expectation that by contributing their ideas, thoughts and experiences, they will gain new insights and deepen their understanding of the artwork or object being explored. This mutual sharing benefits everyone involved, as each participant contributes to the collective learning experience. Through this cooperation and teamwork, participants build camaraderie and reinforce the idea that working together leads to rewarding outcomes for everyone.

This type of shared guided experience is therefore both rewarding and enjoyable. I have lost count of the number of times people have said to me after a programme, "I never knew you could do this in a museum". They are genuinely surprised by the interaction, sense of connection, and active engagement.

Earlier in this section, we discovered that, in the past, guided experiences in museums primarily focused on the facilitator's expertise, knowledge and insights alongside the showcased artworks and objects. Everything revolved around the 'expert' leading the group. However, when we design and facilitate our guided programmes with shared visual inquiry in mind, participants become active partners in the process of discovery and learning, rather than

passive recipients of information. The expert takes on the role of a facilitator. Instead of centring the experience on their own knowledge, they create opportunities for participants to share their thoughts and insights. The facilitator stands beside participants and supports them in their discoveries.

This change in role is a game changer. You are the 'guide on the side', supporting participants in their exploration and discovery of knowledge. It's energising to be in a space where everyone is collectively engaging in inquiry and following their curiosity, and where ideas are flowing freely from everyone in the group. Once you start down this path, it's hard to go back.

All of the 8 Practices that you will discover in Part Two of this book work towards creating a supportive environment in which participants are encouraged to explore their own ideas and perspectives, ask questions, and collaborate with one another to deepen their understanding. The facilitator plays a key role in creating a space that encourages shared visual inquiry, participation and active engagement. Through the use of open-ended questions and Questioning Practices, reflective prompts and collaborative activities, the facilitator helps to guide the group towards a deeper understanding of what they're looking at. At the same time, participants are encouraged to share their ideas, observations and insights, building on each other's thoughts and perspectives.

By actively fostering and promoting shared visual inquiry, you are promoting a deeper level of engagement and learning. You are also creating a sense of ownership and investment in the learning process, as participants feel empowered to contribute to the group's collective understanding.

What shared visual inquiry looks like

Shared visual inquiry typically involves group discussions and multimodal activities, where participants are encouraged to share their thoughts, interpretations and ideas about an artwork or object. We reason together out loud, put forward new ideas, respond to and add to the ideas of others, and generate further questions. Shared visual inquiry thrives on open-ended questions, active listening and respect for diverse perspectives. The goal is to create a dynamic and inclusive learning environment where everyone can engage with the artwork in a meaningful and personal way.

Shared visual inquiry can help increase engagement in museums or galleries in several ways, by:

Encouraging active participation: Shared visual inquiry invites visitors to actively engage with an artwork or object, rather than passively observing it while listening to someone else's perspective. By asking questions and sharing their thoughts and ideas, participants become more invested in the construction of their own interpretation of

an artwork or object. This active participation ultimately makes the experience more memorable.

Facilitating personal connections: Shared visual inquiry allows participants to connect with the artwork on a personal level, by encouraging the sharing of their own experiences, perspectives, and emotions. This personal connection can increase their sense of relevance and meaning, which in turn can enhance engagement.

Promoting critical thinking: Shared visual inquiry encourages participants in your guided experiences to analyse and interpret the artwork themselves, rather than just accepting a predetermined interpretation. By asking open-ended questions and listening to diverse perspectives, visitors can develop their own critical thinking skills.

Fostering social interaction: Shared visual inquiry creates a social space where visitors can interact with each other and learn from each other's perspectives. This social interaction can increase their sense of community and belonging, which can also enhance engagement.

By fostering a sense of shared visual inquiry, the Thinking Museum® Approach promotes a deeper level of engagement and learning. Chapter 3, on Facilitation, and Chapter 5, on Creating a Community of Collaboration, look in depth at how to create and sustain this foundation in a practical way.

3. Personal discovery

I was once on a guided tour in New York at the Metropolitan Museum of Art, with a well-known tour company known for their renegade tours. The guide was an actress and a master storyteller. Her presentation and communication skills were outstanding and her stories were well-researched and fascinating. What she was saying was really interesting, but she didn't once ask us what we thought about what we were looking at, or whether we had any questions. Nor were there any pauses for us to think about and respond to what we were seeing. At one point, I did manage to stop her flow and ask her a question, but she answered in such a hurried way that I felt that I was wasting both her and other people's time on the tour. Personal discovery was not valued on this museum experience. I felt passive, rushed, and apathetic. I have always remembered this experience for all the wrong reasons.

Apathy can set in very quickly in a museum experience. If your group becomes accustomed to listening, being passive and receiving information, they will come to the conclusion (fairly quickly) that their contributions are irrelevant and they won't bother to actively participate. By moving away from the transmission of information and instead inviting participants to share their own thoughts and ask questions, our guided experiences can empower participants to make personal discoveries. When participants feel like they have a stake in the experience and that

their contributions matter, they're more likely to engage deeply with the content and come away with a sense of personal growth or enrichment. So, creating opportunities for personal discovery goes hand in hand with fostering active participation and engagement in museum experiences.

Alongside facilitating guided experiences in museums for various audiences and in diverse locations, I've also observed and participated in hundreds of tours myself, lasting for 1, 2, or even 3 hours In some of these programmes I was asked to share personal experiences, thoughts and ideas, but in the vast majority the opportunity did not arise. Sometimes educators used questions - some open-ended, others leading, recall, or closed – whilst others didn't seem to have room for either questions or participant contributions.

I have encountered guides who have rigidly kept to their script, while others seemed more interested in sharing their own thoughts, with one spending over 20 minutes pontificating on an artwork without even looking at the participants. The occasions when I was asked to share my thoughts were rare exceptions amongst all these other experiences.

In all of these examples it's important to remember that such approaches were the preferred way to offer guided tours back in the day. In addition, the default mode of

training for museum guides and educators has focused heavily on content in the past (and may still to this day), rather than skills, techniques and tools. Others might deliver their programmes in this way out of a genuine passion for the subject matter, a belief that their method offers the best educational value or the most efficient and effective use of their limited time together in the museum.

Participant-centred programmes take this idea – of an informative, expert-driven experience where the guide actively shares their knowledge with the group – and flip it on its head. In this type of guided experience, the focus shifts entirely to what the participants have to say. Participants are actively encouraged to share their thoughts, ideas, experiences, responses, and any other insights they may have during the guided experience. These experiences value social interactions highly – such as the shared visual inquiry we discussed earlier – aiming to foster connections and build relationships among participants. Encouraging personal discovery, our final foundation, lies at the heart of these experiences.

Personal discovery is about actively creating opportunities for visitors to make meaningful connections between artworks or objects and their own ideas, interests and perspectives. When we foster personal discovery and responses on our guided experiences, objects and artworks are explored through a personal lens, rather than solely from an (art-)historical perspective.

This plays out in two ways. Firstly, by prompting participants to share their interpretations, experiences, and responses, we create a space where each person's unique perspective is valued. Secondly, when we encourage visitors to bring their own knowledge and experiences with them to the museum, it helps them to find more relevance and meaning in the artworks and objects on display. This enriches the experience and in turn creates deeper connections between participants and the artwork or objects, leading to meaningful (and ultimately, more memorable) encounters with the museum's collection.

Personal discovery liberates participants from the pressure of needing to 'say the right answer' or feel knowledgeable about the art or objects in order to explore them. When we create the conditions for there being no wrong answers, participants visibly start to relax and get comfortable in their surroundings. This judgement-free zone allows individuals to engage authentically, and as the fear of being wrong fades, participants feel more confident sharing their thoughts and insights, leading to richer discussions and deeper exploration.

As a facilitator, your role here is to encourage participants to trust their own ideas and interpretations and empower them to share their perspectives with others. It is crucial, therefore, to create a space where multiple interpretations are welcomed, so that everyone will feel comfortable sharing their ideas without fear of judgement or criticism.

Cultural and societal norms play a significant role both in shaping how people behave in museums and in defining the boundaries of acceptable behaviour. These norms influence various aspects of visitor behaviour, including how we speak in the galleries, how we interact with objects, and the norms of interaction during a guided experience. There's sometimes an expectation to speak in hushed tones or respond in a certain way. And, there can be a feeling, particularly with art, that you need to know something about the subject before you can talk about it. These norms and expectations can prevent people from fully participating in museum experiences.

When we promote personal discovery as a principle in our programmes, we are essentially encouraging participants to form their own connections and perspectives with what's on display, rather than leaning solely on what the wall label, curator or you (as the facilitator) has to say. This means everyone can participate, regardless of their background knowledge of the subject matter at hand. Everyone is encouraged (but not required) to bring their own subjective lens to the discussion, a lens that will be influenced by their own values, beliefs and experiences. It's important to stress here that encouraging personal discovery doesn't necessarily mean that you won't be sharing contextual information. In the Thinking Museum® Approach information is seen as an intentional tool for engagement and it can be used strategically, wherever/whenever it can best help further the discussion. Any

information you decide to share will sit alongside other participants' thoughts as one in a row of many perspectives.

The word 'experience' is used intentionally in the title of this book. An experience suggests a more personal, immersive, and sometimes emotional engagement with the content. In this sense, a 'guided experience' is a meaningful and engaging encounter, where discovery happens between people, places and objects. Using the word experience underscores the importance of paying attention to the whole participant journey too, right from physical entry into the museum, up until the exit at the end.

A 'peak experience' is a profound, intense moment characterised by feelings of joy, connection, and a sense of being part of something larger than yourself.[8] Peak experiences are memorable moments, when your perspective on the world shifts. Peak experiences also often bring a sense of heightened reality and clarity, along with feelings of ecstasy, awe, and being deeply moved. Guided experiences in museums can create the right conditions to spark these experiences by creating an environment that encourages personal discovery. By sharing multiple perspectives, stimulating curiosity, and encouraging self-reflection, guided experiences can prompt visitors to explore their own beliefs, values, and identities. Research in fields such as cognitive psychology, educational psychology and experiential learning theory suggests that meaningful learning and personal transformation often occur when

individuals are both emotionally engaged and intellectually stimulated. When this synergy occurs, people are more likely to experience moments of insight, connection, and personal transformation. Therefore, the experiences we create and facilitate can potentially serve as catalysts for sparking peak moments, providing plentiful opportunities for personal discovery and growth.

People tend to evaluate experiences based on the intensity of their peak moments and how they felt at the end, rather than considering the experience as a whole.[9] This concept, known as the 'peak-end rule', can also apply to guided experiences in museums. These peak moments might include engaging with certain objects or artworks, enlightening discussions with the group, and/or moments of personal discovery. These strong positive moments will last in participants' memories and impact future behaviour. Creating opportunities for personal discovery as a foundation plays a significant role in enhancing the richness and memorability of an experience.

In Part One we have looked at what engagement is and what it might look and feel like on guided experiences. We've explored the 3 Foundations – observation and noticing, shared visual inquiry, and personal discovery – and how they work together to create engagement.

In Part Two we'll move from theory into practice. We'll discuss the 8 Practices that put these concepts into action,

and how to implement them effectively into real-world museum experiences.

Before you move on to Part Two, take a moment to pause and reflect on the foundations explored here.

1. How do you feel about the 3 Foundations discussed in this section? Are there any that particularly resonate with you? Which of the three might you struggle with?

2. Can you think of any professional experiences or situations where you have already applied some of the concepts discussed in this section? If so, how did they work out for you?

3. Finally, how might you apply the insights gained from this chapter to improve your guided experiences?

Notes

1 Technical University of Denmark (April 15, 2019). "Abundance of Information Narrows Our Collective Attention Span", EurekAlert! Retrieved 28 June, 2024 from https://www.eurekalert.org/news-releases/490177.

2 The Art Engager (podcast audio) (March 21, 2024), Bianca Bosker, interview with Claire Bown, Retrieved 28 June 2024 from https://podcast.artengager.com/episode/how-to-engage-with-art-with-bianca-bosker

3 Matthew D Lieberman, *Social : Why Our Brains Are Wired to Connect* (Oxford, United Kingdom: Oxford University Press, 2015).

4 Cynthia Felix et al., "Greater Social Engagement and Greater Gray Matter Microstructural Integrity of Aging Adults," Innovation in Aging 4, no. Supplement_1 (December 1, 2020): 794–94,

5 Susan Magsamen and Ivy Ross, *Your Brain on Art: How the Arts Transform Us* ([S.l.]: Random House, 2023), 203.

6 Matthew D Lieberman, *Social : Why Our Brains Are Wired to Connect* (Oxford, United Kingdom: Oxford University Press, 2015), 4.

7 The Art Engager (podcast audio) (March 21, 2024), Bianca Bosker, interview with Claire Bown, Retrieved 28 June 2024 from https://podcast.artengager.com/episode/how-to-engage-with-art-with-bianca-bosker

8 Abraham H Maslow, *Religions, Values, and Peak-Experiences* (Harmondsworth, Eng.; New York: Penguin Books, 1994).

9 Barbara L. Fredrickson, "Extracting Meaning from Past Affective Experiences: The Importance of Peaks, Ends, and Specific Emotions," Cognition & Emotion 14, no. 4 (July 2000): 577–606, https://doi.org/10.1080/026999300402808

PART TWO

THE PRACTICES

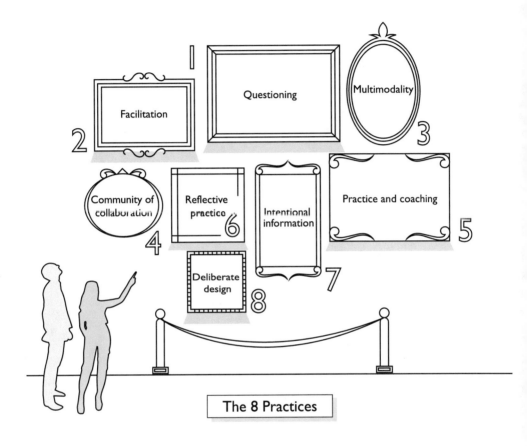

1

Facilitation

Questioning

Multimodality

2

3

Community of collaboration

Reflective practice

Intentional information

Practice and coaching

4

6

5

Deliberate design

7

8

The 8 Practices

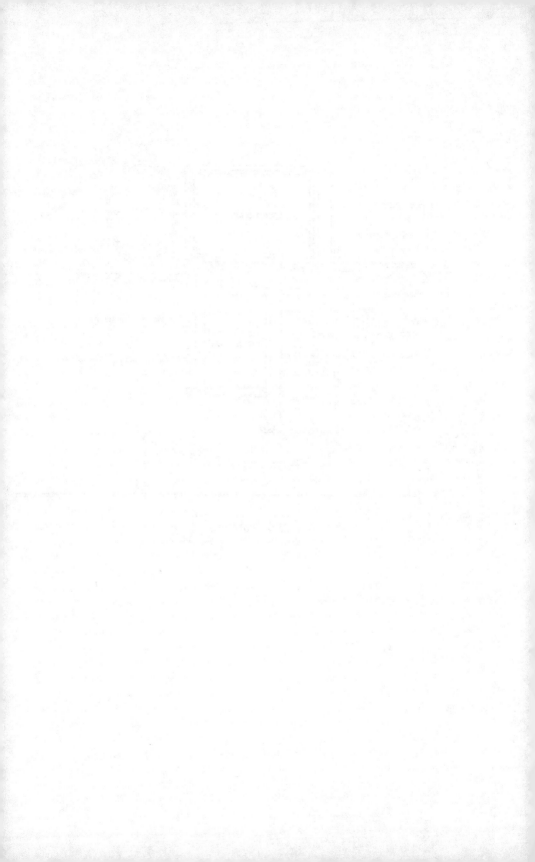

2
Questioning

"The greatest compliment that was ever
paid me was when someone
asked me what I thought,
and attended to my answer."

– Henry David Thoreau

When I was carrying out research for my master's thesis I spent a long time chatting to museum guides and educators about the struggles they faced leading inquiry-based guided experiences. As part of my study, I took the time to quietly observe educators at work in the museum with their groups. On one such occasion, I noticed a museum guide carrying an A4 piece of paper around the museum. Curiosity got the better of me, and after the tour I asked her what she was carrying. A little sheepishly, she told me it was a cheat sheet of questions to use with her group to create more interaction and participation. She said that she found it hard to phrase her questions in an open-ended way, couldn't remember what questions to ask when, and found the whole inquiry process a little "messy".

I was impressed by her dedication to honing her questioning skills and her commitment to making her programmes more participatory. However, I couldn't help but feel that something must be awry if museum guides needed to carry a list of 'good' questions along with them on a tour.

And she had a point. Facilitating discussions in a museum setting that are based on a series of open-ended questions **can** be complex. Not only do you need to formulate your open-ended questions, but you also need to think about the order in which you'll ask them. Being able to formulate and sequence a series of open-ended questions also requires skill and some degree of forward planning on the

part of the educator. Done well, it provides a good framework for discovering an artwork or object with a group, building on each other's ideas and sparking off new ones too. All too often, however, museum educators can struggle to confidently formulate and sequence questions consistently. They may not have the time to create a series of questions before each programme. This may force them to improvise on the spot, and if they don't feel they have an innate flair for questions or have not spent some time working on the skill, it can turn out to be a bit of a lottery.

If you have a good questioning technique and ask insightful and thought-provoking questions, you can instantly engage people, provoke their curiosity, find out what they already know and make your programmes more interactive. On the other hand, questions can also work against you.

I've observed a lot of museum programmes, tours and experiences in my career. The impromptu questions I hear being asked are often convergent in nature (e.g. *What is this object?*), or are in fact leading or recall questions instead of truly open-ended ones. This results in 'Guesswhat's-in-my-head' teaching: asking questions to check if specific answers or ideas have been remembered. Guesswhat's-in-my-head teaching seeks predetermined, correct answers. Unfortunately, this creates an environment where participants feel pressured to guess what the educator wants to hear, rather than resulting in genuine en-

gagement with the participants, or the artwork or object. These kinds of questions stifle curiosity and discourage participants from taking part. The wrong question at the wrong time can close down or cut a discussion short or even put pressure on participants to answer. A retrieval question can make your participants panic if they don't know or remember the answer. A vague question can lead to tumbleweed moments - that moment of silence when nobody says anything. Poorly phrased questions are awkward and uncomfortable - for you, as the educator, and for the participants.

A few years ago I asked a participant on one of my team trainings to think about how she might make her museum and gallery programmes more interactive. She answered quickly: "I need to ask more questions". In part, this is true. No matter the subject of your guided programme, be it art, archaeology, history, or science, you can foster participation and interaction by asking questions. However, there's more to it than that. What you actually want to create is a 'community of inquiry' in your programmes - a place where two types of questions are valued: questions from yourself and questions from your participants.

In practice, this means:

1. Asking great questions throughout your programme Creating a climate that encourages questions from your participants

It's a two-way process. It's not just about the questions you ask. It's also about creating the *right conditions* for your participants to want to ask questions. It's worth remembering that even though it's important to ask the right questions to the right people at the right time, you also need to pay just as much attention to creating the right conditions for your participants to feel more inclined to ask you questions. Chapter 3, on Facilitation, and Chapter 5, on Creating a Community of Collaboration, go into this subject in more detail. Creating a community of inquiry builds connections between you and others, and it fosters a greater sense of participation. Your audience is able to take a more active role in the programme and this will lead to deeper insights.

I've often seen museum guides and educators grapple with phrasing questions in the best way possible. Even though our questions are at the heart of any inquiry around artworks or objects, few educators are actually trained in the art of asking questions. From personal experience, I know that good questioning is a skill that requires time and patience to master. For the lucky few, questioning is an innate talent, but for the rest of us, it's a skill that we actively need to work on.

Additionally, educators sometimes find it challenging to structure and sequence their questions in inquiry-based programmes. They might have a good questioning technique, and know how to phrase questions well, but they

might not know when and how to use them. They might also find that they get lost in their discussions with participants and, importantly, don't know where they're going next with their questions. Using questions in an organised way, gradually building each question on the previous one is essential in a balanced discussion - one that mirrors the Discussion Cycle (as seen below).

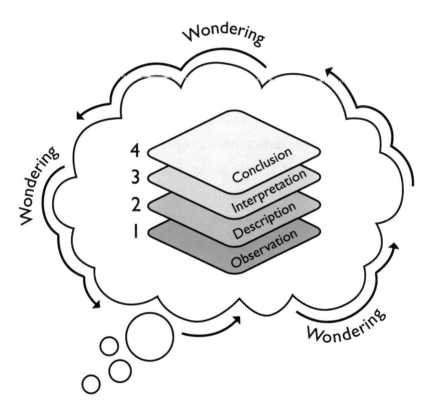

A well-rounded discussion on a guided experience begins with observation and description, before moving on to interpreting meaning and significance and finally, drawing conclusions and insights.

Frameworks and protocols are often used in museums to combat these issues and to support individuals in formulating and sequencing questions. This chapter will explore how these tools are used to aid questioning, organise discussions, delve into content, objects, or ideas, and engage audiences. Then I'll share why 'Questioning Practices' are favoured over frameworks in the Thinking Museum® Approach.

Questioning Practices are structured sets of questions or prompts that are used to guide inquiry, stimulate critical thinking, and facilitate learning. They assist the educator in facilitating discussions about art and objects in the museum and engage participants deeply in the conversation. We'll explore what Questioning Practices are and what sets them apart from a standard protocol or framework. I'll then share 10 Questioning Practices that you can use in your guided experiences as part of your core repertoire to spark curiosity and engage participants more deeply.

Let's begin with a general overview of questioning frameworks.

An introduction to questioning frameworks

One of the simplest ways to encourage participation, interaction and thinking in your guided experiences is to ask open-ended questions about an artwork or object. However, museum educators sometimes use fixed strategies,

routines, or protocols to support the discussion due to difficulties in fostering engagement and structuring conversations. These frameworks come from a wide range of sources and help to steer and guide the process of questioning. They are tools for sparking conversation and inquiry and consist of a series of (usually) open-ended questions that follow a sequence, sometimes scaffolded. Through regular use, these sets of questions become ingrained in our practice. The more we apply them, the more automatic they become. Eventually, they become habits and an essential part of how we engage, teach and communicate.

Questioning frameworks are used in a variety of settings where inquiry, discussion and critical thinking are valued; settings such as education, professional development, meetings and discussions, research, coaching and mentoring, interviews and assessments. Their structured approaches facilitate critical thinking, problem-solving, and developments across various sectors. By providing effective frameworks for asking questions, these strategies aid both the facilitators (in leading the conversation) and the audience (in engaging more deeply with the material).

As part of my master's thesis, I researched questioning frameworks that are used to interpret art and museum objects. Various questioning frameworks exist for exploring a wide range of materials (mainly art), each providing a structured approach to inquiry. Some are designed

specifically for use in museums and gallery environments, while others are not.

Some frameworks begin with a focus on careful observation and description, while others opt for a more open-ended approach. For instance, the Visual Thinking Strategies (VTS) protocol begins with a period of silent looking and then asks a broad first question: *What's going on in this picture?*[1] This question, the first of 3 in the VTS sequence, encourages participants to freely share their observations and interpretations with the facilitator. There is no distinction between the different cognitive processes. It's worth noting, too, that in VTS discussions, this first question is only posed once. In contrast, frameworks like Terry Barrett's Critical Response Method (CRM)[2] and Project Zero's thinking routine, See Think Wonder[3], both start with careful observation and description, based on the opening question: *What do you see?*

Some frameworks separate out the observation and description stages. For example, the Observe-Describe-Interpret-Prove strategy (ODIP) developed at the Columbus Museum of Art in Ohio, begins with asking: *What do you see? What information is there?* Then, participants spend time fully describing what they see: *If you were asked to explain the appearance of this artwork to someone on the phone, what would you say? What descriptive words best describe this piece? What details could you give?*[4]

As the discussion unfolds, most questioning frameworks move on to interpretation of some sort. This might involve delving deeper into the artwork or object's meaning and significance by considering factors such as historical context, cultural influences and the artist's intentions, where appropriate. Project Zero's See Think Wonder asks: *What do you think about what you see?* as an open and generative second question, while ODIP opts for three more focused questions: *What is going on? What is the artist trying to say? What's the story?* Other questioning frameworks may place emphasis on providing evidence or supporting details to strengthen interpretations – questions such as *What do you see that makes you say that?* or *What clues did you use to come to that conclusion?*

While there isn't a one-size-fits-all formula for questioning frameworks, those for art often follow a structured progression designed to facilitate a well-rounded discussion. This may include observation, questioning, and interpretation in many different guises and formats (association, speculation, evaluating, comparing, problem-solving, connection-making, reasoning) and conclusion-forming. This logical progression from surface-level observations to deeper interpretation allows participants to engage with the artwork on multiple levels. While the exact structure may vary, depending on the specific strategy or context, the goal remains the same: to encourage thoughtful inquiry and exploration that leads to deeper insights and understanding.

However, a note of caution. Questioning frameworks can sometimes feel restrictive and inflexible, especially if contextual information is not (strictly) allowed. Similarly, if questions are not prescribed you might struggle to remember the right phrasing, especially if this process does not come naturally to you. If the questions are already set, then wording and phrasing is key. Each question needs to be precise enough to capture the imagination. However, too many rules about wording can feel restrictive – if deviation from the pre-prescribed wording or order of the questions is 'not allowed', participants (and facilitators) can quickly become disengaged due to the rigidity of the framework.

Questioning frameworks are also intended for repeated use so that, over time, the museum educator and participants can automatically follow the steps. While this can be advantageous, it can also lead to the framework losing its impact. In guided museum experiences, when we employ a series of questions to guide our art and object discussions, we aim at the same time to make every use intentional and meaningful for the specific group we're with. This is where Questioning Practices (QPs) come into play.

Over the past decade I've drawn on a wide variety of questioning frameworks from the fields of educational research, museum education, psychology, facilitation, and coaching practices to inform my museum and gallery programmes.[5]

However, while these questioning frameworks have been valuable, in my museum practice, I found myself needing to create my own structures. Perhaps this should not be surprising; many questioning frameworks were not originally designed for guided museum experiences, but for other contexts, such as classrooms or meeting rooms. Often, they seemed too limited and inflexible to work well in the museum environment. These experiences motivated me to create my own Questioning Practices specifically tailored to the unique aspects of the places, people, and objects I engage with regularly. In museums, our needs diverge significantly from those in classrooms, meeting rooms, or coaching spaces.

Museum and gallery environments have distinctive characteristics, such as diverse collections, broad audiences, unique settings and contexts. Additionally, guided experiences in museums, with their brief duration, participants of all ages (who may or may not know each other) and movement, present unique challenges not always addressed by existing frameworks.

I've developed a repertoire of Questioning Practices with museum educators specifically in mind. They have been designed to foster genuine curiosity, reflection and connection. These practices have been tested with a variety of different materials and audiences. Each practice has evolved and improved thanks to feedback from participants who have taken part in my workshops and

programmes. Let's explore what Questioning Practices are and how you can use them in your guided experiences.

Questioning Practices

What are Questioning Practices?

A Questioning Practice (QP) is a structure to actively and intentionally support question use and foster participation and engagement on guided experiences. They are used in the Thinking Museum® Approach to guide inquiry, stimulate critical thinking, and facilitate learning around art and objects. They use a series of carefully chosen questions or prompts to engage participants meaningfully and to encourage observation as a means of discovery, shared visual inquiry and personal discovery. The 10 Questioning Practices in this book provide a suite of structures that can be used with different objects, audience preferences and programme goals. The key features of Questioning Practices are:

Intentionality: Questioning Practices are used intentionally. This means selecting the appropriate questioning practice for each specific artwork, object or audience, aligned with your goals. Intentional use also implies adapting the QP to suit the particular group you are engaging with, rather than rigidly applying the same questions or modalities each time. Lastly, intentional use means that, as facilitators, using QPs helps us to actively hone our questioning skills and become more effective questioners.

It's a *practice*, not a framework: Viewing QPs as practices, rather than frameworks or protocols, allows us to move beyond the idea of 'applying' skills, techniques and strategies. From here, we can acknowledge that questioning is a skill to be cultivated and developed over time. This perspective encourages regular reflection, experimentation, and learning. Additionally, Questioning Practices are just one practice amongst 7 others in the Thinking Museum® Approach. It's the synergy of all of these practices together that is important, each practice complements and enhances the others to create meaningful and engaging learning experiences in museums. Tools and techniques used in isolation cannot create meaningful connections and relationships with participants on our programmes.

Liberation over constraint: Questioning Practices are meant to liberate rather than constrain. They free up mental bandwidth, allowing you to focus your attention on other facilitation techniques. Instead of being burdened by the mechanics of formulating questions on the spot, you can concentrate on creating a warm and welcoming space, actively listening to participants, and guiding the conversation in meaningful directions. In essence, QPs empower facilitators to be more present and responsive.

Depth of engagement: Questioning Practices involve a deep level of engagement for both the facilitator and the participants. Some frameworks or protocols are used for productivity (getting things done) or as an activity that

tends to create more superficial and fleeting engagement. QPs offer a flexible yet structured way to facilitate, explore and discover artworks and objects in museums, at greater depth.

Personalisation: Facilitators using Questioning Practices will infuse their own unique style, personality, and expertise into the process. Our actions, the way we facilitate, the way we pause after asking a question, the way we might share information, or the way we might intonate a particular question - every time we use a QP we bring our personal touch to it.

Flexibility and adaptability: Flexibility is a core tool of the museum educator; it allows us to adapt our approach based on the specific context and needs of each guided experience. Repeating the same strategy over and over again makes participants switch off. Questioning Practices are built for flexibility and adaptability. Facilitators can tailor their approach, based on the specific context, audience, and desired outcomes. We want to be able to allow what game designers Katie Salen Tekinbas and Eric Zimmerman describe as "free movement within a more rigid structure".[6] With QPs, we adapt, create and innovate.

Meaningful interaction: Questioning Practices aim to foster meaningful interaction and understanding, for both the facilitator and the participants, going beyond simply following a set of predefined steps or questions. A QP is

intended to inspire and energise us. It is not used in a perfunctory way.

Continuous improvement: Facilitators use Questioning Practices to actively reflect on and refine their approach over time. QPs are not static, nor are they used on autopilot. They evolve and adapt in response to changing circumstances, experiences and insights. QPs also have broad benefits for both participants and facilitators. They foster curiosity, wondering, and a deeper connection to art or objects. In this sense, they have a dual purpose: not only do they promote active engagement amongst participants in our programmes, they also assist the educator in formulating questions and determining their sequence.

Why 'practice'?'

Practice, as understood through the lens of its definitions, involves actively engaging in activities, exercises, or procedures with the goal of improving or mastering a skill. It can involve a deliberate and systematic engagement in activities, rituals, or exercises that are aimed at achieving specific goals or outcomes. This can include religious or spiritual practices, like meditation or prayer, that are aimed at deepening spiritual connection or fostering personal growth.

While a routine focuses on establishing habitual sequences of actions for consistency and efficiency, and protocols are formal structures designed to ensure uniformity,

the word 'practice' implies an intentional and active approach. Practices are not mechanical or automatic. Whenever we use a Questioning Practice, we bring a part of ourselves to it. This includes our unique way of asking questions, facilitating discussions or sharing information. It might include something as micro as the way we pause after asking a question, or as macro as how we create a warm and welcoming space for participants. It's an active, individual process that we put effort into. QPs can be approached with the enthusiasm of a ritual, rather than the automaticity of a routine, habit or protocol.

As facilitators, using a Questioning Practice gives us energy - it invigorates our interactions, making them more lively and thought-provoking. It also opens us up to new perspectives and insights. It not only stimulates our intellectual curiosity, it also fosters a sense of connection and engagement with others. When we use a QP with a particular group, we experience a sense of fulfilment afterwards. It feels rewarding and the group feels uplifted too. This shared, dynamic interaction fosters a positive and energising atmosphere, leaving everyone with a sense of enrichment and connection.

The word 'practice' itself involves deliberate and active engagement, with specific goals or outcomes in mind. And in the museum, every discussion we design and facilitate should be created with an intention in mind. Being crystal clear about the goal of your discussion will help

you to intentionally choose the correct QP to structure your discussion.

In guided experiences in museums, Questioning Practices provide us with a flexible structure to guide the analysis of a wide variety of materials, such as artworks, photographs, documents, newspaper articles and primary sources, museum objects and so on. In addition, using QPs regularly helps us to formulate better questions and to facilitate a well-rounded discussion more effectively.

In my work, I often meet educators who are excited about the new tools or approaches I'm bringing to add to their toolkit. They hope that these 'shiny new toys' will solve an issue in their practice or on their programmes, such as a lack of participation or interaction.

As I mentioned earlier, Questioning Practices are meant to be used holistically, alongside the other practices in this book (facilitation techniques, creating a community of collaboration, multimodality, practice and coaching, reflective practice, intentional information-sharing, and deliberate design). It's the combination of all of the practices *together* that make the Thinking Museum® Approach so powerful. In addition, using a Questioning Practice requires conscious effort, focus, and commitment, often involving reflection, learning, and growth. QPs are not a 'one and done' approach.

I'll now share with you the Questioning Practices that I use with all age groups - from young children, to teens and adults. I also regularly use them to guide my own thought processes when I'm designing new discussions around art and objects. In short, using these QPs have changed my practice. While strategies and protocols can sometimes feel monotonous, Questioning Practices infuse guided experiences with a touch of magic. QPs create moments of discovery, curiosity and connection. They go beyond the ordinary.

All of my Questioning Practices have been developed over the past few years in my role as a museum educator, facilitator, coach and trainer. My interactions with groups of all ages and experiences, and their interactions with various types of artworks, objects, and materials in the museum environment have played a key role in their design. The QPs I use have been refined and finessed in real time in the museum environment (and online). Put together, this set of QPs provides a repertoire for you to use on your own guided experiences.

In the following section, you'll find 10 Questioning Practices for use in your museum and gallery programmes. We begin with The Universal, an all-purpose and versatile QP that can be applied to all types of art and objects, and that is suitable for every kind of guided experience in any museum.

10 Questioning Practices

The Universal

OBSERVATION + DESCRIPTION

10 to 1

The
Senses Walk

Yes, And...

INTERPRETATION

Engage
& Imagine

Settings,
Character, Plot

The Connections
Triangle

The Perspectives
Triangle

CONCLUDING

Look Back,
Step Forward

3 2 1 Reflection

The 9 remaining Questioning Practices are divided into 3 categories: observation and description; interpretation; and conclusion. These can be used to focus exclusively on specific cognitive moves, or they can be mixed and matched to create bespoke discussions that are in line with the goal of your overall line of inquiry.

At the start of your journey with Questioning Practices, it can be tempting to want to using all 10 practices at once. However, I recommend getting to know The Universal before you introduce any of the others into the mix. This is because the 4 steps of this initial Questioning Practice mirror the stages of the Discussion Cycle, as seen earlier in this chapter.

Knowing The Universal really well will enhance your ability to facilitate engaging discussions around art and objects. It lays the foundations for productive museum inquiry. In addition, The Universal is easy to set up and straightforward to use. It is self-explanatory and multi-purpose, as the name suggests.

Familiarise yourself with it, exactly as it is written. Try it out with a variety of different artworks and objects, and with a variety of groups. Embrace the process of the Questioning Practice and the rich discussion that follows. Get a feel for the questions and actively re-flect after each use. Approach The Universal as a 'prac-tice' rather than simply an activity or an exercise. After

several sessions it will start to feel natural, fluid and easy to use. The aim is to 'internalise' this core QP as part of the invisible infrastructure of your discussions. Over time you will naturally make it your own, while also staying true to its values and principles. Once this happens, you can then start to add new Questioning Practices to your repertoire, to supplement The Universal.

A multipurpose Questioning Practice:

1.The Universal

The Universal offers a structured and fully comprehensive way to engage with art and objects. It aims to make art or object exploration on guided experiences more engaging, well-rounded and meaningful. This Questioning Practice evolved from my research into core questioning strategies as part of my master's thesis.[7] It echoes *the structured progression* of a well-rounded discussion that I noted was common to the questioning frameworks I explored. The 4 steps in The Universal enhance observation skills, encourage critical thinking, facilitate interpretation and promote reflection. From my experience facilitating art and object inquiries using The Universal, it's the combination of these 4 steps together that creates the most engaging and thought-provoking discussions.

This Questioning Practice is intended to be used universally, with all types of groups, and with all types of artworks and objects. It can be used with a huge variety of materials

– I've used The Universal with paintings, sculpture, historical, design and everyday objects, out and about in nature and with buildings, to name a few examples. It works as well in art museums as it does in historical, ethnographical, science museums and historic houses. It is adaptable, easy to use and naturally leads to open-ended inquiry amongst all types of participant groups. It can be applied in a variety of different situations, circumstances and environments.

The Universal uses 4 questions:

1. Look: What do you notice?
2. Question: What questions come to mind?
3. Interpret: What might this be about?
4. Reflect: What insights did you gain?

How to use it

The 4 simple stages (Look-Question-Interpret-Reflect) of The Universal guide and focus conversations around art and objects seamlessly. Instead of feeling stuck in a programme and wondering what question to ask next, you can lean on the logical structure of The Universal to support you. As this is a core Questioning Practice and the first one you should get to know, here's an in-depth look at how to use it.

The 4 stages

Before you ask any questions, ask participants to observe

The Universal

LOOK:	What do you notice?
QUESTION:	What questions come to mind?
INTERPRET:	What might this be about?
REFLECT:	What insights did you gain?

the artwork or object for a short period of time. This can take place individually and in silence, as a discussion in pairs, or the educator can guide the observation for the group using a variety of different techniques. This also helps to focus the group on the object and fire up curiosity. After a period of time spent looking, ask the question:

What do you notice?

This question allows you and your group to fully observe and describe the object or artwork. This step helps to build an inventory of what you're looking at. Focusing on observing and describing first allows participants to see the whole picture and to notice parts of the object or artwork that they might otherwise have missed. By inviting the group to observe first, you are making it less likely that they will jump to hasty conclusions or make snap judgements when moving on to the subsequent steps. The first question in The Universal sets the stage for the second question. You will find that, after a period of time spent observing and describing, your group will naturally move towards asking questions and wondering about the artwork or object.

What questions come to mind?

After fully describing the artwork or object, the second question asks the group for their questions. This second step mirrors how our minds work when we look at art or objects. As we look, questions arise. This part of the

Questioning Practice formalises that natural process, acknowledging and using our curiosity to engage more deeply with the object. It also provides space for participants to articulate and share their questions, which gives the facilitator a window into what participants are curious about. Finally, it can open up new lines of inquiry and allow the educator time to share any specialised knowledge in response to the group's questions, should they wish to do so. This will depend largely on the outcome or goal you have set for the discussion. As you'll see in Chapter 8, choosing how, when and if to share information intentionally is an important part of the process. Moreover, by observing, describing and then wondering fully, the group will have plenty of ideas on which to base their interpretations.

What might this be about?

This third question allows us to move on to interpretations. This question is intentionally broad and open, because it is intended to allow for a variety of perspectives. It can also be customised to the type of interpretation you'd like to encourage with your group. There are several types of interpretation that we can focus on when we create discussions around art and objects (for example, thematic, symbolic, contextual, stylistic, personal and so on). Each different type of interpretation offers a more focused lens through which to view and understand the artwork. By modifying the question, you can guide participants to engage with the artwork in a way that aligns

with your goals, or that resonates more deeply with your current group. As with any variation, I would encourage you to get to know The Universal as it is written first, before you start experimenting.

What insights did you gain?

The final step brings the discussion full circle and provides an opportunity to reflect on the group's experience. It allows participants to consolidate their thoughts, insights, and personal responses, and to articulate and share what they have discovered. Again, the question is left intentionally open, allowing participants the flexibility to reflect on various aspects of their experience, whether it's their interaction with the group, their observations in the museum, their connection with the artwork, or even their personal thoughts and feelings. By prompting participants to reflect on the process, the last step of The Universal encourages metacognition, enriching the experience for participants by prompting them to reflect on it.

Once you feel comfortable and confident using The Universal, you can experiment with variations. You may want to include other senses in the "What do you notice?" step. Or you can think about changing the order of the second and third steps (Look, Interpret, Question, Reflect). Or you may want to add an extra step. Within The Universal, how you ask the questions is also flexible. You are not restricted to asking the questions exactly as they are worded here, if more specific wording is more

useful to the purpose of your discussion. Keep your variation open-ended and use the goal of the art or object inquiry as inspiration for how you might vary the questions to be more specific about a particular step.

Once you have got to know The Universal inside out, trying it out with a number of different guided experiences and audiences, and a variety of artworks and objects, you can start to explore other Questioning Practices. Here are 9 more QPs, that cover a range of different cognitive processes, to build your guided experiences, chiefly observation and description, interpretation, and concluding. Together, these 10 QPs form a repertoire, allowing you to tailor every museum experience to the group, artwork or theme you're facilitating.

Questioning Practices for observing and describing

2. 10 to 1

10 to 1 asks participants to make a list of all the things they see or notice in an artwork or object. The idea is similar to brainstorming. First, we generate a long list of ideas (or in this case, of things we observe) and then take time to distil our ideas into a shorter list until we end up with just one word.

Look at the artwork or object for at least 30 seconds.

10 to 1

1) What 10 things can you see?
2) Read back over your list. Underline 5 words.
3) Place a circle around 3 of those words.
4) Finally draw a square around 1 word.

How to use 10 to 1

- 10 to 1 can be used to quickly observe and describe an artwork or object. You can set a time limit for the first step and proceed to step 2 fairly swiftly.
- If you have more time, you could invite participants to share their 10 words one at a time, inviting everyone to strike through words they hear that appear on their own lists (like Bingo!). This allows the facilitator time to point out what has been noticed and to ask any follow up questions.
- You can also use 10 to 1 twice – once at the beginning of a discussion and again at the end to see how participant thinking might have changed as a result of the discussion.
- You might also want to consider working in pairs for the list of 10 observations.
- Consider combining this Questioning Practice with any of the interpretive (or other) QPs.

3. The Senses Walk

This Questioning Practice is based loosely on the mindfulness practice of engaging with the 5 senses and being present. It is an imaginative observation and descriptive exercise that encourages descriptive vocabulary. It also helps participants to feel more connected to the whole experience of an artwork.

Jump into an artwork and imagine yourself walking around it. As you walk:

1. What do you see?
2. What sounds can you hear?
3. What textures or temperatures can you feel?
4. What do you smell?

How to use The Senses Walk

- Don't limit yourself to an artwork. What else could you jump into and take a walk around inside? Think about photographs, objects, buildings, and more.

The Senses Walk

Jump into an artwork and imagine yourself walking around it. As you walk:

1) **What do you see?**
2) **What sounds can you hear?**
3) **What textures or temperatures can you feel?**
4) **What do you smell?**

How to use The Senses Walk (cont...)

- Make one or more of the steps into a writing exercise. Use sticky notes for brevity, or clipboards to encourage longer paragraphs of descriptive, creative writing.
- Don't forget to share - it's fascinating hearing where participants chose to jump into an artwork or object and what they saw, heard, felt and smelled from their personal vantage point.

4. Yes, And...

Yes, And... is a core principle in improvisational theatre. It emphasises accepting and building upon others' contributions. Here it is, adapted into an observational Questioning Practice.

What do you see?

1. 'I see X"
2. Next person "Yes, and I see Y'
3. Next person "Yes, and I see Z"

Yes, And...

1) 'I see X"
2) Next person "Yes, and I see Y'
3) Next person "Yes, and I see Z"

How to use Yes, And...

- Participants gather in a group and take turns to describe elements they observe in the artwork or object, using simple statements such as, "I see a red flower." The next participant responds with "Yes, and..." and adds another observation, such as "Yes, and it has green leaves." This process continues, each participant contributing a new observation by using "Yes, and...", until the group exhausts their observations.

- In large works, consider dividing the artwork or object into sections and describing one section at a time.

- There are several variations of this QP. In the first variation, the first person says "I see X", and the second names the previous person's observations before adding their own new one - e.g. "Yes, you see X and I see Y", and so on. This adds an extra layer of complexity and encourages careful listening. You could also continue the process and move on to "I think X", in order to explore further possible interpretations and ideas.

Questioning Practices for interpretation

5. Setting, Character, Plot

The Setting, Character, Plot Questioning Practice deepens engagement with artworks by encouraging detailed observation, imaginative thinking, and narrative construction. Participants describe settings and characters, imagine characters' thoughts, and explore potential stories, enhancing their analytical, creative, and critical thinking skills. This Questioning Practice is best used with narrative and figurative artworks. The setting, figures, and narrative are first fully described, then follow-up questions are asked in order to delve deeper.

Setting:
Take a close look at the setting of the artwork.

- How would you describe the setting?
- How does the setting contribute to the overall mood or atmosphere?

Character:
Focus on a figure in the painting.

- How would you describe this figure?
- Imagine you can hear their thoughts. Based on what you see, what might they say?

Setting:

Take a close look at the setting of the artwork.

- **How would you describe the setting?**
- **How does the setting contribute to the overall mood or atmosphere?**

Character:

Focus on a figure in the painting.

- **How would you describe this figure?**
- **Imagine you can hear their thoughts. Based on what you see, what might they say?**

Plot:

Imagine possible narratives in the artwork.

- **What narratives or stories are suggested?**
- **What might happen next? What do you see that makes you say that?**

Plot:

Imagine possible narratives in the artwork.

- What narratives or stories are suggested?
- What might happen next? What do you see that makes you say that?

How to use Setting, Character, Plot

- Depending on your time constraints or the subject matter, you can choose to focus on 1, 2 or all 3 parts of the practice.
- For settings: Look carefully at the physical surroundings depicted in the artwork, including landscapes, interiors, architecture, and natural elements, such as mountains, forests, or bodies of water. Look at the arrangement of objects, figures, and architectural elements. You could also pay attention to lighting, weather conditions, and colours.
- For characters: Describe the figures fully. Notice their facial expression, body language, and clothing.

- As always, think first about the desired out-come for your discussion. If your goal is to advance understanding of an actual event, for example, further context will almost certain-ly be required for an understanding of what is actually happening in the artwork. In these cases, intentionally share a small amount of information to situate the artwork in a time and place. It should be enough information to spark further discussion, but not too much that it stifles further ideas and interpretations from the group.
- If your goal is to foster creative and imagina-tive storytelling or creative writing, encourage and embrace imaginative interpretations of the artwork.

6. Engage & Imagine

The Engage & Imagine Questioning Practice is designed to encourage personal connections and foster creative, imaginative responses to objects and artworks. Tradi-tional approaches to guided experiences often prioritise historical context and significance, which can overshad-ow participants' own personal interactions and emotional responses to the objects they encounter. When I created

Engage & Imagine, I wanted to shift the focus, asking participants to observe, describe and reflect on what captures their attention or emotions, before exploring any broader cultural, social, and historical meanings and narratives. This initial personal engagement fosters a sense of ownership and closeness with the artwork or object, alongside increasing relevance and meaning, making the experience itself more meaningful. When the historical context is introduced later, participants can then relate this information to their own initial reactions and insights. Engage & Imagine provides a dual perspective that enriches understanding through multiple layers of meaning.

The final step focuses on imaginative thinking. Participants are asked to envision how the artwork or object might transport them to another world or experience. This step encourages creative and speculative thinking. It also provides a creative conclusion to the discussion, ensuring that the engagement ends on an inspiring and thought-provoking note.

- **Notice:** What do you notice? Describe the physical characteristics and visual elements.
- **Engage:** How does it capture your attention or emotions? What initial thoughts or feelings does it evoke?
- **Interpret:** What meanings or messages are being conveyed? What do you understand about its significance or historical context?
- **Imagine:** How does this artwork or object transport you to a different world or experience?

Engage & Imagine

- **NOTICE:**

 What do you notice?

 Describe the physical characteristics and visual elements.

- **ENGAGE:**

 How does it capture your attention or emotions?

 What initial thoughts or feelings does it evoke?

- **INTERPRET:**

 What meanings or messages are being conveyed? What do you understand about its significance or historical context?

- **IMAGINE:**

 How does this artwork or object transport you to a different world or experience?

How to use Engage & Imagine

- It is important to first spend time observing and describing, so you can get the group acquainted with what they are looking at. Thoughts, feelings and questions will come from the time spent observing, so do not be tempted to skip this step.

- This QP encourages participants to connect with an artwork or object on a personal level by encouraging them to share their own perspectives, thoughts, feelings and emotions. Create a warm and welcoming space and encourage, but do not require, participation. Nobody should feel under pressure to share their personal responses.

- For the 'Interpret' stage, you can choose whether you would like to share any contextual information (depending on the goal of your programme) or whether you'd like the group to create their own interpretations, based on their observations and personal responses. If you choose to share information, take the time to ask the group to compare and contrast their personal responses with the context you

shared and to see whether that changes their thinking around the object.

- Engage & Imagine is versatile and can be used in different formats. It works well in pairs or small group discussions, where participants can share ideas and build on each other's thoughts. Alternatively, the 'Engage' and 'Imagine' steps can be used to foster individual reflection through written responses, allowing for introspection and deeper personal engagement.

7. The Connections Triangle

Fostering connection-making in guided experiences enhances learning and understanding. It encourages visitors to engage deeply, think critically, and remember information better. Personal connections to artworks or objects make museum experiences more memorable and impactful, as participants relate what they see to their own experiences. Additionally, museums are communal spaces where shared experiences strengthen social connections and community ties. The Connections Triangle encourages three types of connection-making.

The Connections Triangle

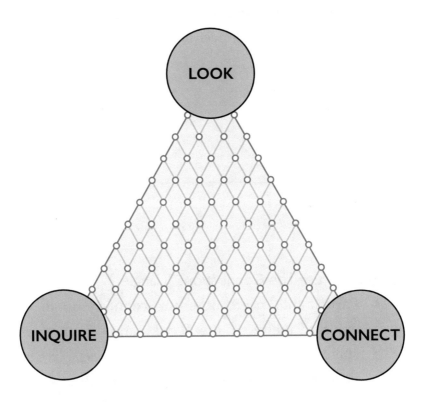

- **LOOK:**

 What do you see? How does it look and feel?

 Observe and describe carefully.

- **INQUIRE:**

 What questions come to mind?

- **CONNECT:**

 What connections can you find?

 ※ object to object

 ※ object to self

 ※ object to world

- LOOK: What do you see? How does it look and feel? Observe and describe carefully.
- INQUIRE: What questions come to mind?
- CONNECT: What connections can you find? Choose from:
 - object to object
 - object to self
 - object to world

How to use The Connections Triangle
- Participants need time for connections to emerge, therefore the 'Look' and 'Inquire' stages are important parts of the process.
- Feel free to share intentional information in answer to some of the questions during the 'Inquire' stage, to further both personal discovery and connection-making.
- In the 'Connect' stage, feel free to choose 1, 2 or all 3 questions to explore. For 'object to object' you could connect all sorts of objects and artworks together - either leave this to your participants to choose (an element of free choice is always appreciated in a guided experience) or you can choose the artwork for them. Think

about: two artworks or objects from different time periods, art from the same art movement, connecting two portraits or landscapes, or connect two objects that are the same but from different time periods – i.e. clocks or teapots.

- As with all questions about personal connections, nurturing an open and trusting atmosphere is especially important for this Questioning Practice.

8. The Perspectives Triangle

Perspective-taking is the ability to adopt (temporarily) another person's point of view. It's about seeing a situation or understanding a concept from an alternative viewpoint. Empathy – which is our ability to recognise, feel, and respond to the needs and emotions of other people – is often the result of perspective-taking. Artworks and objects are great at helping people consider multiple solutions to a problem and look at situations from multiple perspectives. The Perspectives Triangle encourages 3 types of perspective-taking.

- LOOK: What do you see? Observe and describe carefully
- INQUIRE: What questions come to mind?

The Perspectives Triangle

- **LOOK:** What do you see?

- **INQUIRE:** What questions come to mind?

- **PERSPECTIVE-TAKING:** Explore and centre a range of different perspectives. Choose from:

✳ ARTIST:
What's the artist, photographer, or maker's perspective?

✳ OTHER/FIGURE:
What other perspectives are involved?
or
What is the perspective of a figure in the artwork?

✳ ME:
What's my perspective?

- How do they/you feel? What do you see that makes you say that?

- PERSPECTIVE-TAKING: Explore and centre a range of different perspectives. Choose from:
 - ARTIST: What's the artist/photographer/maker's perspective?
 - OTHER/ FIGURE: What other perspectives are involved?

 or

 What is the perspective of a figure in the artwork?
 - ME: What's my perspective?
- How do they/you feel? What do you see that makes you say that?

How to use The Perspectives Triangle

- The Perspectives Triangle (like the Connections Triangle, above) asks participants to first observe, then to describe and share their questions. These are important first steps for getting the group to think deeply about what they are looking at. It's important to see and notice all the details first, before you move on to the perspective-taking questions.
- Choose whether you want to explore all of the perspectives or just 1 or 2.

- For the second perspective-taking question, you can choose whether to explore other perspectives or the perspective of a figure in an artwork, depending on what you are (already) exploring with your group.
- Your personal perspective comes last - this is because our brains naturally place ourselves at the centre. This Questioning Practice necessitates moving away from this starting point, in order to understand other perspectives as well as our own.

Question Practices for concluding

9. Look Back, Step Forward

This Questioning Practice is designed to help you consolidate your museum experiences and consider how they might influence your future perspectives and actions. It is based loosely on Priya Parker's anatomy of a closing, which is described in full in Chapter 9: Deliberate Design.[8]

Take a moment to remind yourself of the various exhibits, discussions, and artifacts you've encountered during your visit.

Look Back, Step Forward

Take a moment to remind yourself of the various exhibits, discussions, and artifacts you encountered during your visit.

✳ *Look back*

What stood out to you?

What are the reasons behind your choice?

Now, reflect on the experience.

✳ *Step forward*

What one thing will you take away from this?

What makes this takeaway significant?

Look Back

What stood out to you?

What are the reasons behind your choice?

Now, reflect on the experience.

Step Forward

What one thing will you take away from this?

What makes this takeaway significant?

How to use Look Back, Step Forward

- What stood out to you? (in the "Look Back" section) prompts participants to recall specific aspects of the programme that caught their attention or left an impression. This part is about identifying memorable moments or elements.
- The "Step Forward" section asks, *What one thing will you take away from this?* Participants are invited to consider the overarching takeaway or lesson from the entire experience. This is about distilling the essence of the programme and its impact on them.

10. 3 2 1 Reflection

A guided experience that ends well always summarises the key themes, insights, and takeaways from the visit. 321 Reflection helps participants to consolidate their learning and reflect on their overall experience.

Look back on the experience and reflect on the following:

- What 3 new things have you learned?
- What 2 things are you going to remember?
- What is 1 question that remains?

How to use 3 2 1 Reflection

- 321 Reflection works best if you can use all three categories at once. If you're short on time, invite the group as a whole to share 3 learnings, 2 memories and 1 question, instead of asking everyone to think about it individually.
- If you're interested in more formal feedback, ask participants to write their answers and hand them to you as they leave.

3 2 1 Reflection

Look back on the experience and reflect on the following:

- **What 3 new things have you learned?**
- **What 2 things are you going to remember?**
- **What is 1 question that remains?**

How to use Questioning Practices

It is important to remember that Questioning Practices are more than a simple strategy to enliven or inject more participation into a museum or gallery guided tour or programme. They are not one-off activities, but are intended for regular and intentional use.

Every artwork or object has multiple interpretations waiting to be discovered by the participants. Questioning Practices gently assist with a flexible structure and a set of carefully chosen questions designed to help that discovery happen.

One of the many powers of Questioning Practices is their flexibility – with 10 Practices to choose from, you can vary the way you work, depending on the goals of your programme or group. It's important to think first about the goal for your discussion, then to think about which Questioning Practice will best serve that purpose.

While it's not important to memorise all 10 Questioning Practices, it is useful to have a core repertoire that you are comfortable with. Your other skills - particularly facilitation techniques - will also play a part in how comfortable you feel using them.

Make space and time for looking at the start, to get your participants focused, keen to participate and curious to

start the discussion. Allow time for thinking too - ask the question in the Questioning Practice, then wait... Silence can be deafening, and your natural response will probably be to fill the void with more words, but always try to hold off. QPs contain open-ended questions which naturally lead to more thoughtful responses, and these types of answers aren't instant. Be patient and comfortable with the silence - think of it as 'thinking time'. Remind yourself (and your groups) often that you're not looking for the 'right' answer, you're looking for a wide variety of ideas, hypotheses, interpretations and inferences.

Participants will surprise you with the ideas and thoughts that they have and the connections that they make throughout the discussion. Remember this when you're planning a session and have doubts about the QP you've chosen (that little voice saying, "I'm not sure this will work"). You will be continually surprised by what participants are thinking and you will notice new things that you haven't seen or thought of yourself before. As an aside, bear in mind that you may not arrive at either a final, definitive interpretation or an end point to your discussion. That's OK. Embrace the process of the Questioning Practice and the rich discussion that follows. The process is more important than the destination.

When you get started, your use of Questioning Practices will be quite structured, possibly even cautious. Focus on The Universal as your first point of call and try it

out with your chosen artwork or object. 'Workshop' the practice by going through each of the steps and working through possible answers to the questions. When you try it out with a group for the first time, you might be worried about whether they will respond to the questions, as well as wondering where and how you should share information and in what direction the discussion will go. At this stage, 10 minutes may seem like a long time for a discussion about an artwork.

As you progress, you will start to feel more comfortable with the idea of using Questioning Practices. You might start to have ideas about applying them in a variety of different contexts and environments, with different types of artworks and audiences. You will start to naturally add your own open-ended, clarifying and follow-up questions to those in the QP, and you will find that time seems to go by quickly when you are facilitating. You are then likely to get more curious about adding new Questioning Practices to your repertoire, supplementing The Universal.

When you become very experienced in using these Questioning Practices you will start to feel a natural fluidity when using them. You will have a substantial repertoire to draw on at a moment's notice. At this stage, the 10 QPs become one with your practice. It's almost seamless, you're not really aware of the individual steps, but more aware of the whole. The structure is still there, but you don't notice it. You are always experimenting, reflecting and

iterating with your practice. You look at artworks or objects and immediately start thinking about different types of discussions and the Questioning Practices you could possibly use with them. You may feel at this point, like I do, that the possibilities are infinite.

By nurturing curiosity and promoting deep thinking, Questioning Practices enhance your guided experiences in museums. Used intentionally, they empower and energise both facilitators and participants to actively discover and explore together.

Notes

1 Visual Thinking Strategies is an approach developed by psychologist Abigail Housen and museum educator Philip Yenawine. This method is based around three carefully constructed open-ended questions which are rigorously adhered to: What's going on in this picture? What do you see that makes you say that? What more can you find? For more information see https://vtshome.org

2 Barrett, Terry. *Interpreting Art : Reflecting, Wondering, and Responding*. Boston: Mcgraw-Hill, 2003.

3 See, Think, Wonder was developed as part of the Artful Thinking & Visible Thinking projects at Project Zero, Harvard Graduate School of Education. For more information see: https://pz.harvard.edu/thinking-routines.

4 Observe-Describe-Interpret-Prove (ODIP) is a strategy used at the Columbus Museum of Art to promote conversation and deep looking when engaging with art. It was developed by educator Barbara Sweney. For more information see: https://www.columbusmuseum.org/wp-content/themes/cma/pdf/odipquickguide.pdf

5 In particular a variety of thinking routines from Harvard Graduate School of Education's Project Zero, (https://pz.harvard.edu/thinking-routines), the 3 simple questions of the Visual Thinking Strategies questioning protocol, developed by museum educator Philip Yenawine and psychologist Abigail Housen (https://vtshome.org/), and the 33 Liberating Structures promulgated by Henri Lipmanowicz and Keith McCandless (https://www.liberating-structures.com/).

6 Katie Salen and Eric Zimmerman, *Rules of Play: Game Design Fundamentals* (Cambridge, Mass. The Mit Press, 2004).

7 These were: Edmund Feldman's Formal Analysis, Terry Barrett's Critical Response Method (CRM), Visual Thinking Strategies (VTS), Observe-Describe-Interpret-Prove strategy (ODIP) developed at the Columbus Museum of Art in Ohio and Project Zero's See, Think, Wonder.

8 Priya Parker, *The Art of Gathering: How We Meet and Why It Matters*. (Riverhead Books, 2020), 248.

3
Facilitation

'The facilitator's job is to support everyone to do their best thinking. To do this, the facilitator encourages full participation, promotes mutual understanding and cultivates shared responsibility.'

– Sam Kaner and Duane Berger

Picture yourself taking part in a guided experience in a museum 20 years ago. Chances are that you would probably have experienced a 'sage on the stage' walk and talk presentation of the collection with little room for interaction or personal discovery.

In recent years, museum and gallery programmes have undergone a transformation. They have shifted towards a more inclusive and engaging model, one that is based around discussion, that is led by questions, and that is participant-centred. This shift has placed extra demands on museum educators to develop suitable techniques - such as effective questioning and facilitation skills - to be able to lead their programmes successfully. It's no longer a case of simply learning the content and delivering it, lecture-style, around the museum.

In this chapter, the focus is on how to facilitate museum and gallery programmes. The word 'facilitate' comes from the Latin word facile which means 'to make easy'. Facilitation focuses on the 'how' of a process, rather than the 'what', and it involves movement towards an agreed point.[1] 'Facilitation' is therefore designed to ensure that everyone in a group can participate and be heard, and the 'facilitator' is the person who guides others through this collaborative process.

What is a facilitator?

For the Thinking Museum® Approach, facilitation is focused on guiding processes, fostering engagement and creating participation.

There are many terms used to describe individuals who lead discussion-based experiences around art and objects in museums and heritage organisations. Some commonly used terms include 'guide', 'mediator', 'docent', 'interpreter' and many more. Each of these terms carries its own nuances and connotations, emphasising different aspects of the role.

For me, facilitator best describes the core of what we do, which is:

- guiding and activating learning and engagement
- sparking curiosity and wonder
- creating the conditions for learning to take place
- ensuring groups feel comfortable, valued and welcome.

In Thinking Museum® Approach the focus is not on the educator and their knowledge or expertise, but on creating a participant-centred experience. As a facilitator, your role is to create a supportive and inclusive space that encourages participants to take an active role in the

discussions and connect with the artworks or objects on a personal level.

A good facilitator will:

1. Effortlessly guide the process
2. Foster participation and connection
3. Encourage the group to work together
4. Ensure that all participants feel visible, valued and understood

At best, good facilitation skills can foster a community of collaboration (as discussed in Chapter 5), with groups happily working together to create a shared understanding of an artwork or object, reasoning aloud together, putting forward new ideas, and responding to and building on each other's ideas.

Your personal facilitation style

Everyone has their own unique way of facilitating experiences with art and objects. Even if you're just starting out as a facilitator, you have a style (even if you don't think you do). Your personal facilitator style is the way you show up and the things you are known for. It also incorporates how you see yourself and how others see you.

Every time you lead a tour or facilitate a museum experience with a group, you are communicating something about yourself. Your participants will also be reading you as you go about your work. Bearing this in mind, it's essential to spend time thinking about whether your groups are perceiving you as you want to be perceived.

Your personal facilitation style is what makes you stand out as an educator. It is a reflection of how you apply different techniques, tools and methods, drawing from your experience and experiences, connecting and communicating with groups in your own way. Your style is unique to you. It's your USP: the way you approach it will be different to how your colleagues or peers do it. Even if two facilitators have received the same training, they will each have their own distinct style, content, and personality. And this style evolves over time, as we learn, experience and grow. Your personal facilitator style reflects your personality and interests.

Self-awareness (knowing yourself) and self-management (choosing your responses and behaviour) are important in our work. Both make us more effective at what we do. When you facilitate authentically (i.e. as yourself), you can connect better with your audience and design, and lead more engaging experiences.

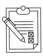

Define your personal facilitator style

1. Prepare: Grab a pen and paper. On a fresh page, write 'Personal Facilitator Style' in the centre.

2. Write: as many words as you can about your style. These can be your thoughts, or they can be feedback you've received in the past. Keep writing and don't stop to judge or analyse. The key is to aim for volume.

3. Optional extension: Ask a colleague or your manager to share 3-5 words that describe your style.

4. Sort: Group words together, highlight any common words or themes that stand out. What words show your uniqueness?

5. Reflect: on what you wrote and any themes that emerged. What themes can you spot? What did you find interesting or challenging about this exercise? What insights do you now have into your unique facilitator style?

This preliminary exercise will get you thinking about your personal facilitator style, and if you want to go further, Chapter 6 explores this in depth. It's worth seeing your personal style as a facilitator as something that will evolve over time, as you grow, develop and change. Even

with years of experience and continuous professional and personal development, you never stop learning. There are always new things to practise, more techniques to learn and better ways to facilitate. This is what keeps your practice fresh, helping you stay enthusiastic and passionate about your work.

Facilitation is a key part of the Thinking Museum® Approach. However, developing good facilitation skills is an art form in itself. Practice and patience are required and the best facilitators make it look easy.

Let's look at the different roles you'll take on as a facilitator, before looking in detail at some core facilitation techniques.

Facilitator roles

As a facilitator you need to wear many 'hats', assuming a variety of responsibilities and functions.

It requires flexibility and adaptability to seamlessly shift between these roles, meeting the needs of participants and creating an engaging experience. Here is a short description of each role.

Coordinator

You are the person ensuring that a programme goes well, making sure that everyone stays on track and on time, everyone understands their roles, and everyone feels part of the process. It's part of your job as facilitator to manage the discussion, which means keeping an eye on timing too. Don't be afraid to interject and refocus the discussion, if needed. While some participants may offer a few words in answer to your questions, others might speak for much longer. A good facilitator can get the conversation back on course, by politely interjecting with questions at appropriate moments or by using phrases like, *If I may stop you for*

a moment... Interjecting in this way will help you to keep control of the discussion whilst helping your participants to feel understood and valued. A good facilitator can also close a discussion, when necessary, by asking for just one more response or using a Questioning Practice (e.g Look Back, Step Forward or 3 2 1 Reflection) to capture the essence of the discussion and move on.

Catalyst

As facilitator of an art or object discussion, you're responsible for instigating that discussion, getting people involved and encouraging quieter group members to take part. You want to stimulate interaction, and foster curiosity and excitement, which is often a balancing act between asking the right questions and making people feel comfortable enough to participate. Following a simple structure for your discussion, by using Questioning Practices, will free up head space, allowing you to be more creative with your groups and giving you more energy to focus on what they are saying.

Listener

Everyone thinks they're a good listener, but how good are your skills really? Active listening involves listening with all the senses. You need to focus on what the other person is saying and the words they are using. Be aware of the tone they are using and any emotions that may be

coming across. Pay attention to their body language, make appropriate eye contact and give verbal encouragement. Embrace silences too.

Observer

Observation is a key part of good facilitation. As a facilitator, you are an observer of your group. You watch your group for signs (i.e. body language, verbal clues) indicating where to direct the discussion next. You pay attention to creating a great group dynamic, establishing trust, credibility and reliability. You stay alert for any signs that group members are feeling uncomfortable or restless and act accordingly.

Rapport builder

Building great relationships and rapport between participants is hugely important in making your programmes not only successful, but memorable too. It's important to bring people together and make them feel socially comfortable and 'at home' in your session. When people feel rapport within their group, they are more likely to actively take part and ask questions. A good group dynamic means that group members trust one another and are happy working together towards a collective understanding of what is being discussed. As a facilitator, it's so important to work on establishing group camaraderie right from the start. You will need to take conscious, deliberate steps to make that happen.

Communication enabler

Facilitators are responsible for making sure that communication happens. You ensure that everyone feels at ease participating, by paying attention to the language you use and the feedback you give to participants. If you're interested in hearing a wide range of comments from all participants, then giving feedback without implied judgement is essential. Aim to give non-judgemental feedback to anyone that contributes to a group discussion and to respond to everyone equally. This sets a tone of fairness within the group.

Climate setter

By setting the climate, you set the tone and share guidelines for the session with your group. This helps to set expectations at the start and encourages everyone to go along with agreed guidelines. You should also establish a warm and open environment, so that participants feel comfortable and are happy to share their views openly and honestly.

Motivator & energiser

Depending on the length of your session and (perhaps) the subject matter, you may find that there are moments when the group needs a boost or an injection of energy. As a facilitator, you should be prepared to re-energise the group and motivate them for the task at hand. This could

involve thinking on your feet and improvising an activity or an open-ended question, or it could mean changing the pace. If participants have been standing or sitting still for a long time, get them moving. A change in pace or an unexpected twist will help to motivate and reinvigorate the group. It can even be as simple as getting people to switch positions or (if the event is virtual) change their view. You should start and end your programme by bringing energy to the room.

Core facilitation techniques

In addition to wearing multiple hats, as a facilitator, you also need to possess a wide range of techniques in your toolkit. The core facilitation techniques the Thinking Museum® Approach focuses on are:

- Using verbal and non-verbal facilitation tools
- Being mindful of your language
- Listening actively

Verbal and non-verbal facilitation tools

Encourage and guide observation
Observation and noticing are a foundation of the Thinking Museum® Approach. Whilst you may be tempted to jump straight into interpretation, don't skip this step.

Giving participants the chance to fully observe and describe an object or artwork before interpretations are offered, reduces the chance of hasty reactions or knee-jerk responses. By making time and space for looking and sensing, group participants are given time to focus fully on what they'll be discussing. With a lively group that is excited to be in the museum, this is a great opportunity to slow down and concentrate for a few moments. Also, the more time you allow a group to look, the more they will see and notice, all of which will stoke curiosity and foster questions.

After a small amount of time looking at the object in question, you can ask the group participants to describe what they see. This is a great way of getting everyone involved in the discussion from the start. Studies have shown that if you can get participants involved within the first few minutes of an activity, they are more likely to stay engaged throughout. This is what you are looking for: a group of keen participants who are all willing to share their thoughts, ideas and input. Making the first step observation offers everyone the chance to participate right away, without needing to have any prior information or knowledge.

A facilitator who encourages looking will also find that their group connects with them and each other, earlier on. Observation is essentially a warm-up for the group, before you open up the discussion to more interpretive, deeper questions. It allows participants to see

the whole picture and notice parts they would ordinarily have missed. It's an excellent way to fire up curiosity and preempt questions too.

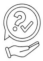

Ways to encourage observation

- Ask the group to look in silence - alone, in pairs or in small groups
- Use a viewfinder to focus their looking
- Divide the group up into smaller ones and ask one smaller group to study a small part of the painting or object
- Incorporate movement: start looking far away, then get closer
- Set a timer if time is tight. This can even become a game for family groups or groups of children: Who can make the most observations within a given time slot?

As facilitator, you could also choose to verbally guide the looking for the group, by providing a guided description that alerts the group to colours, shapes, lines, figures, expressions (or anything you would like to highlight).

Gesturing and pointing

This tool is incredibly simple, but remarkably effective. As participants speak, the facilitator uses gestures and points to what they are mentioning and to physically pinpoint its location on the object or artwork. This encourages active looking (you will notice that participants' eyes naturally follow a pointing finger) and helps other participants to visualise what the speaker is referring to. Try not to assume that everyone knows which part of the object or artwork the speaker is talking about. This 'pointing out' helps to springboard new ideas from other participants too. If, when someone is speaking, you are not sure which exact part they are referring to, be sure to ask them for clarification.

If you're facilitating online, use annotation or your mouse pointer to highlight areas.

You can also use non-verbal gestures, like smiling and nodding, to demonstrate that you are listening and interested in participant responses.

Paraphrasing, reflecting back and restating responses

Paraphrasing is when you repeat, in your own words, what you understood the other person to have said. In art and object discussions, it is a way of showing you have

listened, valued and understood the comments of a participant. Both paraphrasing and reflecting back may include not only what has been said, but perhaps also the emotion or feeling that the participant has expressed. Restating is different, as it involves remembering and repeating a person's words back to them verbatim.

Purposeful paraphrasing can foster trust, whilst also building capacity for more effective thinking. It ensures that participants feel they have not only been heard but also understood. Being able to paraphrase requires you to listen intently enough to be able to understand the links between a participant's thoughts and their expression. After a facilitator has paraphrased their thoughts, if a participant feels that they haven't been understood correctly, they can clarify their thoughts and/or add additional ideas or nuances to what they originally wanted to say.

Paraphrasing is not without its critics, however. In *Time to Think*, Nancy Kline writes that paraphrasing is flawed.[2] She feels that by re-phrasing we might be seen as trying to improve on what someone else has said, rather than believing that the best wording is their own. Kline also believes paraphrasing can damage rapport. For example, if you substitute one word for another and the meaning changes (even slightly), friction or tension could arise. Instead, Kline advocates restating a person's words verbatim. Similarly, when paraphrasing, it is important to ensure that you are not interpreting what someone has said

differently to how they actually meant it. However, restating what someone has said verbatim could also imply that you haven't really understood what someone has said and that you're just repeating it back to them, 'parrot-fashion.'[3]

As a facilitator, it is important to demonstrate that you have heard and understood a participant's words, but it's also important to reflect some of those words back to them. Therefore, it's important to get the balance right when you are engaging in active listening. As with all facilitator techniques, it's important to work out how that might work for you, your unique style and the groups that you work with.

In my own practice, I tend to strike a balance between paraphrasing and restating. I use a mixture of the participant's words and some of my own, literally 'reflecting back' by using a mixture of paraphrasing and restating.

The art of reflecting back

- Use simple phrases to share what you've heard, *e.g. What I'm hearing is..., So it sounds like..., In other words ..., What I hear you saying is..., From what I hear you say..., As I listen to you I'm hearing...*

- Check in to make sure you've understood correctly, e.g. *Is that correct? Did I miss anything?*
- Avoid assumptions and maintain a curious stance

Clarifying and asking for more evidence

Questions that ask for clarification and/or more evidence form an integral part of your facilitation skill set. Clarifying involves asking a question to gather more information and make something crystal clear. It demonstrates that you have heard what the speaker has said, but perhaps do not fully understand yet, so you need more information or are curious to hear more.

Possible clarifying stems could include:

- *Would/Could you tell me a little more about…?*
- *Let me see if I understand…*
- *I'd be interested in hearing more about…*
- *It would help me understand, if you could give me an example of…*
- *So, are you saying/suggesting…?*
- *Tell me what you mean when you…*

Another type of follow-up question is one which asks for more evidence. Again, by asking the question you are demonstrating that you have heard what someone has said. It also gives you the opportunity to demonstrate genuine interest in their thoughts and is a way of saying, *tell me more about this, with some more context.* My go-to question here is *What do you see that makes you say that?* This simple follow-up question asks participants to share evidence for what they are saying. The magic in this question is the 'see', because it asks participants to specifically look for visual evidence that is based in the object or artwork itself. Asking for evidence allows us to add depth to a discussion, by dwelling on and digging a little deeper into what the participant has said. It stops you, as facilitator, automatically moving on to the next comment from someone else and, as such, avoids a quick-fire round of interpretations. It slows down the process and allows time and space for everyone in the group (the facilitator, participants and speaker) to think about what has just been said.

As an aside, I know that *What makes you say that?* is a favourite question for many people and it is also the title of a thinking routine from Harvard's Project Zero.[4] The question asks participants to support their interpretations with evidence. However, in object and art inquiry, the question can be problematic at times. It sometimes puts people on the defensive, in the same way that a personal *Why?* question does, such as, *Why do you think that?* In

discussions around sensitive themes, it could also re-inforce stereotypes, by reiterating a hurtful sentiment.[5] Therefore, as a general rule, when working with artworks and objects I always prefer to use either *What do you see that makes you say that?* or one of the alternatives, below. If you do use *What makes you say that?* it's worth, as Jessica Vance suggests, paying careful attention to your tone and body language as you ask the question, as this will have an impact on how participants receive it.[6] Over time, with continued use of *What do you see that makes you say that?* you will find that participants will automatically start supporting their interpretations with evidence, without being asked. Practising asking this question will also mean that, in time, you will quite naturally ask participants for more evidence, whenever that is necessary or helpful.

Here are some more alternative questions that I use to ask participants for evidence:

- What are you noticing that makes you say that?
- What evidence can we find in the artwork/object, etc. for that idea?
- What do you see that informs your ideas?

- What do you see that made you come to that conclusion?
- What evidence can you share (from the artwork) to back up that idea?
- Can you show us where you see that in the artwork/object?

None of these questions are, however, as catchy as, *What do you see that makes you say that?* Part of its attraction is that it is memorable, and over time it becomes an automatic response.

Linking (bridging, or referring back)

Linking helps the group to follow the discussion and to connect ideas that may have been mentioned earlier on. A skilled facilitator will make links between different strands of thoughts or ideas (e.g. *We have a variety of interpretations here, Sarah mentioned X earlier and Pete now thinks Y*) and note any changes that have happened during the discussion. This could be a change of opinion or new ideas that have surfaced as the facilitator has been sharing information. Highlighting similarities between ideas and grouping together similar strands of thought help the discussion to become a rounded whole. It also helps participants to follow what is being said and connect ideas in their minds, all of which can be used to move the discussion along further.

Whilst a facilitator new to inquiry-based teaching might find it tricky to keep all the varying discussion comments and ideas in their head, over time and with practice this will become second nature. As new facilitators become more familiar with the many 'spinning plates' of facilitation, employing documentation techniques such as sticky notes, word walls, or note taking can help them to recall ideas that emerged earlier in the discussion.

Summarising and synthesising

At certain points during the discussion, facilitators can take the opportunity to summarise what has been discussed so far, by highlighting some key words or points. This helps participants to remember and understand what has been said up to this point. A summary helps to clarify and correct any assumptions or misunderstandings. It is also a useful springboard for fresh discussion, if comments are starting to dry up. If the participants go quiet, you can use that time to describe the point the group has reached.

Synthesising goes one step further and pulls together some of the big themes that are either emerging or have developed, over time, in the discussion. Synthesis means you can outline the emerging common ground, as well as any differences of opinion.

Redirecting

Redirecting asks for others to respond to a question or idea from either the facilitator or a participant. It involves

asking questions like *Does anyone else have anything to add?* or *Is there anyone we haven't heard from yet, who would like to contribute?* Redirecting places emphasis squarely on the group participants, and works towards equal participation from all group members.

When facilitating a discussion, don't allow anyone to dominate the discussion, but equally don't pressure anyone to respond. People should feel encouraged, but not required, to participate. Some people take time to warm up and feel comfortable. Others prefer to remain quiet for the duration. Personally, I dislike pointing at or calling on participants to share their thoughts, as many people do not like being put on the spot or feeling forced to participate. Use subtle hand gestures and eye contact with quieter group members, to encourage them to make contributions. Try to vary the positioning of the group, moving quieter group members closer to the facilitator so that it is easier for them to take part. Use pair-shares, small group discussions and writing exercises to provide opportunities for quieter members to participate more fully.

Closing a discussion

One question I am asked frequently in training sessions is: *How do you finish a discussion?* If you're facilitating a guided tour or educational programme in the museum or gallery, chances are that you will be visiting numerous artworks or objects together and you will need to keep to certain timings. Therefore, when leading interactive and

discussion-based programmes, it's important to know how to finish effectively. The way you close a discussion of an artwork or object will be different to the way you end your entire programme. Here, the focus is on ending a discussion. (For more information on how to close a programme, see Chapter 9.)

If the discussion about an artwork has been lively, it can sometimes be daunting to try and bring it to a close. However, at some point you will need to finish the discussion. Stating that you can 'take one more question or statement...' is a good way to minimise responses in preparation for moving on. You may get two or three more responses, but it will be far less than if you hadn't signalled the 'last call' for contributions. After this, you can compliment participants on the discussion that has just ensued, praising how well they looked at an artwork or object or the variety of ideas that were produced.

Being mindful of language

Use inclusive language

Words matter. The words you use can create connections and feelings of belonging within the group. The words we choose when we communicate can hide unconscious biases and assumptions. They can also (unintentionally) exclude people. Inclusive language is communication that proactively uses words, phrases and expressions that are welcoming.

Your aim as a facilitator is to speak in a way that acknowledges and invites all the group members to participate in the collaborative process of visual inquiry. Thoughtful word choices have the power to create connections and include everyone. It's therefore important that you develop an awareness of and sensitivity to the language that you use when you are with groups. This involves keeping yourself informed and may mean staying up to date with the most current terminology, reading articles and asking your network for advice.

Inclusive language tips

- Using gender-neutral terms: Instead of using gender-specific words like 'he' or 'she', use gender-neutral pronouns such as 'they' or 'them'. Instead of using 'guys' or 'ladies and gentlemen', use 'everyone'.
- Avoid stereotypes: Refrain from using language that generalises or stereotypes certain groups, based on race, gender, religion, or any other characteristic.
- Person-first language: Place the person before their condition or disability. For example, use

'a person with a disability' instead of 'a disabled person'.

- Use inclusive terms for relationships: Acknowledging and respecting diverse family structures and relationships. For instance, using terms like 'partner' or 'spouse', instead of assuming someone's marital status or gender, and 'grown ups' instead of 'mum' or 'dad'.

Provide balanced feedback

Giving feedback to a group member who has made a comment or stated their opinion is important. It shows you have not only heard their response, but understand it too. How you respond to each comment will have an impact on the group itself. Overly positive or negative feedback can limit and close down a discussion. Giving judgemental feedback encourages participants to compare themselves with others.

If you are interested in hearing a wide range of comments from all participants, giving feedback without any implied judgement is essential. This establishes a tone of fairness within the group. Offer non-judgemental feedback to anyone that contributes to a group discussion. Treat everyone equally and do not judge comments. Respond to everyone with the same level of enthusiasm, as participants are more aware than you think of how the facilitator responds to each individual. A tone

of fairness will enable all participants to feel that they are being responded to equally and non-judgemental responses help to build trust within the group. Being non-judgemental does not mean that you cannot be encouraging or show enthusiasm and interest in what a group member is saying. You can still have a personality and share feedback without any judgement.

For example, notice the difference between the following two responses:

'Wow, that's a great idea! I wish I had thought of that.'

And,

'It sounds like you have a good theory there. I'm interested in hearing more about it…'

Which one do you think would build the most trust in the group and encourage others to share their thoughts?

The first comment is very enthusiastic, so you would need to ensure that you responded to all future comments from the group in a similarly positive way, or you would risk alienating other members of the group. The second response still demonstrates sincere interest and encouragement, but uses a more neutral tone.

It's worth developing your own personal response system to participants' comments. Select a few standard,

non-judgemental phrases that work for you and your style of facilitation. Select phrases that you can use universally, in any situation and with any type of group, such as:

Universal responses

'That's interesting…'
'I've never thought about it that way before'
'Will you elaborate?'
'I'm listening, tell me more'
'Let's talk about that…'

If you find it hard to offer a non-judgemental response, try summarising or paraphrasing what the person has said, using the conditional language described below. Using feedback in a fair way opens up the discussion, so that everyone in the group feels that their opinions are valid and valued.

Use conditional language

This simply involves using language that allows for multiple answers or options, for example, by employing words like 'might', 'could' and 'maybe'. Using conditional language confirms that there is no one absolute way

to read certain aspects of an artwork or object. In other words, there is no 'right answer'. This opens up conversation within the group and allows for more possibilities and interpretations. Absolutist language – the use of words or statements that express absolute certainty, such as 'always', 'never', or 'should' - leaves no room for discussion, differing perspectives, or the possibility of other valid opinions. Compare the absolutist phrase, 'Everyone knows that...' to the conditional alternative, 'It is widely believed/commonly understood that...', and you can see the different impact this could have on a group discussion.

Listening actively

Like questioning, it takes time and practise to develop your listening and make it an effective skill. Interestingly, people with strong questioning skills are often seen as good listeners, because they spend time carefully formulating questions that draw information out from others. Listening is an essential skill for a facilitator, as without active listening discussions remain at surface level and don't truly engage all the participants.

Julie Starr calls listening 'a gift we can give others', because it requires you to put aside your own self and thoughts and focus your attention entirely on someone else.[7] This focused listening is not easy in reality - our mind tends to naturally wander and concentration waxes and wanes - but luckily, it is a skill that you can develop with practice over time.

Levels of listening

There are different levels of listening, ranging from cosmetic listening at one end of the scale to deep listening at the other.

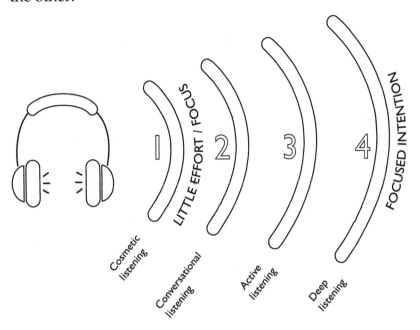

Cosmetic listening:
Your mind is off elsewhere, you act 'as if' you are listening.

Conversational listening:
You are engaged in the conversation, listening-talking-thinking-talking-thinking etc.

Active listening:
You are very focused on what is being said, paying attention reflecting back, summarising.

Deep listening:
You are listening in an emphatic way, noticing non-verbal signals, content of the words.

Cosmetic listening is superficial listening, those moments when you are acting like you are listening (nodding or making appropriate noises or words), but in reality you are only half listening.

In **conversational listening**, the focus is on both the person who is talking and our own thoughts (perhaps, about what we might say next). It feels like 'verbal tennis', with talking and listening switching back and forth between the speakers. In conversational listening, there may be an equal balance in the conversation between the speakers (although this depends on their personalities) and each person can introduce their own opinions, stories and thoughts into the conversation. Conversational listening is a natural, everyday type of listening, which takes place without much thought in most of our normal casual conversations.

At the **active listening** level, we actively focus on what the other person is saying and are attuned to the words being spoken. It requires a conscious effort to mentally register information, reflect what is being said and demonstrate that you are listening with appropriate sounds and noises (i.e. nodding, gestures, expressions, eye contact). Furthermore, you are ensuring that you have not only heard but have also understood what has been said, by asking plenty of follow-up questions for clarification and by restating and summarising the information that you have heard.[8] The main aim in active listening is to gather information and facts, then build a bigger picture of thoughts and ideas.[9]

The last level of listening is **deep listening**. This is the highest level of listening, where you are completely focused on and attuned to what the speaker is saying. With deep listening, your awareness is concentrated entirely on the other person, your mind is quiet and calm, and you have a reduced sense of self-awareness. This is listening in an empathetic way, noticing not just what is being said but the way it is said, by collecting clues from non-verbal signals and listening with your whole body. This type of listening is truly altruistic and in complete service of the other person.

Which levels of listening will you be doing in the museum?

As a facilitator, you will frequently be engaged in active listening. You might also use deep listening (depending on the type of programme you are facilitating) and conversational listening (for example, when walking from one artwork to another and chatting off the cuff with one or two participants) at times.

Active listening involves listening with all the senses. I already touched on some of the components of active listening in this chapter, when discussing paraphrasing, restating and reflecting, linking, summarising, synthesising and redirecting.

As well as giving full attention to the speaker, it is important that the active listener is also 'seen' to be listening. Otherwise, the speaker may surmise that what they

are talking about is uninteresting to the listener. Interest can be demonstrated using both verbal and non-verbal signals. These can be as simple as nodding, smiling, using eye contact and making encouraging noises like *mmm hmm*, or simply saying yes. These signals tell the person speaking that you're listening to them, and actively putting them at ease to continue sharing freely.

Whilst the majority of people believe that they are good listeners, active listening is a skill that takes a lot of practice and conscious effort to improve.

6 ways to improve your active listening skills:

Focusing on what the person is saying and try not to get distracted by other thoughts or follow up questions. If you notice your mind wandering, bring it gently back to what the person is saying. Concentrate fully.

Listening to the person's words, context and tone. The specific words and phrases that are chosen by the speaker are just as important as the overarching themes being talked about. The way

something is said is also interesting: What does the speaker's vocal tone convey to you?

Paying attention to body language cues. Stay aware of any verbal and non-verbal clues that the participant is sharing.

Not interrupting. Be patient when a person is speaking and allow them to finish. Interrupting signals that you don't value what someone is saying. Wait for them to pause.

Listening with an open mind and limiting any judgements or negative comments, as they will compromise your ability to listen. Listening is usually full of assessments and judgements (this is known as 'distressed listening').[10] Instead, aim for distress-free listening, which is listening with an open mind, eager to hear the other person's perspective.

Practising. Become aware of how you listen. Listen to podcasts or audio and see how much information you remember. Have conversations and write down everything you heard, understood and acknowledged afterwards. Becoming more aware of your listening skills is the first step towards improving them.

Advanced facilitation techniques

So far, we've looked at some of the core facilitation tools required to lead engaging discussions around art and objects. Now we'll take these tools a step further and look at the advanced facilitation skills that are necessary for deeper, more challenging discussions. These advanced facilitation techniques lend themselves well to discussions where you are looking to encourage respectful dialogue, good listening and open sharing on subjects of global significance, difficult narratives or sensitive themes.

Starting well

Your first role as a facilitator is always to welcome your participants with an introduction. When you are facilitating discussions around subjects or themes that are significant, difficult or sensitive, it is important to have a good plan for your introduction, to encourage connections. A good introduction is also essential to fostering a great group dynamic.

An introduction is crucial on any type of programme, whether you're leading a guided tour, an educational programme, a 15-minute in-gallery conversation or an online session. At this point group participants are learning what to do, how the programme is going to operate, what is expected and what is acceptable. It's your role to give them

the orientation they need. A good introduction is about placing connection before content. You're establishing trust, forming connections, and building rapport. In the context of discussions on subjects of global significance, difficult narratives or sensitive themes, an introduction is where you will share important information about your role, and any guidelines that are necessary for respectful dialogue.

You will need to introduce yourself and, importantly, explain your role in the upcoming programme. The latter is crucial, because you are setting the tone for the tour - i.e. telling your group what the experience will be like, so that they know what to expect. What you choose to emphasise here will depend on the type of programme you are leading. For example, you might want to state that you are there to guide the discussion, keep it focused and energised, and create opportunities for everyone to participate. By stating what your role is, you are setting expectations.

After you have described and explained your role, you will want to set the tone for the programme. As a facilitator, your goal is to create an open environment, where everyone feels comfortable sharing their views. For this to happen, you can suggest or co-create guidelines that the group will use for the session, such as the Example Guidelines below.

Example guidelines

- Participation is encouraged, but not required
- Listen fully and respectfully to each other
- Don't make assumptions about what others think or mean. We don't all see the world in the same way
- All questions are good questions, so always ask them, no matter how simplistic you might think they are
- Make space for all voices to be heard
- Stay open: we are all free to change our minds
- Make an effort to suspend your own judgement when you listen to others
- If you disagree with someone, try to criticise the idea rather than the person

You may have other museum-based guidelines to share with the group too, but these are specifically intended to set the tone for the upcoming programme. Limiting yourself to 2 or 3 of these is a good idea, to make it easier to remember and repeat them, if necessary, further along in the programme. If you have too many guidelines, you may not be able to remember them all!

(For a deeper exploration of introductions, see Chapters 5 and 9.)

During the programme

Once your programme is in full swing, you may need some facilitative tips on how to keep the discussion going or troubleshoot issues.

Keeping the discussion going

To make sure the discussion stays lively and engaging, keep using open-ended questions, combined with the follow-up questions mentioned earlier. For example, *What do you see that makes you say that?* or *Can you say more about that?*

Use paraphrasing, restating or reflecting back and, where necessary, clarify any comments participants have made that you are not sure about. In any discussions that might be exploring global themes, do not assume that you have understood. If a comment from a participant is not clear, ask them for clarification.

In order to keep all participants engaged in the discussion, acknowledge and validate their ideas and use summarising and synthesising to capture the key themes that have been mentioned.

Use silence or waiting time to allow participants to think and explore possible responses or ideas. Be patient and

allow this valuable 'thinking time'. Whilst silence can sometimes feel awkward, remember that you are actively giving your participants time and space to think through their responses. If there are no responses after a certain amount of time, you can rephrase or ask a follow-up question.

Read the group throughout the programme and look at what is happening. Is everyone participating? Who is not taking part? Who is dominating the discussion? How do people feel? What is the level of energy in the room? Build time and space into your programmes to actively scan your groups and 'take the temperature' of the room.

Dealing with emotional responses

We know that experiences with art and objects in museums and heritage sites make you think. They allow you to draw on your emotions, pull from personal experiences and make connections.

When you work with groups in the museum and enable discussions around artworks and objects that touch on difficult narratives or address challenging subjects, your participants may have strong emotional responses. You have no way of knowing in advance what emotions and experiences may bubble up as a result of spending time with an artwork or object. Participants could also be bringing a variety of emotional states and experiences into the museum with them. Regardless of the cause, it's important to be aware of and sensitive to these emotions

and to recognise that all sorts of things can trigger emotional responses. Although you are often unable to predict when or why responses might happen, it does help to think through any guided experiences you lead and to identify any moments or objects that may provoke emotions or contentious discussion. You may want to think carefully about what Questioning Practice you could select for this moment and walk through the main discussion points in advance. It is important to note that you cannot and will not be able to prepare for all eventualities, as you simply do not know who will be bringing triggering experiences or trauma with them into the museum space, but you can make yourself more prepared by thinking ahead. Every programme you facilitate should create a supportive space for people to share their ideas, ask questions and show emotions. If you will be discussing an artwork or object that could potentially trigger emotion, it is always worth reminding the group to contribute to the discussion with sensitivity. As a general rule, participants will usually mirror your approach, so if you discuss things sensitively, they will follow. Share the guidelines at the beginning of your programme and, if necessary, repeat them throughout.

One of my mantras for all types of discussion-based programmes is this: *Encourage, but do not require, participation.*

This is even more important for discussions that ask for participants to share personal connections, feelings or

emotions. Nobody should feel under pressure to take part and interact. To create a more inclusive and intro-vert-friendly environment, it's best to avoid: calling on participants to answer questions, using gestures like pointing, or naming individuals. As always, but even more so here, allow plenty of time after you've asked a question. Try not to rush to fill silences. Silence can be an important moment for some people, and may spur others to talk, particularly quieter group members. Those that feel happy to respond will do so.

Troubleshooting

There will be times when things don't go as planned. Dur-ing every class, course or training day I'm always asked What if? questions, like 'What if nobody talks?' or 'What if one person dominates the discussion?' So, it's useful to have a general troubleshooting guide for what you can do when things go awry:

What if nobody answers?

This is the moment everyone dreads when they're leading a discussion-based programme. It's the moment you ask a question and receive nothing in reply, except perhaps the sound of tumbleweed rustling past. Chances are that it has happened to you in the past and it will happen again in future. A 'tumbleweed moment' feels scary, because you really do not know why everyone is staying silent. First of all, breathe. Then try to wait a little longer. The moment after you've asked a question will probably seem much

longer to you than to your participants. Give everyone the chance to look carefully and gather their thoughts. Replies to open-ended questions usually take longer to formulate in your head, so be patient with your group and relax. Whilst you are waiting, take this time to observe your group fully and look out for any signs that may give you clues as to why they are silent. If you still do not have any responses after giving ample looking and thinking time, consider rephrasing or rewording your question.

What if someone is not taking the discussion seriously?

You have a number of options here. You could first look for anything that resembles a serious answer in their words and repeat those back to the group. Or you could ask them to think of a different answer. When they respond with another answer, reflect back what they have said to the group.

Avoid asking for evidence when hearing glib responses, as it may cause the person to reiterate what they have just said based on your validation. If the comment is inappropriate, ensure that you say something like: 'I realise that you may not have intended it, but this is a sensitive subject, and that sort of humour/comment makes people uncomfortable.'

What if someone dominates the discussion?

People will play different roles in groups and every facilitator will encounter a group with a person who wants to monopolise the conversation. However, your goal is to

encourage the equal participation of all members of the group. If one or more participants are allowed to dominate, the rest of the group will start to switch off whenever the dominant group members speak. Quieter group members may also feel increasingly frustrated, but hesitant to speak up about it.

After a dominant group member has finished speaking, thank them for their contribution and ask whether anyone else would like to share. A good question to ask to encourage input from all group members is: *Is there anyone here we haven't heard from today who would like to share something?*

You could also take a moment to remind the group of the guidelines, stating that one of the goals mentioned is to provide everyone with the opportunity to share. Finally, changing people's positions in the group is also quite effective. Bring the participants at the back to the front and vice versa. Dominant group members quite often like to 'have the ear' of the facilitator and tend to position themselves close by. Moving participants' positions may encourage quieter members to talk.

What if we go off track?

Open-ended questions are wonderful for promoting discussion, but they can generate quite lengthy responses. As a facilitator, you can ensure that your group stays on track and on time during your time together. You can attempt

to re-focus the discussion by thanking the participants for their contributions and stating that, *in order to accomplish our goal/see everything/finish on time, we really need to move on.* You can give the option to perhaps return to the topic later on. Another tactic would be to summarise where you are at that point and highlight the main discussion points relevant to the theme.

What if participants keep interrupting each other?

You want to be encouraging respectful discussion, with all participants listening carefully to each other. Interruptions can seriously disrupt the flow and change the atmosphere of the group. It may be worth mentioning how you want the group to behave with each other in the guidelines you share at the start of the programme and you can then remind the group of this, when necessary. Otherwise, make a statement to clarify that the goal is to have one conversation at a time, e.g. *Could we remember to have just one person talk at a time and let people finish what they are saying?* Alternatively, you can share the order in which you'd like participants to speak: *Okay. Let's hear first from Rachel, then Harry and then Sarah.*

What if a group member becomes hostile?

Firstly, stay calm and remember not to take this personally. Try to include their negative comments in a more positive way, such as: *That's an interesting/different way to look at it. Thank you for sharing that alternative point of view.* If the behaviour continues, you may want to chat with

the person in-between stops or take them aside. If it's a school group, involve the teacher. Stress that you would like their cooperation if they choose to stay within the group.

What if conflict occurs?

People will not always agree with each other and there may be times when conflict arises within your group. Conflict can range from mild disagreement to full anger. Most conflict can be prevented by having a clear goal and good set of guidelines that reinforce a positive group culture. Remind the group of the areas of agreement, whilst acknowledging that disagreement has occurred, by saying something like: *We have a variety of different opinions here.* Then agree to move on. After conflict has occurred you might also want to think about asking people to share in pairs, or do some writing or drawing, so that the group can refocus.

What if the group doesn't want to end the discussion?

Sometimes your group will get engaged in a lively discussion about the artwork that nobody wants to end. Unfortunately, as described above, your role is to keep the group on track. You will need to make a judgement call as to whether it is worth continuing the discussion here and sacrificing time at another artwork later in the programme.

You could give the group a gentle time warning, such as, *We have about 2 minutes left before we need to move on, so...*

You could also simply state that you will take 2 more responses before you need to move on. Alternatively, put it to the group, by asking them if they would prefer to stay and continue discussing, or move on to see more. Share what the consequences of staying put might be - if it involves missing a highlight from the collection, the group may not be so keen to stay after all!

Facilitation plays a pivotal role in guided experience. A programme without facilitation is like an orchestra without its conductor. Without the facilitator's guidance, the programme may feel disjointed, and lacking in harmony and rhythm.

In this chapter, we have discussed what facilitation is, the roles you will play and the core and advanced techniques you will need at your disposal. From verbal and non-verbal tools to paying attention to language and listening skills, we have built our facilitator's toolkit. By working on these skills, you can create meaningful and engaging experiences for participants. Just as a conductor brings together musicians to create a harmonious symphony, facilitation ensures that your guided experience resonates with purpose and connectivity, and that it makes a lasting impact.

Notes

1 Dale Hunter, *The Art of Facilitation* (Penguin Random House New Zealand Limited, 2012), 19.

2 Nancy Kline, *Time to Think : Listening to Ignite the Human Mind* (London Cassell Illustrated, 2016),

3 "Active Listening: The Key to Transforming Your Coaching (Opinion)", last modified April 27, 2014, https://www.edweek.org/education/opinion-active-listening-the-key-to-transforming-your-coaching/2014.04.

4 "What Makes You Say That? A Thinking Routine from Project Zero, Harvard Graduate School of Education", accessed June 7, 2023, https://pz.harvard.edu/sites/default/files/What%20Makes%20You%20Say%20That_0.pdf.

5 "Honoring Students, Teachers, and the Work of Kerry James Marshall through VTS - Visual Thinking Strategies," last modified March 22, 2018, https://vtshome.org/2018/03/22/honoring-students-teachers-and-the-work-of-kerry-james-marshall-through-vts/.

6 Jessica Vance, *Leading with a Lens of Inquiry* (Elevate Books EDU, 2022), 93.

7 Julie Starr, *The Coaching Manual: The Definitive Guide to the Process, Principles and Skills of Personal Coaching*, 5th ed. (Pearson Business, 2021), 59..

8 International Coaching Federation, "Updated ICF Core Competencies," October 2019, https://coachingfederation.org/app/uploads/2021/07/Updated-ICF-Core-Competencies_English_Brand-Updated.pdf.

9 Starr, *The Coaching Manual: The Definitive Guide to the Process, Principles and Skills of Personal Coaching*, 65.

10 Hunter, *The Art of Facilitation*, 79.

4
Multimodality

'In a profound sense, all meaning-making is multimodal.'

– The New London Group

In museum education, every guided experience that we design and facilitate provides an opportunity to make choices about how we communicate our message or achieve our goals.

Imagine a traditional guided tour, where the guide or educator delivers the content lecture-style, to a passive audience. This is a 'unimodal' approach. 'Multimodal' learning, on the other hand, occurs when different modes or mediums of communication are used to draw meaning from something. Working 'multimodally' involves using a variety of different modes to enrich the learning experience, instead of simply relying on one mode of communication (such as words).

In 1996, a group of scholars collectively calling themselves The New London Group identified 6 modes of communication that individuals can use to make meaning in any given context:[1]

1. Linguistic - written or spoken language
2. Visual - images, graphics, and other visual representations
3. Audio - sound and music
4. Gestural - body language and movement
5. Spatial - physical space and arrangement
6. Multimodal - a combination of any (or all) of the above modes

In the Thinking Museum® Approach we use a variety of modes to engage participants, promote interactivity, and create a more inclusive and individualised experience. In this chapter, we're going to explore the key features and benefits of a multimodal approach, before discovering a number of ways you can embed multimodality into your guided experiences in museums.

The key features and benefits of multimodality

Delivering your programme in a unimodal way guarantees that there will be some participants who will disengage and tune out, as their learning needs are not being met. In addition, people now experience the world in multiple dimensions. We are all used to processing visual information, sounds, text and movement everywhere, all the time. Whilst we might want to offer participants some respite from the fast-paced world outside of the museum walls, it does make sense to design your programmes to incorporate multiple modes. Multimodality is less about pleasing all of the people all of the time and more about offering a wide variety of options for participants, to help them engage with your programmes. Ideally, you will use a wide variety of aids, activities and modes of working in any one session, to appeal to as many participants as possible.

By offering a number of different ways to work, you are able to design sessions that recognise the importance of variety as a way of engaging participants. Too much repetition and predictability in the way you facilitate causes audiences to tune out and disengage, whereas multimodality ensures that every one of your guided experiences is varied and novel. Whilst you are offering opportunities for participants to connect and collaborate with each other through peer interactions, to create a community of collaboration (as outlined in Chapter 5), multimodality complements this process by allowing different voices to be heard throughout your programme. This is because using a variety of modes allows diverse group members to feel confident and empowered to express their ideas and have their thoughts heard, in a way that feels uniquely comfortable for them. When designing your museum and gallery programmes, you want to ensure that you are covering a wide variety of modalities in your plan.

How to incorporate multimodality into your programmes

Incorporate a variety of teaching strategies

Although this book advocates a inquiry-based approach to designing and leading guided experiences, this doesn't mean that all interaction in the museum needs to be based

around talking. A variety of teaching techniques can be employed to fully engage your audiences with what you're exploring. This could involve reading, writing, listening, watching and even pauses or quiet time for reflection. Incorporating a variety of approaches increases participant engagement with and memory of important moments, themes or content within the programme. These different modalities actively stimulate participants' brains and activate new neural pathways, encouraging individuals to think, make connections and come up with new ideas. Handling the information in different ways allows more participants to become personally involved with the artworks and objects, because you're providing opportunities for them to learn in ways which work best for them.

When planning, start with the end in mind and carefully consider your goal in using a particular activity and how it might contribute to exploring and understanding the meaning of an artwork or object. Think about when you will do these activities and whether they are appropriate for the stage of the programme, how much time they will take up, and if you will need any equipment. Less is more at the start, as you begin experimenting to see what works and exploring different possibilities.

Suggestions for multimodal teaching strategies:

- **Include movement when looking at objects or artworks.** Look at something from far away and close up, or from above and below. Do a 360° slow walk around a sculpture, or change places with someone on the other side. Assume the pose of a figure in a painting or sculpture.

- **Step inside a character and imagine** how that person would move, what they might say, and how they might say it.

- **Use drawing, sketching, doodling and scribbling as an observation exercise.** Try a contour or continuous line drawing (drawing without lifting your pencil from the paper) and ask participants to draw by only looking at the object (not at their paper). Or try a 'touch drawing', by presenting an object in a bag that participants have to touch then draw using their imagination. Or, try a 'back-to-back drawing', where one person describes the object (or a part of it) whilst another does the drawing.

- **Incorporate short writing exercises.** Write a postcard home about a place in an artwork.

Share nouns, verbs and adjectives that you observe in an artwork. Step inside an image and write down what you saw, heard, smelt, felt and tasted (a good way to brainstorm ideas for sensory description). Ask participants to write down a sentence describing how they connect personally with the artwork.

- **Add activities that encourage listening and sounds.** Play music or sounds for the group to listen to whilst they look at an artwork. Imagine what type of music an artwork might be, if you could hear it. Create sounds with voices and bodies, in response to an artwork or object. Hand out headphones and allow participants to listen quietly to a text or quote from the artist.

Change the way the group works

Another way to change the pace of your programme and use a variety of modalities is to change the way the group works. Rather than always working as a whole group, experiment with different group configurations to foster more interaction and greater exchange of ideas. This approach creates better social connections amongst participants and reduces the focus on the educator or facilitator, encouraging engagement from all group members.

Pair Share

To promote collaboration and thoughtful engagement, try using a Pair Share approach. During a Pair Share, participants are given the opportunity to share their thoughts and ideas with a partner, rather than having to speak in front of the entire group. This can help to reduce social anxiety and encourage more participation from everyone, even the quieter group members. Some of the thoughts shared can then be 'fed back' to the group as a whole. Pair Share fosters a collaborative culture, as participants work together to discuss and share their ideas. It is a wonderful way to provide a comfortable environment for participation.

Small groups

Smaller group formations change the group dynamic and transform the energy in the room – if your group is low on energy, break them up into smaller groups and you will see the interaction fly again! Try dividing participants into smaller groups of 3-5 people, to work on a specific question or activity. This approach allows for more in-depth discussions and encourages active participation from all members of the group. You could also assign different roles within the groups – such as notetaker and spokesperson – so that everyone has a distinct part to play.

Types of small group activities

Gallery walk

A gallery walk is typically used in educational settings. It involves participants moving around a space to view and engage with displays or presentations created by others. However, this approach can also be applied in a museum or gallery environment, to encourage collaboration, creativity and peer connection.

Divide your group into smaller groups and assign each one an area to walk around in and view the displays. The instructions you share will depend on your goal for the activity. You might want to ask each group to look for connections and contrasts between certain objects in a particular gallery, to record impressions of what they saw, or to brainstorm a list of questions that they have about what they are exploring. A debrief always follows a gallery walk and, depending on your goals, this can also take many forms.

Debate

Debates are great for encouraging participants to engage with different perspectives around a particular issue or topic. Participants are divided into teams and asked to debate a specific theme or question. Each team is assigned a different position, or perspective, on a particular topic or issue. The teams are given time to research and prepare their arguments and thoughts, and then to present their positions to the whole group in a structured way. You could

use a Questioning Practice to structure team discussions, or to choose a variety of perspectives from which to view a photograph, historical document or painting. Always ensure that you share guidelines for respectful discussion too.

Brainstorming

Brainstorming is a collaborative and engaging small group activity which can be used to generate new ideas and potential solutions to a problem or challenge. Participants are encouraged to share ideas without any judgement or criticism. All ideas, no matter how strange or seemingly irrelevant, are welcomed.

Scavenger hunt

Use the idea of a scavenger hunt as a small group activity in one gallery or with one object. Provide each small group with a list of clues or questions related to the gallery or an object (or objects) within it. The clues might ask the group to find specific details within the exhibit or object, to answer questions related to an artwork, or to take photos of specific poses or expressions made in front of an exhibit. Give your group a set time to complete the scavenger hunt, then reconvene to discuss their findings. As facilitator you can lead a debrief or reflection time to help participants make connections between what they discover and the larger themes of the exhibition or gallery. Scavenger hunts are engaging, fun activities that involve teamwork, problem solving, observation skills and active participation.

Role-playing

Role-playing can be used in a museum to help participants explore different perspectives and engage with objects or artworks in a more immersive way. After dividing the group into smaller groups, assign each one a role to play, such as a historical figure or figure within a painting. Provide each group with a set of prompts or use a Questioning Practice - such as The Perspectives Triangle - to guide the interaction with their particular role or person. After the allotted time, gather the whole group together and invite the smaller groups to share their experiences of role-playing. If time allows, ask each group to present their role and act out how they might behave. Role-playing can help to deepen participants' understanding of a theme or artwork, by exploring the different perspectives involved. Working in small groups helps to foster teamwork and collaboration and allows all group members to comfortably participate.

Things to consider before breaking into pairs or small groups

To ensure that the activity stays effective and engaging when breaking a large group into smaller groups or pairs, there are several things to consider:

Purpose

Consider the purpose of the activity and whether small groups or pairs would be more effective or engaging. For example, if the goal is to encourage brainstorming

or discussion, small groups may be more effective than pairs.

Group dynamics

Consider the dynamics of the larger group and if certain individuals might not work very well together in pairs or small groups. If you have a mix of quieter with more dominant group members, try to combine them in the smaller groups. If you're working with students, ask the teacher beforehand if there are certain configurations that they have in mind. It's important to ensure that everyone feels comfortable and safe in their small groups or pairs.

Time

Consider the amount of time needed for the activity and whether breaking a larger group up into pairs or small groups will allow adequate time for discussion and collaboration. Ask yourself: *Is there enough time in the programme for this activity?* Also, don't forget to communicate a time limit and decide on a signal and location for when and where everyone should come back together.

Resources

Do you need any resources for this activity? Will each group have access to the materials they need to complete the task? Remember to bring any necessary resources with you on the day of the programme.

Facilitation

Consider what type of facilitation is needed for the activity and whether you will be able to support every small group. If possible, visit each of the groups whilst they are doing their various activities and listen in to the conversations. Check for understanding of the activity (if necessary) and answer any questions as they come up. Try not to interfere with or interrupt the group process, but be there in case you're needed.

Logistics

Consider the logistics of breaking a large group into smaller groups or pairs, including how the groups will be formed, how they will transition between activities, and how they will share their findings with the original whole group. Before splitting people into smaller groups, fully explain what you are asking each group to do. If necessary, provide written instructions for the group to refer to. Working in groups can be noisy, so ensure that other visitors are not disturbed and that there is adequate space for group members to hear one another.

Supplementary materials and visual aids

You can use a variety of props, supplemental materials and visual aids to make your programmes more multimodal.

Pencils and notepads are useful for your participants. You may want visitors to sketch an entire object or write down

things they are observing. Sticky notes are also great for getting people to note down short phrases or words, and when used as 'exit tickets' at the end of the session.

Tactile objects are great to pass around (in a safe way and in line with health and hygiene protocols) and explore texture. These hands-on materials can be really helpful for exploring objects from the past and from different cultures. For the visually impaired, handling objects is a way of making collections more accessible. For any visitor incorporating senses other than seeing, tactile objects offer them a richer understanding of the objects in the collection. Bring in samples of marble, wood or other sensory objects to touch. Pass around spices to smell, or tools that were used once by artists or workers.

Use photographs, artist's letters and quotes, video clips and music, to add context and depth to your discussions. For family groups I used to have a whole box of props and visual aids to choose from before the tour, including magnifying glasses, torches, viewfinders and stopwatches.

Bring in the senses

Bringing all of the senses more fully into our programmes invites more opportunity for interaction. In museums, chances to use all of our senses (not just our visual sense) are important, because a museum is a place where touching (for example), is often not allowed. Be playful, and

think of opportunities to bring more of the 5 senses into your programmes.

Sight

Most museums and galleries rely heavily on visuals to convey their message. How could you enhance your participants' visual experiences in the museum?

Think about positioning your group in an optimal spot for viewing, by adjusting the distance between the participants and the artwork or object to help them all appreciate the details and nuances of what they're seeing. Consider the framing, mounting, display cabinet and placement of the artwork or object within a gallery, in order to appreciate its importance or unique qualities. Using the information on a label or the wall text adds the curator's perspective to the discussion. These elements (amongst others) can really help to enhance your participants' visual experience, ultimately helping them connect with and appreciate the objects on a deeper level.

Hearing

How often do we pay attention to our auditory experience when viewing an artwork? Sound can play an important role in a museum or gallery programme. Think about how you might use your imagination to invoke the sense of hearing. What might you hear if you were to step inside the painting you are looking at? What quote could you read out to deepen the meaning of a particular object?

Could you incorporate soundscapes, music or narration, to enhance the experience for your group? Enhancing a participant's auditory experience when viewing an artwork or object can provide them with additional context and insight into its meaning and significance.

Touch

Many visitors are introduced to the sense of touch in the museum space in a negative way, through the judicious use of 'Do not touch' signs. Occasionally they may have the chance to enjoy interactive exhibits that allow them to touch and feel objects. Try to create an environment where the sense of touch is encouraged. Bring along objects for visitors to touch which replicate the feel of an object that they can't actually touch. You could bring fabrics, metal or wood to represent something that is on display. Use tactile displays, replicas or 3D models to allow participants to interact with objects in a more meaningful way.

Smell and taste

Incorporating smell and taste into a guided museum experience can be challenging, as it may not always be appropriate or feasible. Some exhibitions or events pair food and drink with specific artworks or exhibitions, so why not imagine what the food in a still life might taste like, or what recipes you could create from the ingredients in front of you? Bring different scents with you for participants to smell. Scent and taste can evoke memories and emotions, but you may find that to incorporate these

senses you are relying much more heavily on imagination to conjure thoughts about the smell of an old book or the taste of a sour lemon, rather than using the real thing.

By incorporating multiple senses into your museum or gallery programme, you can create a more engaging and memorable experience for visitors. It's important to consider the appropriateness of each sense, as well as how it fits into the overall message and theme of the experience.

Shared ownership

As a facilitator, it is important to create a feeling of shared ownership within your programmes, by incorporating a variety of modes of working that don't always rely on your leadership and group management. You want your group to be co-conspirators and co-contributors to your programme, and for them to feel involved and included. For this to happen, allow as many opportunities as possible for them to explore their own ideas.

This can be achieved by giving the group options and agency throughout the programme, by asking them what they would like to look at, and by allowing them to explore their ideas. This shared ownership and agency can create a sense of community and belonging, which can lead to a more meaningful and long-lasting learning experience. Choices are important. Offer participants options throughout the programme. This can include selecting which artworks or objects to view next, which activities

to participate in, or which questions to explore. By giving participants options, you allow them to take ownership of their learning experience.

Encourage collaboration when exploring objects or completing activities. This collaborative approach can create a sense of shared ownership and fosters a community of collaboration. Engage participants in discussions about the artworks, objects or ideas. Allow participants to frequently share their perspectives, ask questions, share their interests, and pursue their own ideas. Use prompts, Questioning Practices or discussion questions to encourage participants to investigate artworks or objects on their own or in small groups.

The use of multimodality in guided experiences is crucial for creating an engaging and inclusive learning experience for all participants. By incorporating a variety of modes of communication and interaction, programmes can accommodate a wide range of learning preferences. This not only creates a more inclusive environment, but also helps participants to engage with the artworks or exhibits on a more personal level, leading to a more meaningful and fulfilling learning experience.

Lastly, it is also important to recognise that participants in your group will have a wide range of learning preferences that are activated by their individual purpose, motivation, and inclinations. No two participants will have

the same preferences. Participants become fully engaged when they are presented with a variety of ways to interact and communicate with you and with each other. Use this opportunity to design multimodal programmes that appeal to as many modes of learning and communication as possible. Ultimately, this will lead to a more fulfilling experience for everyone involved.

Notes

1 New London Group, "A Pedagogy of Multiliteracies: Designing Social Futures," Harvard Educational Review 66, no. 1 (April 1996): 60–93.

5
Creating a community of collaboration

'Collaboration – a social act of understanding.'

– Joseph P McDonald, Nancy Mohr
and Alan Dichter

In this chapter we'll be exploring how the Thinking Museum® Approach creates a community of collaboration for group experiences in museums and galleries. We'll look at what a collaborative community is, the benefits of creating one and how you can work towards harnessing the power of the group. We'll also be exploring the roles that group dynamics and building rapport can play in great group experiences, alongside how to optimise the group experience by building awareness of and sensitivity to how you can improve and foster a collaborative community.

Museums are communal gathering places and social hubs. Studies show that a significant majority of museum visits occur in groups, while only a small percentage, ranging from 5% to 20%, visit exhibitions alone.[1] Given this social nature of museum visits, it makes sense to harness the power of collective learning and interaction in these settings.

The majority of group or collaborative learning is based around conversations, discussions and dialogue. Although there are many different types of collaborative activities that can take place in the museum environment, the most prevalent activities happen via discourse or talking. In *Teaching in the Art Museum*, Rika Burnham and Elliot Kai-Kee suggest that each type of talking is fundamentally different in purpose, structure and tone, and should be seen as 'separate modes of teaching'.[2]

Conversations, discussions and dialogue also have different patterns of interaction. Whilst a **conversation** is an informal back-and-forth, a **discussion** could be seen as a space where an array of ideas and thoughts are bounced around, and **dialogue** might be much more tightly focused, with a facilitator guiding and shaping the events. For the purposes of this book, these 3 terms are used interchangeably as the Thinking Museum® Approach offers a flexible framework for creating all forms of conversation, dialogue, and discussion. The circumstances will ultimately dictate which type of 'talking' you create for your group.

In all these differing forms of shared discovery, collaboration is key. Shared group experiences not only allow us to exchange ideas with others, they also teach participants how to cooperate in a group, by listening to other people talking and respectfully engaging in discussion. In inquiry-based approaches to guided experiences, a group works collectively towards deciphering and understanding an artwork or object. This can be achieved through a variety of activities or approaches, not only conversation, discussion and dialogue, but also writing and drawing, movement and drama, and so on (for more on incorporating multimodality, see the previous chapter). This deciphering and meaning-making gives participants space to interact and exchange ideas, reasoning together out loud, responding to and building upon the ideas of group members, and generating further lines of inquiry.

The Questioning Practices discussed in detail in Chapter 2 support group learning and provide a flexible structure for discussions. The steps of the framework scaffold participants' thinking and understanding. Participants are all asked to observe, describe, build interpretations, make connections, reason and wonder about objects and artworks. The questions in the Questioning Practices invite multiple interpretations and everyone is encouraged to participate, regardless of their age, ability, or experience. The facilitator guides the discussion from one point to another, offering everyone the opportunity to speak, giving non-judgemental feedback, and reflecting back a variety of responses and perspectives. In addition, the facilitator is constantly looking for new ways to bring others into the discussion and to connect lines of inquiry.

Participants are therefore a central part of the process. Without them, no discussion or learning would take place. By observing and describing, wondering and suggesting, the discussion starts to take off. Because there are no 'right' or 'wrong' answers, the conversation unfolds easily, and everyone feels comfortable taking part and sharing their thoughts. Each participant brings their own personal experiences and connections to the process too. So how can you learn to harness the power of a community of collaboration?

Group dynamics

As museum educators, we are already familiar with sharing information and connecting visitors with knowledge. Just as important, however, is understanding the dynamics of a group, and knowing how to establish group camaraderie.

The term 'group dynamics' originated in the 1940s. It was first coined by Kurt Lewin, a social psychologist and change management expert. Group dynamics refers to how people behave, react and respond to one another in group environments. Even before the Covid-19 pandemic, building great relationships between participants was important for making your programmes, tours and sessions engaging. Now, it's a necessity. Museums and galleries bear a responsibility to their visitors to create opportunities for social interaction and collective *joie de vivre*.

As a facilitator, you can create the conditions to build great relationships between your participants, making people feel socially comfortable and visible. Consciously paying attention to group dynamics will help you to create group experiences where everyone is happy to participate and feel like they are amongst friends.

Groups with a positive dynamic are easy to spot. You will notice that group members feel safe and trust each other.

They are happy to work towards a common purpose or goal and hold each other accountable. They also exhibit creativity.

Positive group experiences that engender a sense of harmony and energy are full of moments known as 'collective effervescence'. Collective effervescence is a term attributed to sociologist Emile Durkheim, and it describes the harmonious energy that flows through communities when they participate in a religious ritual together. Today, this idea can be applied to any shared group experience at a concert or play, or to the group feeling you might share with your team mates when playing a football match together. It can certainly be applied to shared group experiences in museums and galleries. Collective effervescence is a feeling that we have all experienced from time to time. It's a joyous, uplifting feeling of being at one with a crowd. Whilst interactions do not always rise to this level, it's not hard to see why people would want to create experiences that enhance joy, meaning and belonging between members of a group.

It's not difficult to create a positive group dynamic within every programme you facilitate, but it does require you to make an effort and take deliberate steps as facilitator - you can't just leave it up to chance.

Common characteristics of groups

Let's return to basics and look at how to define a group and what the common characteristics are. A group is essentially an assemblage of persons gathered closely together and forming a recognisable unit. In Priya Parker's book, *The Art of Gathering*, she defines a gathering as: 'The conscious bringing together of people for a reason'.[3] Each group that you encounter in the museum will have unique characteristics, but there are some commonalities - origin, roles, space and size - and all of these will have an impact on group dynamics.

Origin

The origin of your group will have an effect on how they behave, respond to and interact with one another.

You might be working with groups of close friends or family groups that share long-lasting, close relationships. Or you might have temporary groups that will only be together for the duration of the programme (for example, individuals who have joined a guided tour and did not know each other prior to the experience). Some participants will be grouped together by their class or year group at school, or by a shared interest, club or hobby. Others may be in a group of colleagues from work or other associations. All of these will have different group dynamics. Taking the time, before the programme starts and in your introduction, to find out how (or if) people in the group

know each other will help you to create better group camaraderie.

Roles

The roles people play in a group depend on a variety of factors, such as whether or not they know the other group members, whether they are familiar or comfortable with the environment they are in, and how they might be triggered by either the situation or the theme of the programme.

Kenneth Benne and Paul Sheats identified more than 26 types of functional roles that one or more individuals may take on in group situations.[4] They classified the roles as: task roles; personal and social roles; and dysfunctional (or individualistic) roles. Some roles in groups may emerge as the process continues, and others may be formed by the interactions that take place.

An effective group will be made up of a large number of individuals representing the more positive roles. Bear in mind that each group will also contain a variety of personality types, including those tending towards introversion, extraversion and ambiversion. As, in our role as facilitator, we spend relatively short periods of time with members of groups, it is worth being aware of how a group is working together and how their interaction and cohesiveness might be improved.

Design

The design of the environment is an equally important factor for enabling good group dynamics. The museum environment itself affects how people interact with each other and with the artwork in question. The grand scale of the architecture can be intimidating for some and the sheer magnitude of the galleries and objects within can be overwhelming. There are a lot of people who are simply not at ease visiting museums, who feel that they do not belong there. Your role as a facilitator is to connect with your participants and make them feel comfortable. You are there to make the museum a warm and inviting space for everyone visiting.

Likewise, if the participants on your programme are unable to see the artwork that you want to discuss, participation and interaction will be limited. If the group have been positioned on a busy corridor, with lots of through traffic, participants will not be able to get into the flow of the discussion. Be aware of the space you use in every part of your programmes, and design it so that participants are positioned for maximum eye contact (with you, with each other, and with the object) and participation. Ensure that every person can easily see and hear others, and that nobody has to strain to catch someone else's eye. If necessary, do a walk-through beforehand to check on these factors, then check in with your participants and scan their body language throughout the programme, looking for clues that their comfort needs are being met.

Space

It is surprising how much you can learn from simple observations of space in a museum or gallery programme. 'Proxemics' is the study of how people use space and how differences in that use can make us feel calm or stressed. The amount of distance that one person will put between themselves and others (or their 'personal space') will vary from culture to culture, but also with how well the group knows each other and how comfortable they feel in the museum environment. The next time you are facilitating a group experience in a museum, observe how people stand in relation to one another and to you. As you move around the museum, watch the ways in which the participants position themselves. Who do they prefer to stand next to? How close do they position themselves to the facilitator? Is there a front row and a back row?

As a facilitator, you will want to organise your group and their positioning so that everyone can communicate and interact with each other. This means physically adjusting the positioning of your group so that it is the most conducive to what you want to achieve and to the kind of atmosphere you want to create. If you want your group to move in or move back, tell them so. If you would like them to form a semicircle in front of the object, state this clearly. The group will quickly catch on that it's important. As facilitator, you can design the space to your advantage and for maximum engagement and interaction. This may mean that you have to retire a stop or two, if the

space around it/them doesn't meet your needs and criteria - although the artwork itself may offer the opportunity to have a great discussion, if the location or space it is situated in doesn't, then it's worth evaluating if you should include it or not.

Size

Size is an important determinant of how the group will function and gel together. Larger groups can feel anonymous and hard to control, whilst smaller groups can make participants feel that there is too much responsibility to contribute frequently.

Groups in museums can vary in size dramatically, depending on the size of the organisation and the resources it has available. Around 12-15 people is a common size for a guided tour or group programme (although larger groups exist too). Luckily, this also happens to be an ideal group size - with 12-15 group members everyone can participate, everyone can be heard, and it is fairly easy to facilitate the building of connections and trust. Groups smaller than this are good for sharing more personal reflections, or for people with a shared interest. A group size larger than 15 people will need skilled facilitation, requiring frequent small group breakout discussions and clever use of space.

Group formation

In 1965 Bruce Tuckman, an educational psychologist, came up with a model that identifies 5 stages of group development. The stages, most commonly applied to small teams in corporate environments over a period of time, are: Forming – Storming – Norming – Performing – Adjourning.

We can adapt this model to designing and facilitating museum and gallery programmes where people come together as a group for a relatively short period of time, with a defined start and end point. Being aware of these phases (as illustrated below) can help you to design and facilitate your museum and gallery programmes with a collaborative culture in mind. (The 3 phases of a museum or gallery programme are discussed in detail in Chapter 9).

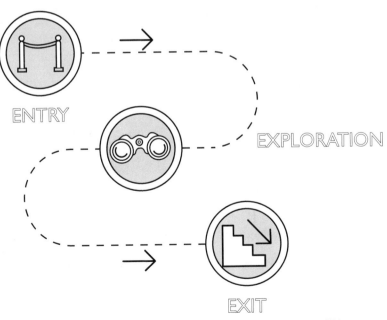

ENTRY

EXPLORATION

EXIT

Let's look at each of the phases (Entry, Exploration, and Exit) and how they relate to creating a community of collaboration.

Entry

The Entry phase is concerned with everything that happens before the session and at the very start of your programme. This includes any communication or discussions that you have with your group before they arrive at the museum, and also your 4-part introduction and warm-up. The Entry phase focuses on establishing trust, creating connections, and setting the tone and goals (whether in your pre-programme communications, your introduction once the group has arrived, or when you are warming up and getting the group connected). The aim is to ensure that everyone in the group knows why they are here, who everyone is, what they are going to do and (especially in an interactive programme) how they will do it. Now let's take a look at what is needed, when.

Pre-programme

A programme can be made or broken before the participants even enter the building. What can you do to prepare your participants in advance of their visit? Museum educators have long used pre-activities with school groups to get them prepared for their museum visit, in advance of passing through the doors. Think about how you want your group to show up and apply this to your pre-programme communications. This is

not only about logistics and pathfinding, but also about setting expectations. Give your group a feel for what is going to happen and how. If you want your group to be prepared for participation and interaction, signal this in your pre-programme communications, in order to set the tone.

Introduction

Once the group has actually arrived in the building (or online, this applies to digital sessions too), make the transition to the start of the programme as seamless as possible. Try to avoid long queues as they enter the building or have coat checks. Have someone to guide the group through the entrance procedure, so that they start their museum programme unharried and fresh.

A good introduction is essential to forming a great group dynamic. The opening moments of your museum or gallery programmes are crucial. A good introduction contains 4 parts: an introduction to yourself, an introduction to the museum, time to connect with your participants, and space to introduce the programme. In your introduction you are establishing trust and forming connections. (For more information on introductions, see Chapter 9.)

Warming up

During the early stages of a group coming together, you will want to start warming your group up. This involves choosing techniques, strategies and activities at the

beginning of your programme that will energise your group and create connections. These are simple activities that won't make any group members feel self-conscious, exposed or under pressure to respond.

I like to save any advanced activities, more complex Questioning Practices, and deeper thinking for the middle of my programmes, when the group is fully warmed up and used to the environment, to me, and to each other. At the beginning of my programmes, I use low threshold activities that are not too demanding. The aim is to create a comfortable atmosphere for the group, encouraging their active participation without overwhelming or intimidating them.

Observation and noticing exercises are a great way to get the group looking and discovering together and, crucially, to get them speaking too. Use a variety of activities to get your group acclimatised, whilst building trust and forming connections.

Suggestions for gentle warm ups:

- **Observation exercises:** Use an activity such as a 60 Second Look (look at the artwork or object for one minute before turning away and trying to recall as many details as possible). Or try Observation Race, where 'teams' of participants compete to try and find the most details in an artwork or object in a given time.
- **Open questions**: *What do you wonder? What would you ask the artist? What would you ask the sitter? Where would you jump into this work?*
- **Check ins**: Rose and Thorn - participants are asked to share a 'rose' (e.g. a positive, or something that's going well today) and a 'thorn' (e.g. something they feel stuck with). Weather Report is also effective - ask: *What weather conditions describe how you are arriving today?*
- **Physical exercises:** grounding exercises, a minute of meditation, breathing or stretching, neck rolls, or shaking out of arms and legs (n.b. for adults use with caution, because they may feel more self-conscious, but this is great for primary age children)

- **Writing exercises**: this can be as simple as asking participants to write one wish for the next hour on a sticky note. You can invite your group to share their wish aloud, or ask them to place their note on a portable flipchart (to avoid having to ask every person to read theirs aloud)
- **Pair-share**: this is a great way to start bringing a group together to discuss something, just for a couple of minutes
- **Use a card deck**: for spontaneous questions/ activities that the group choose themselves

These sorts of warm ups apply for the first 10-15 minutes of your programme. Depending on the type of programme you are facilitating, they can be incorporated either into your first artwork or object stop, or into your introduction. They are all gentle, undemanding activities that essentially bring people together and warm them up for participation. Incorporating some low-threshold activities at the start of your sessions helps people to build psychological safety and feel confident about participation.

On a personal note, I dislike inauthentic ice-breakers that invoke participation just for participation's sake. These

sorts of enforced 'connection' activities often fail to connect to the purpose of the programme, and they do not appeal to introverts. A genuine warm up will connect participants to each other, to you, and to the purpose of why they are coming together in the museum.

Let's now look in detail at the 3 common strands of focus at the Entry phase: establishing trust, forming connections, and setting the tone.

Establishing trust

The 'trust equation' was first introduced by David Maister, Charles M. Green and Rob Galford in their book, *The Trusted Advisor*.[5] In this equation there are 4 variables we can use to weigh up trustworthiness. In the trust equation, being deemed trustworthy is about being credible, reliable, establishing intimacy, and demonstrating a balanced level of self-orientation.

In guided experiences in museums, **credibility** shows up in our knowledge and our presence. It's about how competent and capable we are in our role and the skills and experience we bring to it. **Reliability** relates to being consistent and dependable, and to keeping our promises. If we say that we're going to explore Van Gogh's life and work in depth, then we need to live up to that promise. **Intimacy** means that the participants feel comfortable in our presence, in terms of the upcoming programme, and in terms of any subjects we might discuss together.

They are confident that we will handle any information that they share respectfully and appropriately. Together, credibility, reliability and intimacy build trustworthiness.

Self-orientation is the only factor that potentially removes trust. If people think that you are motivated by high levels of self-interest, they won't perceive you as trustworthy. If they think that all you care about is sharing how much you know about a subject, this will erode any trust that they have in you. In order to balance the trust equation, the group needs to know that you care about the 'we' more than you care about the 'I'. The trust equation is a useful model for reflecting on how trustworthy our participants perceive us to be.

Where do my strengths and weaknesses lie in the trust equation?

Answer these questions:
Credibility (Words): How is your knowledge of the museum collection? What are your strengths and weaknesses? How experienced are you in facilitating interactive museum programmes?

Reliability (Actions): Do you consistently do what you say you're going to do? Do you deliver on your promises in your programmes? How do you do this?

Intimacy (Emotions): Do you make your participants feel comfortable in their surroundings and on your programme? If so, how? Do participants know that you will handle any information they share respectfully and appropriately? If so, how do you demonstrate this?

Self-orientation (Motives): Do you put the needs of your participants first? How do you demonstrate that 'we' is more important than 'I'?

Forming connections

Leading a successful museum programme is not just about being knowledgeable and sharing your expertise on a subject. Connection before content, an idea from organisational designer Peter Block, is a principle that I've implemented into every area of my practice.[6]

This means making a conscious effort to:

- connect people to each other
- connect the participants to me

- connect participants to the museum and the collection
- connect people to the purpose of the programme
- create a warm and inviting space

The ability to make connections is a core skill when working with groups in the museum. In traditional museum programmes, we might prioritise the delivery of content and/or our knowledge around a certain theme or exhibition as the main goal(s) of our programmes. In the Thinking Museum® Approach, forming connections is the higher priority.

Making time to form connections demonstrates to your participants that your programme is not information-driven, but participant-centred. Information is still shared, but in a way that prioritises connection. This means that, even in a 1-hour programme, you make the time and space to engage the group with each other, you, the museum, and the objects you're discussing together. If you skip the connection-making and go straight to content-sharing, participants won't be as keen to participate and the discussions will lack depth. Failing to create these connections with your group and then sharing your knowledge is like talking with your microphone turned off - the information you share will fall flat.

The power of connection increases audience engagement, interaction, and involvement in your programme. You can form powerful connections with people through your introduction, by asking open-ended questions throughout,

by checking in with your participants, and by being genuinely interested in your participants from the moment that you meet them. You can create opportunities for connection by incorporating multimodal ways of working into your programmes - such as pair-share, discussion in small groups, writing and drawing exercises, and more. Using facilitation techniques (as discussed in Chapter 3) will also create an environment for participants to share and connect.

Make connection a core intention for your practice. Although you will want to create connections throughout your programmes, making the time and space to form connections during your introduction and warm up is crucial. Design your programme intentionally, so that it allows time for this kind of warm up for participants.

Reflect on making connection a core intention

How can I start my programmes with connection, to get my participants engaged?

How can I focus on connection in my programmes?

How will I make connection a priority in my practice?

Setting your expectations, tone and goals

The Entry phase should set the tone and any goals for the programme to come. This essentially means making sure that everyone understands what will happen during the programme and how this will be achieved. Your role as facilitator should be defined during your introduction, and participants should also know what is expected of them and how they will work together. (For more information on setting the tone, expectations and goals for guided experiences, see Chapter 9 on Deliberate Design.)

Exploration

This is the phase that takes place in the main body of your guided experience, after your introduction. Similar to Tuckman's storming, norming and performing stages, you will hopefully see a community of collaboration forming at this phase, as individuals in the group get to know each other and work out their differing roles within the group. You might also see differences of opinion and/ or some individuals dominating the group or testing the guidelines that you set in your introduction.

When Tuckman's model is applied to teams in work environments, they usually pass through the three phases of storming, norming and performing over a long period of time and in a linear fashion, but with widely distributed or online teams (groups), the latter may not be the case. When you're with a group in the museum, you have a relatively short period of time to encourage

individuals in that group to connect and collaborate. As facilitator of the group, you are responsible for ensuring that your visitors have an enjoyable and engaging time in the museum. This can mean that you wear many hats, as you manage both the group and the dynamics of the people within it.

As well as being knowledgeable and enthusiastic about your subject matter, in this phase you need to be organised and in control, keeping the group on track and on time, and staying flexible enough to respond to any new situations or needs on the spur of the moment. Your aim is to create a high-performing group in a short period of time, where group members are on the same page, motivated, and working together to discover meaning and build interpretations. Being aware of your group's needs, implementing basic strategies for psychological safety, encouraging equal participation, and paying attention to body language will all help you to create a collaborative culture during this phase of your programme. It's worth looking at each of these aims in more detail, so let's explore them now.

Maslow's hierarchy of needs

If you're working with groups in the museum regularly, you need to be aware of Maslow's hierarchy of needs and how it might apply to your programmes. Maslow's hierarchy is a pyramid split into 3 levels of needs. It starts with basic needs (at the bottom), moves through psychological

needs (in the middle), and ends with self-fulfilment (at the top).

Basic visitor needs during museum or gallery programmes are, for example, clear orientation at the start (Entry phase), clear instructions when required, adequate breaks, and opportunities for sitting. Special needs should also be included as part of basic needs, along with any safety or security information. If you don't satisfy people's basic needs, you cannot progress to satisfying the higher needs of the group.

Psychological safety

The mid-point of the hierarchy is concerned with psychological needs, which encompass feelings of belonging and self-esteem. In a guided experience, this plays out as psychological safety and intellectual comfort, including how comfortable your participants feel in their surroundings. This starts at the Entry phase (with your 4-part introduction that includes a warm welcome, and shares your guidelines and purpose) and extends into the Exploration phase. It is important to remember that when individuals do not feel psychologically safe in a situation, they tend to share and contribute less. A facilitator will be aware of the group's basic needs, whilst assessing their psychological needs.

Here are 4 ways to build psychological safety in your museum programme:

Be precise with information, expectations and commitments

To build psychological safety, your participants need to trust and connect with you, so be crystal clear about any instructions you share, as well as any expectations you set for the programme. Ensure that your participants know what the goal is for the session and what will happen when, and be prepared to remind participants at various points, if necessary. Participants are more likely to trust you and the process if they feel safe in your hands and not 'all at sea' with what is happening.

Value and appreciate ideas

Valuing and appreciating ideas is part of your facilitation skillset. Doing so enables your participants to openly share their thoughts, in an environment where their thoughts, ideas and opinions are welcome. Try to be non-judgemental as you listen to participants' ideas, and thank them for their contributions. Paraphrasing, restating, reflecting back, or following up on their thoughts will go a long way towards establishing psychological safety.

Actively ask for questions

It's important to actively encourage questions from your participants throughout the programme. Ask for wonderings, different viewpoints, or to hear from people who have not yet voiced an idea. Allow waiting time before talking more. Often, people who are internal processors will need more time to formulate their thoughts before

voicing them, so help them by training yourself to pause and gently encourage input.

Provide multiple ways for participants to participate

While some participants may be happy to share verbal responses, others may prefer to have more time to think through ideas by chatting with a partner or doing a quick writing exercise. Online, you can encourage participants to make use of online collaboration tools, like Zoom chat, Miro or Padlet, in addition to having whole group discussions. (For more ideas, see Chapter 4 on Multimodality.)

Intellectual comfort

Creating a community of collaboration is not just about making participants feel psychologically safe, you need to make them feel intellectually safe too.

Ashby Butnor provides a great definition of intellectual comfort: 'I imagine this feeling of comfort as similar to feelings of relaxation and belonging, free of stress and doubt, while being entertained, amused, or satisfied in some way'.[7] In this sense, intellectual comfort means creating a warm, inviting space where participants feel they belong, regardless of what they know or what brought them to the museum in the first place. It also means valuing and appreciating participants' ideas and making them feel at ease with their present level of knowledge.

Museums can be intimidating spaces. Many people hold the belief that museums are not inclusive spaces for them and that a certain level of knowledge is required before you can enjoy being there. This feeling is particularly prevalent in art museums, and around art in general. Inquiry-based programmes can certainly make some people feel uncomfortable - for example, if a person is only used to participating in traditional style walk-and-talk tours (where the museum guide talks to their audience for an hour or more), being asked to participate and share their thoughts can feel somewhat intimidating. Likewise, if your school experience was one where the teacher stood at the front of the class and transmitted information for your absorption or memorisation, a discussion-based programme (where you are asked to share what you think about an artwork) can feel like a tall order. This is why it's important for everyone to feel that the museum is a place where they belong.[8]

Working as museum educators, we can come across a wide variety of knowledge levels in groups on museum or gallery programmes. Likewise, we might see a variety of different motivations for being there, depending on whether the visit is intended as a reason for learning something new, to extend existing knowledge, or simply for pure enjoyment. Your job as facilitator is to ensure that everyone feels confident and able to participate fully in your programme, whatever their motivation or knowledge level upon arriving.

As an aside, creating intellectual comfort doesn't mean you can't try to gently push beyond participants' comfort zones at times, so that they can discover new things. It also does not mean that your programmes should be without intellectual challenge!

When you engage in discussions with your participants in the museum, you're never completely sure where the discussion might go. It's essentially open-ended, even though you may have some parameters in place, such as a theme or idea that guides the programme. This means that there will be moments of discomfort and wondering, alongside moments of discovery and 'a-ha!' moments. The moments of discomfort may come from hearing opinions or perspectives that are different to your own, realising that you're changing your thinking as a result of the process, or when you're struggling to make sense of an artwork. At the same time, in any discussion-based approach there will also be lightbulb moments - moments when you're amazed by what someone else has just said, or when you're thrilled to discover something new.

What we are aiming for with intellectual comfort is for our participants to feel secure quickly, so that they can learn new things. If a participant does not feel comfortable in a museum on a guided experience, they won't take part and participate, and therefore their potential to learn new things and enjoy themselves is undermined. Fear, insecurity, apathy and other things may all get in the way

of participants offering their thoughts and contributions, preventing them from asking questions on your museum and gallery programmes.

In his article on intellectually safe classrooms, Trevor Baba says: 'Intellectual safety encourages respectful relationships, meaningful learning environments, and productive disagreement. It's about creating a positive environment where everyone is respected'.[9] Ashby Butnor also asserts that intellectual safety is not simply about feeling comfortable, it is also a 'feeling of trust in oneself and one's community to honestly and genuinely engage in thinking'.[10]

You'll find that participants are more willing to participate when they know that their comments and thoughts will be taken seriously. When they feel that the environment is intellectually comfortable, they are happy to demonstrate their curiosity, without fear of what other people will think. Everyone feels welcome and that they have a place. Everyone feels heard and that they are a part of the process of discovery. Everyone can contribute, no matter what their level or background.

Trust is key here - when the atmosphere and environment that you create on your guided experiences is warm and welcoming, trust grows, and when you have trust, participants will have more courage and inclination to share their thoughts, ideas and feelings. Intellectual comfort involves valuing and appreciating visitors' ideas as valid,

but also making them feel comfortable with their present level of knowledge.

Here are some ideas for fostering this kind of environment and atmosphere on your programmes:

It all starts with you...

...As these things so often do! It's all about your commitment to creating a positive space on your museum and gallery programmes, where all participants feel comfortable to share their thoughts and ideas. Make it a priority!

Use your introduction

Use your introduction to find out information about your participants. In a 4-part introduction you include time to connect to your participants and ask them questions about themselves. At this point you're finding out what they know about the museum, its collection, the subject matter of the tour, etc. What do they know in advance? What do they not know? How do the levels differ in the group? You won't discover everything you need to know in your introduction, but it will give you time to assess basic information about where your guests are coming from. Use this time wisely!

Show genuine curiosity

Continue to learn about your participants as the programme continues - demonstrate a genuine curiosity in them and what they know (or don't know).

Don't make assumptions

Don't make any assumptions about prior knowledge. This is common in museum programmes, where educators (unintentionally) assume what their participants already know about history and art history. It is crucial to remember that just because you are knowledgeable about a subject, it does not mean everyone (or anyone) else in the room shares the same level of understanding. Making assumptions can hinder people's participation and engagement. It is best to approach each interaction with an open mind, allowing participants to ask questions and providing information in a way that is accessible and inclusive to all.

Don't use jargon

Every field has its own jargon and common terms. Everyone who has expertise in a specific subject area, or is used to that subject's terminology, eventually gets used to using it. With this in mind, when you're trying to share information about your subject, or ask a question about it to someone who may or may not be knowledgeable already, it's important to avoid using any attached jargon or specialist language. This is because you want as many people in the group as possible to understand what you are saying or asking.

Avoid assumptions about the group's prior knowledge of any terms that you use regularly. Although you know the terms and they are a regular and common part of your

language, your audience does not necessarily also understand them. You may not even know that you're using jargon, because it may feel so normal to you to speak this way. Does your group really understand what you mean when you talk about 'perspective' or 'composition' in art? Does everyone really know what that '-ism' is that you're talking about?

Jargon is a gatekeeper, which can prevent people from participating. It doesn't create an environment of intellectual safety. Avoid acronyms, technical terms and archaic language. If you really must use jargon, or an uncommon phrase or concept, provide definitions or analogies to simplify them. Ask someone who is not in your field to participate in one of your sessions and get them to tell you whether you use jargon frequently.

Get your group talking

Get your participants used to talking in the museum, with the people there with them, as soon as possible. Use low-threshold activities to get them talking straight away on your programmes, things like observation-based activities and discussions. You can raise the bar as your programme continues, as the group warms up and levels of confidence rise.

Encourage questions and wonderings throughout

Asking for wonderings, and things your group are puzzling over, on a regular basis helps you discover what your participants want to know more about.

Let your group know that you are all 'in it together'

Let the group know that your programme is a communal journey of group discovery and that the more input they give, the more they will get out of it.

Equal participation

Being a facilitator of a museum or gallery programme means that you are interested in how people participate in the process, rather than just the end result. It means that you care about fostering equal participation amongst group members and will actively promote it.

Hearing from everyone allows us to hear multiple perspectives and generates more creative responses and ideas. However, participation is not mandatory. A mantra for all of your programmes might be: *participants should feel encouraged, but not required, to participate.* Following all the guidelines for creating a community of collaboration will encourage equal participation, but you should also make a note to consciously look for individuals who are not participating. Encourage the group to work together to look at objects and artworks to discover meaning, and encourage group members to point out things that interest or intrigue them, to share memories or stories, and to ask questions.

There will be group members who are quieter than others and there will be those who try to dominate the proceedings. There could be a variety of reasons why someone is

choosing not to participate. Quieter group members may be intimidated by the surroundings, shy, lacking in confidence, or disengaged from the session. Appreciate that there may be some group members who are not as keen as others to speak, at first, but they may want to add to something someone else has said or share some thoughts with a partner instead of with the group as a whole. Try to bring quieter group members into the conversation considerately, but not by calling on them or putting them on the spot. When you ask them a question, make sure it's one they can easily respond to, or offer alternative ways of working that don't require them to speak in front of the whole group.

With dominant group members, who frequently answer any questions you ask, or who talk at length, you might need to intervene or redirect them if they continue to dominate at the expense of other group members. You can thank the participant for their contribution, then ask for thoughts from other group members. You might also want to give them a task, to redirect their energy into something else. This could be 'reporting back' from a small group discussion to the group as a whole, or being notetaker for a group.

Reading a group

In order to read a group you need an ability to understand the mood in the room and how receptive people are being. It involves reading between the lines to try and

understand what participants want (and what they don't want). When you're facilitating discussions in the museum, it is extremely helpful to be able to know how to 'read the room' (i.e. read your group). Paying attention to others and listening for clues can pay dividends. Being able to read a group and see how engaged they are, if they are enjoying the programme, following along, or even if they are listening, is extremely important when you're aiming to create a community of collaboration.

Being able to read a group can help you to capitalise on things that are going well (and do more of them). It can also help you to change course and adjust, in real time, to address any issues or concerns before they become too serious. In essence, reading a group helps you to confirm or change your plan for the programme. Paying careful attention to what the group is doing allows you to be flexible and adapt in the moment, based on the clues you're picking up from your group. It also allows you to personalise experiences, and satisfy what the group is in need of at the time.

It's important to be able to pick up on clues, not only from the discussions taking place, but also from any underlying reactions and things that are being left unsaid. These subtle cues aren't always easy to pick up on, but you can train yourself not only to be aware of them, but to influence group dynamics by paying more attention. Here are some helpful ways to read a group:

Find out as much as you can at the start

If at all possible, take the time to get to know your group before you start a programme with them. Sometimes it's possible as they're getting off the bus, or arriving at the museum and taking their coats off. Interact with the group and chat to them as they arrive.

As mentioned earlier in this chapter, your introduction is the place where you want to get to know your group and find out as much as you can about them. Your goal is to find out who's in the room and what their relationships are to one another. Find out as much as you can about who's who in the room and which distinct interest areas are important to each individual.

Observe body language

Body language is defined as: 'the conscious and unconscious movements and postures by which attitudes and feelings are communicated'.[11]

When we talk about body language we're referring to a wide range of human expression - such as posture, eye contact, use of space, voice, gesture, and so on. These are signals that we communicate non-verbally - 'wordless signals' that can be indicators of engagement. These signals are quite often sent instinctively, rather than consciously. Observing body language can therefore help us to understand how participants might be feeling, relative to what they are saying (or not saying).

However, be aware that body language and facial expressions can give us false clues. Crossed arms is a really good example of this: although crossed arms can be a sign of someone feeling fed up or disengaged, it can also just be a convenient way to do something with your hands when you're standing. A given behaviour doesn't always mean just one thing. Body language is complex and can depend on context. Look at body language in combination with what people are saying, as usually they are saying the same thing with their voice and body. We can glean a lot of information from non-verbal communication, but we do need to be cautious about making assumptions and jumping to conclusions that confirm our preconceptions.

Think of a variety of possible reasons why people might be behaving in a certain way. Keep your emotions in check and don't take anything too personally. Participants could be bringing all sorts of emotional states into the museum with them and their behaviour is not necessarily a direct result of what you're doing. Keep an eye out for positive signals and focus on those. Scan your group. This can be done at the start of a programme (you can learn a lot in the first 5 minutes) and regularly throughout. Notice who's standing where and who they are next to. Who's together? Who's alone? What's the rhythm and pulse of the group? Who's smiling? Who isn't? Then, do your best to read how they're feeling through their facial expressions, posture and body language.

Reading the room is definitely more challenging in a virtual discussion, but you can still pay attention to facial expressions and watch participants' eyes. Take time every so often to scan the participants in full (rather than just the few you see on your screen) and notice how they are responding to what you are saying. Are people nodding, smiling and engaging with you? From time to time, you could take a brief pause to observe what's happening in the (virtual) room.

Listen

This means listening without thinking of something to say or how what the person is saying relates to what you are thinking. Try to rid your mind of thoughts and tune fully into what is being said.

Listening well is especially important in online discussions, where things like body language and eye contact are not as obvious or clear. As you listen, pay attention to the emotional tone in the person's words, which will give you clues about their responsiveness.

Listening more ensures that you talk less. By talking less, you'll be able to tune in to others, listening to what they are saying and the way they are saying it. You will also be better able to pay attention to any clues they are giving you about how they are feeling. Use paraphrasing, or reflecting back and lots of open-ended questions, giving the participants the chance to talk and yourself the chance to listen carefully.

Create moments to 'take the temperature' of the group

Throughout your programme, you want to have moments when you can observe your group and take a moment to take the temperature of the room. This means thinking about how you could sequence your stops or activities so that you can build in a few moments to learn about the energy of the group and their willingness to participate.

It could take place during a pair-share or small group activity, where you observe how individuals in the group interact with one another. You may notice who is talking, who is not, who looks keen, and who looks a bit more reluctant. It could also take place just after you've asked a question, during your waiting time, when you could scan the group and watch people's facial expressions and body language closely. This means designing space(s) in your programmes when you don't have to take such an active role, so that you can pause and observe. This will also give you time to think about how the group are responding to your programme so far and whether you need to tweak or change anything. Perhaps you need to tone down some elements, or switch up others.

Sometimes you can almost feel a shift in your audience's attention. People might start looking at their watches, phones, or other things in the room, rather than at you or the artwork or object you're discussing. Or the group may suddenly become quiet or noisy in response to a comment.

If you observe this happening, you should respond to the changing situation, rather than continue as if nothing has happened. Be flexible and go with what is happening in that moment. If the room has suddenly become tense, diffuse the situation with humour or empathy, to lighten the mood. Get comfortable with deviating from your plans and thinking on your feet.

Check in with your group

At regular moments in your programme, do a check in with your group. This could be as simple as asking how everyone is doing, or what they are thinking. You could also take this opportunity to give a quick summary of what is still to come in the programme and see which parts the group are looking forward to. These quick check ins usually come in the form of closed questions and are really easy to insert into your programme at regular intervals. You can also get the group itself to confirm if your reading of them is accurate, by asking things like, *I'm sensing that as a group there's not a lot of energy today - am I seeing this right?* Often, the group will confirm what you think you are seeing and tell you that they are in fact really tired!

One final thought about reading a group: make allowances for the fact that any group is made up of a variety of individuals. Don't assume that what you're reading in one person is the same for the whole group.

Paying attention to body language

As mentioned above, body language is not an exact science. But paying attention to and noticing it can give us clues about what is going on, as long as we are open to a variety of possible reasons. So let's explore some areas of body language in more detail and see what insights they might give us.

Face and eyes

Faces can be very expressive, in terms of showing what we are thinking, but some of us are easier to read than others. Micro-expressions, like quick smiles, raised eyebrows, or small frowns can be telling. Some people will wear all their emotions on their face, whilst others will be much harder to read. It's widely agreed that the facial expression of emotion is universal, i.e. you'll easily recognise the main emotions - happiness, sadness, anger - in someone else's face.[12]

Making eye contact with someone can mean that you are engaged in what is happening, curious and open. A lack of eye contact could mean that someone is disengaged or distracted by what is around them. It's very natural not to have eye contact all the time, but if someone is avoiding it, it could indicate that you need to do more work to engage and connect with them.

Body

Pay attention to what hands are doing when you are scanning your group. Busy or fidgeting hands may indicate

feeling uncomfortable, or that a person is thinking about something else. It could also be a tic or a habit, so do what Ximena Vengoechea does and look for predictable patterns when discussing a particular topic or scenario.[13] If you see anybody signalling discomfort – by twirling their hair, reaching for their neck, playing with a necklace – you might want to think about doing a pair-share or using small groups until the group feel more comfortable sharing. Better to be cautious than to just forge ahead regardless. Careful and consistent observation will give you information, and this information will help you to navigate the group as a whole.

Building rapport through mirroring

Mirroring is something we do with people we like or are interested in: we copy their body language, speech, facial expressions, and more. It sends a signal that we are connected to that person in some way. It's actually a subconscious process, so the next time you are out and about in the museum, observe and notice people. Who is mimicking who? Look at people talking. Are their gestures and postures similar?

We can build rapport (trust and understanding) through body language, facial expressions and gestures. When mirroring happens, you know that there is rapport in your group. The next time you are with a group, notice whether anyone is mirroring other people. This indicates whether rapport is present. If not, this may mean that you need to work a bit harder to build connections in your group.

You can also use mirroring to consciously create rapport. When you mirror others, you create an empathetic bond that signals connection. When someone is talking in your group, notice how the other person is and meet them there. Get into physical rapport with them (i.e. stand as they are standing) and match your voice tone as you reply to them. You can also maintain eye contact and share gestures.

Posture

Posture is all about how we hold our bodies. It can relay info about how someone is feeling, as well as possible hints about their personality.

Scan your group and notice how they are standing. Are they facing you? Is their stance open and upright or are they slouching? Slouching doesn't automatically mean that someone is disengaged, but it could mean they are uncomfortable. Has there been a lot of standing so far? Maybe look for an opportunity to sit down, or change the way you are working from a large group to smaller groups, to give participants some variety. Also, keep an eye out for anyone leaning in or inching towards you, which might be signs of engagement and that the person is actively enjoying your company.

Exit

The Exit stage is the final phase of group formation in a guided experience. (We will explore how to end well in Chapter 9.) A great facilitator will end on a positive note

and give space to reflect on significant moments, what has been learned or experienced, and how thinking has changed, before turning towards the bigger picture of what the group would like to take away with them. Taking time to end the programme well (rather than ending with logistics) will mean that your programme has a bigger impact on your participants. It will also leave them with longer-lasting memories of what they discussed and how they felt about it.

Creating a community of collaboration in a guided experience is essential, because it encourages people to work together, learn from each other, and be actively involved in the experience. By fostering a collaborative community, participants feel encouraged to share their ideas, listen to others, and solve problems collectively.

Reflect on the insights and ideas shared in this chapter, and consider how you can apply them in your specific context. In other words, how can you actively cultivate a community of collaboration in your museum programmes?

Notes

1 Aleksandra Igdalova, Safiyyah Nawaz, and Rebecca Chamberlain, "A View Worth Talking About: The Influence of Social Interaction on Aesthetic Experience and Well-Being Outcomes in the Gallery," May 1, 2024.

2 Rika Burnham and Elliott Kai-Kee, *Teaching in the Art Museum: Interpretation as Experience* (Los Angeles: J. Paul Getty Museum, 2014), 80.

3 Priya Parker, *The Art of Gathering: How We Meet and Why It Matters* (Riverhead Books, 2020), ix.

4 Kenneth Benne and Paul Sheats, "Functional Roles of Group Members," Journal of Social Issues 4, no. 2 (April 1948): 41–49.

5 David Maister, Charles Green, and Robert Galford, *The Trusted Advisor* (New York: Simon & Schuster, 2002).

6 Peter Block, *Community: The Structure of Belonging* (Berrett-Koehler Publishers, 2009).

7 Ashby Butnor, "Critical Communities: Intellectual Safety and the Power of Disagreement.," Educational Perspectives 44, no. 44 (January 1, 2012), 29–31.

8 Other heritage or cultural venues are included within the umbrella term of 'museums', e.g. heritage organisations, historic houses and gardens, cultural organisations, etc.

9 Trevor Baba, "The Importance of Intellectually Safe Classrooms for Our Keiki," Educational Perspectives 51, no. 1 (2019), 28–30.

10 Butnor, "Critical Communities: Intellectual Safety and the Power of Disagreement.,"

11 John Simpson, Edmund Weiner, and Edmund Weiner, *Oxford English Dictionary* (Oxford University Press, USA, 2000).

12 Harry Lansley, "The Seven Universal Facial Expressions," last modified April 16, 2018, https://www.eiagroup.com/facial-expressions-explored.

13 Ximena Vengoechea, *Listen like You Mean It: Reclaiming the Lost Art of True Connection* ([New York, New York]: Portfolio / Penguin, an imprint of Penguin Random House LLC, 2021).

6
Practice and coaching

*'An ounce of practice is generally worth
more than a ton of theory.'*

– E F Schumacher

W

hat does it take to gain mastery of a skill or an approach, embed it into your practice and make it your own?

If you've read Malcolm Gladwell's book, *Outliers*, you may have come away with the impression that it takes 10,000 hours of practice to become an expert at something. However, it is important to note that Gladwell's '10,000-hour rule' (as presented in the book) is a simplification of research conducted by psychologist, Anders Ericsson. Ericsson's research found that it takes an average of 10 years (or 10,000 hours) of deliberate practice to achieve expert-level performance in a particular field.[1] In reality, 10,000 hours of practice is not a hard and fast rule, but is instead an average of the time needed by participants in Ericsson's studies. The actual time it takes to become an expert depends on various factors, such as the complexity of your skill, your starting level (or ability), the quality of your practice, and the feedback you receive on your practice.[2]

Simply practising for 10,000 hours without trying to improve your technique, stretching yourself, or receiving constructive feedback is unlikely to lead to progress. Nor is relying on your intellectual understanding of a topic alone. For example, you may be reading this book, underlining certain sentences and bookmarking certain pages, agreeing in theory to the principles at play in the Thinking Museum® Approach. That's great. This book will

give you a deep and comprehensive understanding of the concepts and best practices associated with the approach. But,… you will only really grasp how transformative this approach is once you start *practising* it.

Theoretical knowledge is not the same as practical application. If you're learning how to play a new board game, you may read through all the rules and listen to knowledge being shared by people who've played it before. You may think you have a good grasp of the rules and an understanding of the game, but it's only when you start playing that you really see what the game is all about - all the nuances, strategies and tactics that come into play. In essence, the game starts to come alive at that point.

The same is true with the Thinking Museum® Approach. If you wait to understand all the concepts first, you'll not only never get started, but you'll be delaying fully understanding how it feels to be a facilitator. It's important that you jump in and get started whilst you are reading this book. Don't wait until you feel you have all your ducks in a row! This chapter is as much about the importance of practice and coaching as it is about taking action, learning as you go, and using your experiences along the way to improve and refine your skills over time. You won't become a facilitator overnight, but you will have started the learning process, instead of keeping everything at a purely theoretical level.

The theory in this book (the *What?* and the *Why?*) is equally as important as the practical application (the *How?*) and it requires hands-on experience, feedback and refinement. Building practice and coaching into your learning journey ensures that you have opportunities to apply the approach in real-world situations, to receive feedback and to make necessary adjustments to improve and grow. With this sentiment in mind, this chapter will dive into what practice and coaching look like in the Thinking Museum® Approach. We will explore how to develop a regular practice habit (and what this might look like) and how to integrate coaching into your learning journey, ultimately leading to the development of your own unique facilitator style.

Practice

How to build a regular practice habit

Adopt a growth mindset

Your mindset is the lens through which you look at things, your outlook, or your world view. It is an expression of the beliefs that you hold and the fundamental beliefs that shape how you see things. You may have heard of 'fixed mindset' and 'growth mindset'. The terms were coined by Stanford researcher, Professor Carol Dweck, to describe belief systems regarding our ability to change, grow and develop over time.[3] By recognising that our mindset is not

fixed (and can therefore be changed), we can adopt new beliefs that allow us to grow and develop.

As you read this book and try out the ideas in your practice, embrace the belief that you can grow and develop through practice and effort. Seek out challenges and persist when you come across obstacles or setbacks, seeing them all as an opportunity to learn. Welcome feedback and remain open to trying new things. In her research, Dweck found that individuals who adopt a growth mindset are more likely to embrace 'the power of yet', meaning that when they encounter or are learning a new skill, they remind themselves that even though they may not have mastered it yet, they have the potential to learn and improve with practice and effort.[4]

By adopting a growth mindset, you will develop a belief in your ability to learn and improve over time, in turn helping you to become more resilient in the face of challenges and to develop a love of learning. Part of our work as museum educators and facilitators is to enjoy the process of learning and personal development, coming to view it as a journey rather than a destination. There are always new things to learn and new ways to improve, even for experienced facilitators!

Commit time

It is important to set aside time to practise on a weekly basis - on your own, with colleagues, or as part of your work

within museums. Decide when, where and what you are going to practise and with whom, and hold yourself accountable to that commitment.

If you are working on a specific exhibition or new museum and gallery programme, it may make sense to practise with colleagues who are involved in the same project or are working towards the same goals, to ensure that everyone is on the same page. You could also simply practise on your own or with others who share the same interests as you. You might opt to practise a particular Questioning Practice for a whole month, exploring a variety of different artworks or participant groups, making notes and reflecting on the experience. You might choose to focus on one stop in your programme, and introduce a inquiry-based element there. You might also like to experiment with working on a particular skill (such as listening) over a period of time, or to play around with pacing and pauses.

Whatever approach you take, the key is to make a regular commitment to practise, even when time is short or it feels too challenging. Over time, you will build confidence and mastery in your abilities as a result of this consistency.

Set goals

Setting clear and specific goals helps you stay focused during your practice sessions and ensures that you can measure your progress. Be mindful of the fact that not all goals are created equally.

A 'session goal' is a specific goal that you set for a particular practice session or work period, whilst an overarching goal is a larger, long-term goal that you are working towards. Therefore, your overarching goal could be to embed the Thinking Museum® Approach into your practice as an educator, but it could also be to transition from a traditional way of delivering guided tours to a inquiry-based approach.

Another overarching goal might be working specifically on an aspect within your practice that needs attention, such as your questioning or facilitation skills, or getting to know some new Questioning Practices. Your overarching goal can be broken down into smaller session goals for each practice session, to move you closer to your main objective. This larger goal gives you the big picture direction and purpose, whilst the smaller session goals help you to focus your efforts on details during a particular practice session.

If your overarching goal is to transition from a traditional way of delivering guided tours to an inquiry-based approach, your well-rounded session goals might include some of the following:

1. **Practise active listening skills:** Set a goal to work specifically on your active listening skills throughout a particular tour or discussion, with the aim of encouraging dialogue and understanding participant perspectives.

2. **Incorporate open-ended questions:** Brainstorm a list of new open-ended questions about an artwork and then set yourself a goal to incorporate a certain number of these into your next tour or discussion, with the aim of encouraging participants to share their thoughts and experiences.

3. **Practise a new Questioning Practice:** Set a goal to practise a new Questioning Practice at one point during a specific tour or discussion, with the aim of encouraging participants to engage in deeper, more reflective thinking.

4. **Facilitate group discussions:** Set a goal to facilitate a short group discussion during one part of a tour, with the aim of encouraging participants to interact with each other and share their perspectives.

5. **Introduce multimodal activities:** Set a goal to introduce a specific interactive activity during a tour, such as drawing, writing or movement, with the aim of encouraging participants to engage more deeply with an artwork or object.

6. **Solicit feedback:** Set a goal to solicit feedback from participants after a tour or discussion, with the aim of understanding what worked well and what could be improved.

Goals that are specific and clear help you stay focused, motivated and accountable as you progress towards your desired outcomes. If you find setting goals tricky, start with the desired outcome – ask yourself, *what do I want*

to achieve? - and work backwards to identify the steps needed to achieve it. Breaking the goal down into smaller steps, or 'backward planning' in this way, helps to create a concrete plan of action and makes the goal more achievable. Overall, setting practice goals is a very effective way to make meaningful progress towards improving your skills and achieving your larger objectives.

Track your progress

Tracking your progress as you practise is part of your reflective practice. We cover this extensively in the next chapter, but it's worth adding here that, without reflection, practise sessions are left incomplete.

Always evaluate what went well and any areas you might need to work on for next time, no matter what. It helps you to set more focused goals for future practice sessions and to understand your learning process better. You will also see how far you've come if you commit to documenting the process through journalling, filling out an evaluation worksheet, recording yourself, or by using any tracking tool that you prefer.

Consistent reflection after regular practise reinforces your growth mindset too, as you will begin to see 'failures' and missteps as opportunities for learning and growth.

When things go wrong

There will inevitably be times when things don't go according to plan and you don't meet the expected outcomes. It can be frustrating and discouraging, especially when you are practising in order to reach a goal. Setbacks and challenges are a normal part of the learning process and it's how you respond to these perceived failures that can really make all the difference.

Look at any setbacks with curiosity, an open mind, and a willingness to learn from the experience. Being self-critical is counterproductive and can hinder your progress (and confidence!). Instead, ask yourself some of the following constructive questions to help you reflect and move forward, instead of dwelling on what went wrong:

When things go wrong. Ask yourself....

1. What were my goals and expectations for this situation, and why did they go wrong?
2. Did I take the time to adequately plan and prepare?
3. What went well? And how can I build on those successes in the future?
4. What could I do differently next time?

5. What factors beyond my control contributed to the failure and how can I better anticipate and manage those factors in the future?

6. How can I use this experience as a learning opportunity and incorporate what I have learned into future programmes?

7. How did my emotions and mindset affect my actions and decisions leading up to the situation?

8. Am I being too hard on myself, and how can I balance the need for self-reflection with self-compassion?

Experiment and iterate

It's through trying new things and being willing to fail, sometimes over and over again, that we discover what works and what doesn't.

You need to take risks and adopt an experimental mindset when you practise, so that you can actually move forward and progress. This involves being willing to try things you've never tried before, taking calculated risks, and learning from the outcomes, whether these are successes or failures. It also involves being curious and willing to explore different possibilities without fearing mistakes.

In design, there is a strong focus on testing out new ideas and learning from the results, whilst understanding that failure is an inherent part of the process. Through experimentation and iteration, designers learn to refine their ideas and approaches over time, leading to better outcomes and more effective solutions. This mindset can help you to innovate, improve, and grow in your practice in your guided experiences too. Embrace it!

Patience

Last, but definitely not least… be patient. Mastery of any skill takes time and effort. When I first started facilitating discussions in the museum, I used to feel mentally exhausted after each guided tour or educational programme, as if my brain had run a marathon without any training. And it's no wonder I felt that way, because practice takes concentration, focus and sustained effort. Although you may look like a swan on the surface, effortlessly and gracefully gliding through the museum, beneath it you are paddling frantically as you focus on listening to your group, creating equal participation, and achieving your goals.

When we are learning something new, we are often working to build new neural connections in our brains. Additionally, when we are practising, we are often pushing ourselves beyond our comfort zones to face new challenges, all of which can be mentally tiring. It may not always be visible to others, but the hard work and

persistence required to improve through practice can be draining.

Progress often happens gradually, over time, and it can be frustrating not to see progress immediately. This is where your reflective practice helps you to see the progress you are making. Refer back to it regularly, so that you can celebrate small wins and big milestones, and see how far you have come. Focus on what you've accomplished, not what you have yet to achieve. Be kind to yourself, practice self-compassion, and be patient enough to give yourself the space and time to learn and grow.

Coaching

What is coaching?

Coaching is a 'human development process that involves structured, focused interaction and the use of appropriate strategies, tools and techniques to promote desirable and sustainable change for the benefit of the client and potentially for other stakeholders'.[5] In other words, coaching is a process that supports and guides individuals in achieving their goals or improving their performance. Coaching can take many different forms and be applied in various contexts. It can take place individually (through self-coaching), one-to-one, or in small groups.

As a museum educator, I have a strong commitment to maintaining and developing my knowledge and skills over time, keeping up with best practices and developments in the field. In 2022 I took this one step further and studied for a coaching certification (ILM Level 5 Certificate in Effective Coaching and Mentoring). The process of gaining this qualification felt at times like holding a mirror up to myself. It allowed me to see the *How?* and *Why?* of my practice clearly for the first time. This has given me a better understanding of the way I work and how I show up. Coaching has had an impact on my own museum education practice and experience, and it continues to have an impact on the teams and individuals I work with in the museum. Learning how to coach has been invaluable for me, in terms of providing time and space to develop and grow as a person, as well as a museum professional. It has also impacted how I teach individuals and teams to implement the Thinking Museum® Approach.

How to implement coaching techniques into your development

Find your community

A 'community of practice' is a group of people with a shared passion or common purpose, who come together to fulfil both individual and group goals. They may share resources and ideas, as well as providing mutual support and encouragement. Ultimately, it's a group of people who are all interested in growing and developing together.

During the first year of the Covid-19 pandemic, I started an online membership of museum educators, guides, docents and creatives, so that we could all learn together. We shared ideas with each other, asked each other questions and reflected on our discussions. We practised regularly too. In our practice sessions we took turns leading discussions around either an object or an artwork. Facilitators would set goals and outcomes in advance, and after the discussion we would all reflect and discuss, giving and receiving feedback. You can create your own community of practice by getting a group of like-minded educators, gallery teachers or guides together and having regular meet ups in the museum or online.

Seeing how other people work can be a real eye-opener for your own practice. You can see firsthand how they ask questions, connect with their group, engage their participants with the artwork or object, and make everyone feel comfortable enough to participate. Watching others at work helps to increase your own awareness of your skills and strengths. It's also a source of inspiration and ideas.

Likewise, facilitating a discussion during these sessions can be very beneficial. It provides an opportunity to practise and refine your facilitation skills in a safe and welcoming environment. It also offers you the chance to ask open-ended questions and guide the discussion. By receiving feedback from peers, you can identify areas for improvement and continue to develop your facilitation

skills. To gain maximum benefit from the session, it's worth using questions to structure the feedback process. Here are some suggested questions to start the discussion, first asking the facilitator for their thoughts, then opening up the discussion to the audience. Choose any, or all, that seem appropriate:

Questions for the facilitator:
1. How did you feel about teaching/leading a discussion this time? How did it feel to facilitate today?
2. What went well during the discussion? What are some things that you'd like to work on for next time?
3. Did you achieve your intended outcomes/goals? If not, what could have been done differently?
4. What inspired today's artwork/object choices?
5. What did you learn from leading a discussion today?
6. What do you want to work on for next time? How will you achieve this?

Questions for the audience:

1. Does anyone have any questions they would like to ask the facilitator?

2. Did everyone have a chance to participate and contribute to the conversation?

3. What did you learn from the discussion? Did you gain any new insights or perspectives on the artwork or object being discussed? Were there any connections made during the discussion that you hadn't considered before?

4. What did you learn from watching X facilitate a discussion today?

5. How could the discussion be extended or continued beyond the session? Are there any follow-up activities or discussions that would be helpful?

6. Did the facilitator use any techniques or approaches that were particularly effective? If so, how could these be incorporated into future discussions?

7. Were there any moments during the discussion that stood out to you as particularly impactful or meaningful?

8. Did you learn anything new about yourself or your own practice through this discussion?

9. How could you apply what you've learned during this discussion to your own work or practice?

10. Is there any further feedback on the discussion session you'd like to offer?

Feedback

Receiving feedback is an essential part of the craft of facilitation. It is crucial for effective practice and growth. Throughout your learning and development, always seek feedback from others, such as mentors, coaches or colleagues, and be open to receiving constructive criticism.

Feedback can provide valuable insights into areas for improvement and help you to identify blind spots in your practice. There is nothing like seeing yourself through other people's eyes for raising your self-awareness. It helps you to gain insight into how you are perceived by others and how your actions may be impacting those around you. This can be especially valuable when you are trying to learn a new skill or improve your practice. By seeking feedback from mentors, coaches, colleagues, or others who are experienced in the area you are trying to develop, you can gain valuable insight and advice which ultimately helps you to improve and grow.

Coaching questions for when you are seeking feedback:

- What did you observe during my practice that stood out to you?
- What did you think worked well, and what could be improved?
- What suggestions do you have for how I can improve my practice in this area?
- How can I build on my strengths and address any weaknesses?
- What additional resources or support might I need to continue developing my skills and knowledge in this area?

Sometimes, feedback can be challenging and difficult to hear. It can feel like a personal critique or judgement. Luckily, we can train ourselves to approach feedback with a growth mindset and see it as an opportunity. When receiving feedback, listen carefully to what the person is saying and try to avoid jumping to conclusions, being defensive, or being dismissive. Even if you don't agree with everything the person is saying, listen to their perspective and consider it constructively. You can then ask questions to gain a better

understanding of what they are saying, clarify points, and identify any actions you need to take to improve.

Sometimes it helps to take time to process feedback before we respond to it. Hearing comments about ourselves can be emotional, and by taking our time to respond later we can do it more rationally and constructively. Choose to receive feedback from those who have your best interests and well-being at heart. They might be colleagues, mentors, supervisors, friends or family. In general, it's best to ask people who are supportive and invested in your growth and development.

Reflection

Developing a reflective practice increases your self-awareness, something that is very important for coaches and mentors. Engaging in regular reflection gives you a better understanding of where your strengths and weaknesses lie. It can help you to be more creative and innovative, try out new things, experiment, and improvise. It also helps you to make sense of what is happening when things don't go according to plan. Being reflective gives you a way to learn from experiences, especially those which don't go according to plan – you might even be able to reframe these types of experience as challenges or opportunities. In essence, reflection helps you to improve the way you coach, develop new professional practices, and enrich the experience for both you and your participants.

Develop self-awareness

Take time during this process to work on your self-knowledge. Know who you are as a facilitator, what your purpose and goals are, your values, your strengths and weaknesses, your triggers and personal biases. When you have a strong sense of self-awareness, you are better equipped to reach and connect with people on a deeper level. You will create more engaging museum experiences, because you are able to relate to the experiences and perspectives of others. Additionally, when you bring your real self into the room, you are more likely to inspire others' trust and respect, which can in turn help you build stronger connections between participants in your museum and gallery programmes.

Self-awareness is an ongoing process. If you are new to inquiry-based approaches it is never too early to start thinking about developing your awareness of how you show up as a facilitator. Developing a personal signature style, or a unique approach that reflects your strengths, values and personality, also helps you to stand out as a facilitator who creates meaningful connections with and amongst your participants.

Now let's explore your purpose, strengths, weaknesses, and values, before defining your personal facilitator style.

Strengths wheel

A strengths wheel is a visual tool that helps you to identify your personal strengths across various aspects of your life. We'll use it here to explore your strengths as a facilitator of guided experiences in museums and to work out a growth plan.

Once you have used the strengths wheel to identify your personal strengths across your practice, you can use this information to set goals, and to find strategies to further develop and leverage your strengths.

Download the Facilitator Strengths Wheel and Growth Plan via the link below to identify and assess your strengths, set goals and areas you would like to work on.
www.theartengager.com

Strengths Wheel instructions

- Download and print the Facilitator Strengths Wheel via www.theartengager.com.
- The segments on this customised Facilitator Strengths Wheel cover a range of different facilitation dimensions.
- For each of the statements, decide whether you're:
 - ᵒ 'taking your first steps'
 - ᵒ 'on your way'
 - ᵒ 'doing okay'
 - ᵒ 'strong' or
 - ᵒ 'super strong'
- Mark this down on the page. You can add dots, or colour in the segments – whatever you want to do is fine, there is no right or wrong way, and this is your plan.
- Take your time and think honestly about your answers to these statements.

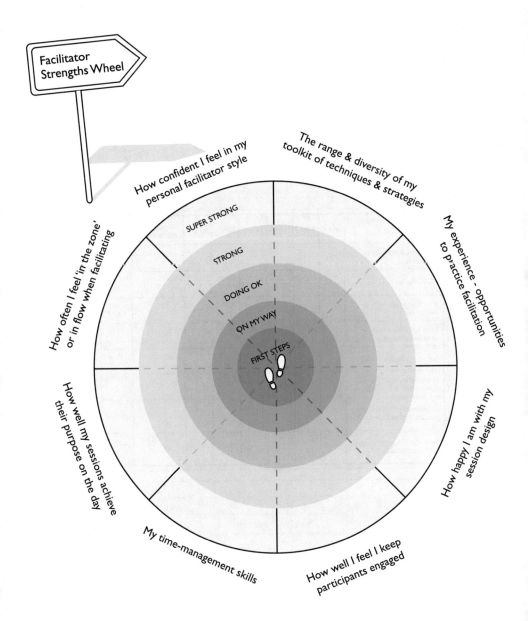

Facilitator Strengths Wheel

How confident I feel in my personal facilitator style

The range & diversity of my toolkit of techniques & strategies

How often I feel 'in the zone', or in flow when facilitating

My experience - opportunities to practice facilitation

SUPER STRONG

STRONG

DOING OK

ON MY WAY

FIRST STEPS

How well my sessions achieve their purpose on the day

How happy I am with my session design

My time-management skills

How well I feel I keep participants engaged

Growth plan

This self-awareness exercise builds on your 'scores' from your Strengths Wheel.

Growth plan	Score	Why 1	Why 2	Why 3	Why 4	Why 5	Thoughts & observations	Actions
The range & diversity of my toolkit								
My facilitation experience								
How happy I am with my session design								
How well I feel I keep participants engaged								
My time management skills								
How well my sessions achieve their purpose								
How confident I feel in my personal facilitator style								
How often I feel 'in the zone' when facilitating								

5 Whys exercise

Use the Facilitator Growth Plan PDF to explore your strengths using the 5 Whys questioning tool. The 5 Whys helps you to quickly get to the root of something and drill down to its underlying cause. You can also use the 5 Whys for troubleshooting, improving quality, problem-solving, or just to resolve simple to moderately difficult challenges.

Growth plan instructions

- Download and print the Facilitator Growth Plan PDF via www.theartengager.com.
- In the 'Score' column of the table, add your score for each statement from the strengths wheel. Write down whether you were 'first steps', 'on my way', 'doing OK', 'strong', or 'super strong'.
- For each of the statements and scores, including those scoring 'strong' or 'super strong', you're going to ask yourself why you've scored it that way. Do this 5 times, and fill in each space in the table as you go.
- Review your answers on the Strengths Wheel and the 5 Whys table. Set yourself some goals based on your identified strengths and what you would like to work on.

1. How did the Facilitator Strengths Wheel and Growth Plan exercises help you gain a better understanding of yourself and your unique abilities?
2. What were some of the goals that you set for yourself based on your identified strengths?
3. What were some of the key insights or learnings that you gained from this process? How will you apply these insights?
4. What steps will you take to continue building on your strengths and achieving your desired outcomes as a facilitator?

Purpose statement

Purpose is the driving force behind why we do what we do. Many people who work in museum education are drawn to the field because of their passion for art, history, science, or culture. They are motivated by the opportunity to share their knowledge and enthusiasm with others. Purpose helps to give passion direction and meaning. Here, you are going to try and define your purpose using a 3-step process.

Note: Purpose is not fixed. It can evolve and change, just as we do. Identifying a purpose here does not mean that you can't revisit it as you gain new experiences, develop new skills and encounter new challenges.

Define your purpose

Work through these 3 steps to help you reflect on your purpose as a facilitator, and to become more aware of the type of facilitator you aspire to be.

1. What do you love to do? Identify what you truly enjoy doing. Write down activities that you find fulfilling and purposeful. Look back at past experiences and accomplishments, big or small, that hold significance for you.
2. Who is your audience? Identify the individuals or groups you serve or wish to serve. Be specific about who you want to work with.

3. What impact do you want to have? How does your work benefit your audience? Think about what impact you want to have on the lives of the people you work with in the museum. What do you want them to take home with them after having participated in one of your programmes? Jot down your thoughts on the impact you aim to have.

4. Combine your answers to create a purpose statement in the following style, bearing in mind how you want to develop and grow beyond where you are now and the impact that you want to have in the future. **I love [what you love to do] with [audience(s)] in order to [impact].**

Don't worry about making it perfect right away. The most important thing is to start developing something that feels like it's heading in the right direction. Your purpose statement can evolve and be refined over time. If you're working with a team, this can be a great activity to do together. Keep your statement in a safe and easy-to-find place (such as your journal), or pin it up in an easy-to-view position.

Values

Values are defined as the principles, beliefs and ideals that guide and influence our behaviour and decision making.

Often our values lie in our unconscious, so we may not even be aware of them. However, they still influence our behaviour and motivate us to act in certain ways. When it comes to finding your personal facilitator style, understanding your values can help you align your work with what matters most to you. It can also help you to make decisions that feel authentic and meaningful.

Find your values

1. Head to your favourite search engine to find a comprehensive and curated list of personal values online. Look for websites or platforms that are well-regarded in personal development, psychology, or coaching.
2. Pick out the values which resonate with you the most. Add in any you think are missing. Circle them.
3. When you've highlighted all the values that you think are relevant for you, the next step is to distil them down to a top 5.
4. Once you have a list of 5, prioritise them in order of importance.
5. Finally, ask yourself: *How can I align my work as a facilitator with these values?*

Defining your personal facilitator style

Defining your personal facilitator style means identifying your unique approach to facilitating guided experiences. What is the unique approach you use to engage visitors and create meaningful experiences for them?

This involves understanding your strengths, purpose, goals and values. Your personal facilitator style can inform the way you design and lead activities, the way you interact with participants, and the way you measure success. Having a clear personal facilitator style is essential for delivering high-quality and engaging programmes.

Being aware of your personal facilitator style can help you to be more confident in leading discussion-based programmes too. When you know your strengths and limitations, you can play to your strengths and work on stretching your limitations. This can lead to a greater sense of purpose and general fulfilment in your practice.

Notes

1 K. Anders Ericsson, Ralf Krampe, and Clemens Tesch-Römer, "The Role of Deliberate Practice in the Acquisition of Expert Performance," Psychological Review 100, no. 3 (1993), 363–406.

2 "Blow to 10,000-Hour Rule as Study Finds Practice Doesn't Always Make Perfect", last modified August 21, 2019, https://www.theguardian.com/science/2019/aug/21/practice-does-not-always-make-perfect-violinists-10000-hour-rule.

3 Carol Dweck, *Mindset: Changing the Way You Think to Fulfill Your Potential* (London: Robinson, 2017), 25.

4 Carol Dweck, *Mindset: The New Psychology of Success* (Random House, 2006) 25.

5 Cox, Bachkirova and Clutterbuck, *The Complete Handbook of Coaching* (SAGE Publications Ltd, 2018), xxix.

7
Reflective practice

'We do not learn from experience… we learn from reflecting on experience.'

– John Dewey

A reflective practice is simply the art of thinking about or reflecting on what you do in an intentional and systematic way. It's a process of self-awareness and self-evaluation, where you reflect on your experiences, actions and decisions, learning from them to improve your future performance. It involves looking back at specific situations, examining what happened and what was achieved, and exploring how things could have been done differently.

It's worth noting that reflection and reflective practice are related concepts, but there are key differences between the two.

Reflection is the general process of thinking about and evaluating your experiences, actions and decisions. Whilst reflection can be a one-off occurrence, **reflective practice** is a more intentional and structured ongoing process of self-awareness and self-evaluation, with the goal of continually improving your performance and outcomes.

Reflective practice is also the ability to reflect on your actions, **reflectively** *and* **reflexively**. The reflective part asks you to look inwards - examining your thoughts, feelings and actions, to consider what went well and what you could work on next time. The reflexive part allows you to zoom out and consider the beliefs, values and assumptions that inform your practice, by noticing any

patterns, biases and influences that may affect your actions or shape your perception of a situation.

Reflective practice is commonly used in a wide range of professional settings, particularly where professionals are working closely with people - such as social care and healthcare environments, and educational settings. In museum education, developing a reflective practice is essential for analysing our teaching approach, evaluating the effectiveness of our guided experiences, and making improvements based on what we discover. In our day-to-day interactions with visitors, we are learning all the time, in everything we do. A reflective practice is a way of recognising and articulating what we're learning as part of a continuous process.

In the Thinking Museum® Approach, reflective practice is a way of being. It involves adopting a mindset of learning from everything that we do, developing more self-awareness (rather than self-criticism), and entering into the spirit of continuous learning. It's about understanding that our work as museum educators, guides and docents is never complete, but instead is an ever-evolving process of growth and development. It's as much about adopting an appropriate attitude and mindset as it is about the practical applications. In essence, it's a commitment to ongoing learning and growth, self-awareness and critical thinking, and this can benefit us in all aspects of our lives, not just in our museum practice.

Developing a reflective practice is a crucial skill for museum educators, as it increases your self-awareness. Engaging in regular reflection gives you a better understanding of where your strengths and weaknesses lie. It can help you to be more creative and innovative - to try new things, experiment and improvise. Being reflective provides you with a way to learn from experiences - especially those which haven't gone according to plan - and even to reframe these types of experiences as challenges or opportunities. Ultimately, it helps you to improve how you facilitate, develop new professional practices, and enrich experiences for both you and your participants in your museum and gallery programmes.

Developing a reflective practice is a personal process. The key is to find a process that works for you and to make reflection a regular habit. It won't happen overnight. Some people find it easier to adopt a practice of reflection, evaluation and learning than others. What's important here is to be patient and consistent, and to find a pathway that suits your needs. It takes time to develop a routine for reflection that feels like a natural and integral part of your practice.

In this chapter we'll be exploring the benefits of adopting a reflective practice and a few key ways to start reflecting on your actions. The exercises in Chapter 6 lay the foundation for developing your reflective practice and building your self-awareness.

Building your own reflective practice

How to get started

Time

The most common reason for not committing to reflective practice is a lack of time. However, I think that regular reflection is something that you can build into your routine. It doesn't have to be an in-depth exercise every time, but it should happen on a regular basis, so that it becomes a habit. If time is short, you can take a minute between two museum programmes to mentally scan what happened in the previous tour, thinking about what went well and what you'd like to work on next time. Doing a quick 1-minute reflection is far better than skipping reflection altogether.

Slow down

Take away all distractions and allow yourself to be in the moment with your thoughts. Put everything on mute and give yourself some quiet time. A minute of breathing will help get your brain into a more reflective and relaxed state. Rushing through reflection may result in superficial insights or missed opportunities for self-awareness and growth. So try to be in the moment and stay fully attentive to the details of what you're reflecting upon, for the duration.

Be curious

Approach reflection with curiosity and don't judge yourself. Adopt an open-minded and inquisitive attitude towards your practice and experiences. Adopt the willingness to question assumptions, challenge beliefs, and explore new perspectives or possibilities. Curiosity in reflection involves a genuine desire to learn, grow, and discover insights from your own experiences, without any judgement or preconceived notions. Try not to criticise yourself. This is about objectively noticing, reviewing and reframing.

When to reflect

The first step in the process is to make a conscious effort to set aside regular time for reflection. This involves deciding on a time and place when you can engage in reflective practice. It can be a few minutes every day (for example, after each tour or programme that you facilitate or at the end of the day), or for a longer period once a week, depending on your schedule and needs. The best time for you to engage in reflection depends on your personal preferences, your schedule and your lifestyle.

Determining the best time to reflect:

1. **Look at your daily routine and schedule.** When do you have downtime? This might be during your morning coffee or lunch break, or after work. Identify the quieter moments in your day when you regularly take a break. Choose a time when you are relaxed but still able to focus.

2. **Experiment with different times of day.** If you're not sure which time would work best, try experimenting with different times. Try reflecting in the morning, afternoon or evening, and see how it feels in terms of both your brainpower and your time constraints. You may find that one specific time of day works better than others.

3. **Pay attention to your energy levels.** If you're feeling tired or stressed, it may be harder to reflect effectively. Consider scheduling reflection time for when you're feeling more alert and energised.

4. **Make it a regular habit.** Once you've identified a good time of day for reflection, make it a habit. Schedule reflection time into your daily

or weekly routine, so that it becomes a part of your practice. Focus on developing the habit by consistently reflecting over a defined period of time.

5. **Don't give yourself a hard time if you miss a session.** It's hard to build a consistent habit of reflection - particularly when other things take priority. Instead of criticising yourself, ask yourself why you missed a day and what you can do differently next time, to ensure it doesn't happen again.

6. **Remember: any reflection is better than none.** Although more time and effort spent on reflection can lead to deeper insights and more meaningful learning, even a brief moment of reflection can provide some benefits, such as increased self-awareness and growth. Even spending a minute or two thinking through your thoughts about a programme that just happened can be beneficial, and it doesn't always have to involve writing or a formal process. Asking yourself questions, considering different perspectives, or simply taking the time to process your emotions and reactions to something will all provide opportunities for learning.

To get the most out of reflection, it's important to find what works best for you and turn it into a regular habit. Reflection can be a powerful tool for personal growth and development, so it's worth making the effort to find a time that suits you. If your first attempts don't work, repeat the steps until you find a pattern, time or method that does work. Start small, and be patient with yourself as you work to integrate reflective practice into your routine.

Build regular moments of bite-sized reflection

Pause and review
Take regular moments throughout your day to pause and consciously review your actions, behaviours, or decisions. Consider what happened, what you did, and how you responded in a particular situation. Pay attention to your thoughts, feelings and reactions, during and after the event.

Do some 'reflection in action'
Donald Schön, a renowned scholar in the field of reflection, proposed two types of reflection:[1]

a. Reflection-**in**-action, which is reflecting as something happens (e.g. during a guided experience); and
b. Reflection-**on**-action, which is reflecting after something has happened.

Being able to think about what you are doing whilst you are doing it is an incredibly useful skill for educators.

For instance, if you notice that your group is becoming restless or struggling to understand something, you can quickly assess the situation, make a decision and take immediate action. This might involve wrapping up a discussion and moving on, or it might mean involving more participants in the conversation.

The steps to take would be to observe the situation, consider why it is happening, then respond by doing something differently. Reflection-in-action is an immediate reflection of what's happening in the moment and it's incredibly useful. It allows you to personalise experiences and draw on your own experience, so that you can change things.

Reflect on small moments

Reflection doesn't always have to be focused on significant events or challenges. Reflect regularly on small moments throughout your day, such as interactions with your colleagues, decisions you've made, or tasks you've completed. The key here is to cultivate a habit of intentional reflection, even in seemingly insignificant moments, in order to foster continuous learning, self-awareness and growth.

Check in with yourself

Throughout your day, make a point of checking in with yourself. Ask yourself how you are feeling, what you are thinking, and what is important to you in the present moment.

Ask yourself questions

Ask yourself reflective questions throughout the day. For example, *What am I learning from this situation?*, or *How could I have handled that interaction differently?* Be honest with yourself, so that you can develop more self-awareness.

Developing a more in-depth reflective practice

As you start to feel more comfortable and confident with your regular, bite-sized reflective practice, think about how you could develop a more in-depth reflective practice to further your insights.

Here are some ways to take a step further in your practice.

Keep a reflective journal

Journalling can be a great way to develop a reflective practice. It doesn't suit everyone, but before you decide that describes you, do bear in mind that journalling doesn't have to be complicated or time-consuming. Taking a few minutes after a guided experience (or at the end of the day) to jot down a few thoughts can be illuminating. Keeping a regular reflective journal for your educator practice will allow you to keep a record of your progress and make changes when necessary. Remember to review it regularly, so that you can identify patterns and areas for growth.

To make journalling effective as a practice, you will need to ensure that you make it a regular habit. Buy a small

journal that you can carry with you to make quick notes at any time. By regularly reflecting on your work, you can look back and see how you've grown, spot patterns, and use this information to inspire new thinking.

There are lots of journalling prompts available on the internet (see below for more), just google 'journal prompts for educators' and you will get lots of inspiration, including big questions like, What is your greatest strength?

Alternatively, you could use the same framework every time you write in your journal, so that it's easy to recall and you can get started immediately without having to find a new prompt. Start by reflecting on what you did, what happened, what went well, and what you want to work on for next time.

Journalling doesn't always have to involve writing. Instead, you can experiment with drawing, sketching or doodling to reflect and express your thoughts, emotions or experiences. You could make collages from printed materials, or use photographs to represent your reflections, by selecting images or words that resonate or taking photos of objects or artworks that you have worked with in the museum, documenting your experiences and revisiting them later on for reflection.

Reflective prompts

Instead of (or in addition to) a reflective journal, you can also use journal prompts to reflect regularly on your practice as an educator. This involves using open-ended questions or statements as prompts to guide your reflection. As mentioned earlier, there are plenty of prompts available online, ranging from larger questions about your teaching style and strengths, to more specific questions about a particular lesson or programme.

Suggested prompts for your journalling practice:
- What did I learn today and how can I apply it to my work tomorrow?
- What were the most challenging moments of the day as a whole, and how did I overcome them?
- What was the most challenging part of my tour or programme today? Why was it challenging and how did I handle it?
- What was the most successful aspect of my tour or programme today? What contributed to its success?
- How did I feel during my interactions with others today?

- What goals did I set for myself today and did I achieve them? If not, why not, and what can I do differently in future?
- What did I do today that I'm proud of?
- What could I have done differently today to improve my work or interactions with others?
- What is one area of my practice that I would like to focus on improving? What steps can I take to work on this area?
- What did I observe today that made me think about my work in a different way?
- What new ideas or insights did I gain today that I want to explore further in future?
- What was one moment during my day today when I felt truly present and connected with my participants? What contributed to this feeling, and how can I cultivate it again in the future?

You may find it helpful to vary the reflective prompts you use in your journalling practice. One approach is to mix larger questions that encourage you to reflect on your overall teaching and facilitator style, strengths, and weaknesses, with more specific questions that ask you to consider a particular tour or experience.

The most crucial aspect of reflective journalling is developing it into a regular habit. Even a brief 1-2 minute reflection at the end of the day or after leading a tour can be enough to get started, and you can always write more if you wish.

Free writing

Free writing is an effective reflective technique that involves writing continuously for a defined period of time. It allows you to document your response to experiences, opinions and events in an uninhibited, free-form manner. Think of it as a way to 'download' your thoughts onto paper without censoring or editing them.

Free writing is a form of stream-of-consciousness writing, where you write without worrying about grammar, structure, or coherence. It's a tool for accessing your inner thoughts and emotions by capturing them in written form, gaining clarity and self-awareness through the process. With regular use, it can help you explore your knowledge, gain self-awareness, and communicate your thoughts and feelings.

Free writing

1. **Choose a prompt:** Decide on a prompt for your free writing exercise. It could be an image, a question, or both. For example, you could reflect on a class you just taught, a tour you led, or an online session you facilitated.

2. **Set a time limit:** Set yourself a time limit for the exercise. It could be 5, 10, or 15 minutes, depending on your preference and availability.

3. **Start writing:** Begin writing and keep the flow going without stopping to judge or edit your writing. Don't worry about sentence structure, grammar, or spelling. The goal is to keep your hand moving and let your thoughts flow freely. If you run out of ideas, write whatever comes into your head without pausing.

4. **Review and underline:** When the time is up, read back through what you've written and underline any key words or phrases that stand out to you. You can also put your writing aside for a while and return to it later with a fresh perspective.

5. **Edit and organise:** Later on, you can edit your free writing by ordering the parts that make sense to you more logically.

You can also try free drawing or doodling as an alternative to free writing. By allowing your thoughts to flow freely, you can access deeper, subconscious thoughts and insights that might not surface when you're overthinking or self-censoring. Both free writing and free drawing can be effective tools for reflection, self-expression, and gaining insight into your thoughts and feelings.

Peer reflection

Peer reflection is a process of reflection that uses input and feedback from others, namely your peers, in a collaborative and supportive environment. It involves engaging in reflective discussion, sharing insights, providing feedback, and learning from each other's perspectives and experiences.

In the Thinking Museum® Approach, peer reflection is an important part of practice and coaching. Often, groups of museum educators and gallery teachers will get together to facilitate discussions with each other, to workshop new ideas for a guided tour or educational programme, or to evaluate an existing tour or programme. They may share observations, challenges, insights and experiences with each other, and engage in honest and open discussion, in order to learn from each other and brainstorm ideas for improvement.

Observe others

Observing others is a very simple way to develop a reflective practice. By seeing fellow museum educators at

work, you can gain insights into different teaching styles, alternative strategies for engaging visitors, and a variety of other approaches to facilitating meaningful learning experiences in a museum setting. It provides an opportunity for you to witness the diverse ways in which educators interact with visitors, by adapting to different learning needs and overcoming challenges.

As gallery teachers and museum educators, we often work in parallel with others and rarely get to see them doing what they do. Seeing other educators in action is always inspiring. You can learn so much from seeing your peers at work. By observing your peers you can reflect on your own practice, compare your approaches with those of your peers, and identify any areas for improvement. You can learn so much from the successes and challenges of others, and applying these lessons to your own work will likely lead to a more well-rounded and effective approach to facilitating your own museum programmes. Observing others can also foster a community of collaboration and shared learning amongst team members, which promotes both professional growth and a continuous cycle of reflection, improvement, and innovation in your shared educational practice.

Seeing your colleagues at work in the museum is an eye-opening experience, but seeing yourself as your colleagues see you can be a transformative experience.

Observe yourself

I am a huge advocate for observing yourself in action as a great way to learn and grow in your practice. This kind of observation promotes self-awareness, identification of patterns, self-assessment, and ownership of learning, all of which contribute to continuous improvement and professional development.

If you're able to obtain a recording (video or audio) of yourself leading a tour or educational programme, it will give you far-reaching insights into how you work. We often think we teach and facilitate in a certain way, or say certain things, but it's only when you see yourself in action that you truly find out what you're doing. Watching or listening to a recording can be challenging, but try to approach it with an analytical mindset (rather than being self-critical), by making notes on what went well and what you want to work on in the future.

If you embrace self-observation as a reflective practice, it can lead to meaningful growth and development as an educator.

Share and reflect with others

You can also develop a more reflective practice by sharing your experiences with others and asking for their feedback. Reflection doesn't always have to be a solo activity. In fact, it can sometimes be more helpful to reflect *with others*.

Set up regular practice and coaching sessions, where small groups of educators and guides take turns to lead a short discussion around an artwork or object, followed by feedback and discussion (10 minutes for the discussion, and 10 minutes for group reflection afterwards works well). After each discussion ask the facilitator to reflect on their experience. Then ask the group to share what they appreciated about the facilitation, followed by any suggestions they have for facilitating differently in future. Round up with time for each facilitator to share what they are going to work on for next time.

Finding regular times to meet with others to reflect and share your thoughts collectively will quickly make a visible difference in your practice.

Research

Engaging in research and staying up-to-date with new developments in your field is a crucial aspect of reflective practice. As you become more reflective, you will develop a thirst for learning and staying current with new techniques and methods.

Research can greatly contribute to your reflective practice in several ways. First, it exposes you to new perspectives, ideas, theories, and viewpoints, all of which challenge your existing assumptions and beliefs, prompting reflection on your current practice and consideration of new approaches. Furthermore, it demonstrates a commitment

to professional growth and continuous learning, helping you to assess how well your current practice aligns with current knowledge and to identify areas for improvement or further development. Additionally, research provides a broader understanding of the context in which you work, including any societal, cultural, and technological changes that may impact your practice.

You can incorporate various forms of research into your practice. For instance, starting a book club with fellow educators can be an excellent way to stay ahead of developments and foster the discussion of ideas. Book clubs not only help you to stay accountable in your reading, but also foster the discussion of ideas and exploration of potential applications in your own work or practices. This collaborative approach to research generates new insights and promotes better retention of key concepts, enhancing the overall impact on your practice. You might also want to do some research and get inspired by attending conferences, and events, or by taking courses and classes. These all help you to meet other people, share ideas and get new sources of inspiration. All of which you can explore afterwards in your journal.

In conclusion, reflective practice is a powerful tool that can greatly enhance your professional growth and development. By engaging in reflective practice, you will develop a deeper understanding of your own practice, gain insights into your strengths and areas for improvement,

and cultivate a questioning, inquisitive approach to your work. Take the time to pause and reflect, in order to make informed decisions about the art and object experiences you lead and how they might look in future. As you embark on your reflective practice journey, remember to be curious, open-minded and willing to challenge your assumptions. Embrace reflection as a practice and watch as it transforms your guided experiences for the better.

Notes

1 Donald A Schön, *The Reflective Practitioner: How Professionals Think in Action* (London: Temple Smith, 1983).

8
Intentional information

*'Think of the information you hold as a
well-stocked pantry. Though you may have
innumerable ingredients, you use only those
that make a specific dish tastier.'*

– Olga Hubard

Imagine you are in a museum, participating in two different group discussions about the same artwork. The first dialogue is framed around a particular theme or idea, and information and knowledge is shared throughout. In the second no contextual information is shared, and participants are free to interpret and engage with the artwork in their own way. Both discussions offer unique opportunities for meaning-making. Both encourage participants to slow down and engage more deeply with the artwork. But which dialogue provides the deeper experience? Is it the one providing more information and context, or the one allowing for greater personal interpretation and exploration? Does information help or hinder the experience of engaging with artwork?

Each of the approaches have their own strengths and limitations, so ultimately the answer may lie somewhere in between the personal preferences of the individual participant and the goals of the museum programme. Certain circumstances may call for different approaches. For example, if the primary goal of the programme is to place the artwork within a particular historical or cultural timeline, then a themed discussion with contextual information may be more appropriate. On the other hand, if the goal is to encourage personal reflection and emotional engagement, an open discussion might prove more meaningful. A hybrid approach, combining elements of both types, is also an effective way to engage with an artwork

or object on a personal level, whilst also providing any necessary information and historical context.

Whilst information can provide context and enhance understanding, it should be thoughtfully integrated into the experience, rather than being its sole focus. Programmes that rely solely on information sharing may limit participant engagement and hinder their ability to have a personal and meaningful experience with the objects themselves.

One of my favourite articles is by Patterson Williams and is called 'Object-Oriented Learning in Art Museums'. In it she says: 'The primary aim of museum education must be to bring together people and objects, not people and information about objects'.[1] She goes on to say that the essential experience of the visitor is that of seeing, reacting to, and thinking about an object.

Sometimes we place too much emphasis on the delivery of content, information or knowledge. We assume that visitors are in the museum to learn something new. We forget that some visitors are also in the museum for social interaction, enjoyment and recreation, or personal reflection and meaning-making. Recognising and catering to these diverse motivations can help us to challenge our assumptions about what we think visitors want (or should want) from a museum programme, and how much information is truly necessary for the experience.

In guided experiences, the level of information shared also needs to be responsive to the audience's background, interests, and prior knowledge. Everyone brings their own diverse experiences and varying levels of familiarity with the subject matter with them to a museum programme. As a result, a one-size-fits-all approach, which sees you repeating the same format over and over again for different groups, may not effectively engage all your participants. Whilst I can give you the tools to streamline your content and select what might be the most appropriate choices for a certain audience, you will also need to be prepared to be flexible and willing to adapt your practice accordingly. When you deliver your programme(s) you will need to gauge the level of engagement each time. In response to this, you will potentially need to adapt the amount and type of information and delivery accordingly, in line with what you discover about the group and their interests, or whenever unexpected moments arise. Different participants may have varying levels of curiosity and desire for more in-depth information. Remember that, even with careful preparation using the What? How? When? framework, there will always be moments when you are required to think on your feet and make adaptations in the moment.

Your job is to be fully aware that the information you provide can have different effects on participants. It can lead to moments of clarity and insight (a-ha! moments), where participants make connections and deepen their

understanding. Conversely, it can cause confusion or overwhelm if it is not effectively communicated. Your role as a facilitator is to encourage participants to inquire and discover. Instead of providing all the answers, focus on guiding them towards finding their own insights. Offer relevant information and knowledge as a tool that supports their understanding. However, it's also important to strike a balance. Provide enough information to spark curiosity and further exploration, but avoid excessive details that might kill the discussion and stifle participants' thinking.

Group discussions about artworks and objects have played a pivotal role in museum education in recent years. Recognising the importance of creating interactive and inquiry-based experiences, many museums and heritage organisations have dedicated effort to training their teams accordingly. However, there is one aspect that is often overlooked in the pursuit of transitioning from a more traditional walk-and-talk style to a dynamic, interactive, and inquiry-based approach: explicitly teaching museum teams how to confidently use their knowledge in a more intentional way.

By exploring strategies on how, when and if to share information, as well as emphasising the role of information as a tool for engagement (rather than overwhelm), this chapter seeks to equip you with the necessary skills to create impactful and well-balanced interactive experiences for your participants.

It will change how you think about the knowledge you have and the information you share.

Monologues and lectures

A monologue (or lecture) is not the most effective way to deliver information in a museum or gallery programme. Participants have little control over the pace of delivery, leaving them unable to pause, process, and think about the information being presented. The 'presenter' does most of the talking, leaving not much room for active participation by the group. It promotes one-way communication, hindering dialogue and interaction between participants. It often fails to establish any sort of connection between the visitors and the artworks or objects, leaving them feeling disconnected and disengaged. Additionally, a monologue or lecture requires sustained focus and concentration for a longer period of time.

In 2000 Microsoft conducted a study and found that the average person's attention span was 12 seconds. Fast forward 15 years, and it dropped to a mere 8 seconds.[2] Our attention spans are shrinking due to the abundance of information in our lives. This means that relying solely on a monologue to convey information during a museum or gallery programme can result in participants either quickly losing interest or becoming overwhelmed.

Many facilitators of museum and gallery programmes may not realise that they are delivering lectures or engaging in monologues. It's only when they observe themselves in action that they become aware of it. In addition, some facilitators may feel a sense of responsibility to convey a certain amount of knowledge or cover specific content during a programme. This can create pressure to deliver information quickly or at length, and in a more didactic manner, by inadvertently slipping into lecture or monologue mode.

There is usually a genuinely positive intention when museum educators want to share their knowledge and expertise with their audience in this way. They may believe that by providing a comprehensive understanding of the topic, or by sharing everything they know, they are offering added value and enriching the participants' experience. However, in an inquiry-driven approach it's essential to consider the perspective of all the individuals in the group.

Overwhelming participants with an abundance of information leads to cognitive overload, where individuals struggle to process and retain the information provided. This too can hinder their ability to form meaningful connections with the programme content and artworks. Additionally, it's important to remember that every participant brings their own perspective, experience and knowledge to the museum or gallery setting. By allowing space for their voices and interpretations to be heard, you can foster a more inclusive and engaging environment.

An inquiry-based approach

An inquiry-based approach involves facilitating inter-active and dialogue-driven museum experiences, where participants actively engage with artworks, objects and ideas. It emphasises open-ended questioning, critical thinking, and collaborative discovery. It is a multi-way process that encourages the exchange of ideas amongst all participants, as well as between participants and the objects or artworks themselves. The facilitator serves as a guide, facilitating and mediating these interactions between group members.

An inquiry-based approach offers several benefits. Firstly, it ensures that no two programmes are the same. Facilitators can adapt their questions and the flow of information to create unique and engaging experiences for each group. This flexibility allows for experimentation and playful exploration, and you will discover how different questions or information can impact the conversation. Secondly, an approach based on inquiry encourages deeper and more memorable conversations amongst participants. These conversations foster critical thinking, reflection, and the exploration of diverse perspectives.

This approach not only enhances participants' understanding, it also cultivates valuable skills, such as active listening, the expression of ideas, and respectful dialogue

with others. Moreover, facilitating inquiry-based discussions can be a rewarding experience, especially when 'lightbulb moments' occur, where participants make meaningful connections and gain new insights. Discussion-based facilitation is an enriching and fulfilling way of working, for both facilitators and participants.

Success factors for programmes based on inquiry and discussion

When preparing either a single discussion or an entire museum programme, it is important to establish clear teaching goals and determine the structure, based on whether the programme will provide information around a theme, or be an open discussion without any shared contextual knowledge. Thematic discussions provide a more focused framework, whilst open discussions allow for greater freedom and freer thinking. Regardless of the chosen structure, planning for participation and variety is crucial if you want to keep the dialogue engaging and dynamic.

Balance

As a facilitator, it is essential to find a balance between **maintaining control** and **fostering openness** during

discussions. This includes effective time management, to ensure that all participants have an opportunity to contribute and engage in the conversation.

In the introduction to your programme (the Entry phase), strike a balance between providing information and outlining the direction of the programme, and establishing a connection with the group which makes them feel secure about participating. In other words, focus on building rapport and making participants feel comfortable first, before diving into any content and logistics. During the main body of your programme (the Exploration phase), maintain a balance between encouraging participants to share their own views and experiences, and providing them with new knowledge and information. Allow for a diverse range of perspectives and actively listen to participants' contributions. In your conclusion (the Exit phase), identify and highlight the common threads and key insights that emerged during the discussion. This helps to consolidate the learning and provide a sense of closure to the discussion.

(For more in-depth guidance on the above phases - Entry, Exploration and Exit - and on designing effective discussions and programmes, refer to Chapter 9: Deliberate Design.)

The *What? How? When?* framework

The *What? How? When?* framework is a practical tool that can help you determine how to share information effectively, so that you can engage participants in inquiry-based discussions. It involves considering three key aspects: analysing and selecting relevant information to share, thinking carefully about how to share it, and considering when to share it.

What information should you share?

Using the CHOOSE framework

The CHOOSE framework is a helpful tool that guides you in selecting the most relevant information to share during your guided experiences. These 6 essential steps assist you in making informed choices about the information you share:

> C - Choose a theme
> H - Highlight artworks or objects
> O - Observe artworks or objects
> O - Organise research
> S - Structure a plan
> E - Employ Questioning Practices

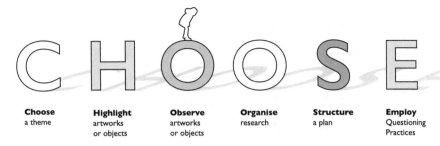

Choose	Highlight	Observe	Organise	Structure	Employ
a theme	artworks or objects	artworks or objects	research	a plan	Questioning Practices

Choose a theme

Regardless of the type of session you are leading, having a theme is beneficial for providing focus and coherence. Even for 'open' discussions, where information sharing does not take place, a loose theme can help maintain structure. If you are sharing contextual information, a theme becomes even more important.

When exploring multiple objects or artworks, it is essential to determine an overarching theme and select pieces that embody the theme conceptually, aesthetically, or historically. This approach ensures a cohesive and meaningful experience for participants and, crucially, helps you make important choices about the information you are going to share.

Without a theme, any information you share becomes an isolated set of facts. Moreover, when too much information is presented without a proper context, confusion can quickly set in, leading participants to lose interest and disengage. This is particularly true for what Sam Ham calls 'non-captive audiences', such as those on museum programmes or guided tours, where the primary motivation is personal interest, enjoyment, or curiosity, rather than

any obligation or requirement to be there.[3] If we connect the information we share to a theme and keep the main ideas to a manageable amount, we can effectively convey information without overwhelming the group or losing their attention, and we can make it 'sticky' too.[4]

7 reflective questions to help you define your theme
Answer any or all of these 7 questions to get more clarity on the theme of your programme or discussion:

1. What kind of conversation do you want to spark?
2. What do you want your participants to learn and remember?
3. Does your programme include just one or multiple objects and artworks?
4. Do you want, or need, to link the theme to a curriculum?
5. Is the theme age or target group appropriate, and does it connect with the objects and artworks?
6. Is the theme broad enough? Does it cover too many different ideas, making it hard to explore them deeply? Or is it too specific, only covering one idea and limiting the participants to that?

7. Why does this theme matter - to you, to the target group, to the museum, etc.?

Once you have selected your theme, consider what you want your participants to learn and remember from the experience, then design the programme with that outcome in mind.

Highlight artworks or objects

The second step of the CHOOSE framework is to select artworks or objects for your programme or single discussion. When highlighting potential artworks, bear the following points in mind.

Accessibility: Choose artworks or objects that are easily accessible and relatable for your group. Consider their familiarity with the subject matter and their ability to engage with the piece. This helps ensure that everyone can engage with the artwork or object and actively participate in the discussion.

Personal interest: Select artworks or objects that spark your own interest. When you are genuinely intrigued by something, it will enhance your enthusiasm and ability to guide an engaging discussion. Your passion for the

artwork or object can also inspire participants and be contagious. Be open to exploring pieces that may not immediately catch your attention. By taking the time to engage in careful observation, you may discover hidden layers, narratives, or artistic elements that can spark your interest and lead to fascinating discussions. Challenge yourself to look with an open mind and you may be surprised by what you uncover.

Detailed: Opt for artworks or objects with details that allow for deeper exploration and discovery through observation. Pieces such as these provide ample opportunities for participants to notice and analyse different elements, encouraging a richer, more engaging discussion.

Theme alignment: If your programme is themed, ensure that the chosen artworks or objects align with your theme or topic. They should contribute to the overarching narrative and reinforce the ideas you want to convey.

By following these loose guidelines, you can select artworks or objects that are accessible, align with your theme, ignite your own interest, and provide opportunity for detailed exploration.

Observe and spend time with your artwork or object

Once you have chosen the artwork(s) or object(s) that align with your theme and meet the above criteria, it's important to spend some time with each, to see where they lead you.

Observing and note taking

As you engage with the artwork or object, take note of any observations, comments, and questions that occur to you. Capture your thoughts in written form (on paper or digitally), so you can refer back to them later. If possible, take a photo of the artwork and save the image in a digital folder for future reference. If you can, spend time with the artwork in the gallery, to get a feel for the environment and space around the object. Do this on your own, or in small groups if you want to hear other perspectives.

1. Look at the artwork or object as a whole.
2. Look specifically at its shape, colours, size, story, detail, etc. Keep looking and allow yourself time to fully observe everything.
3. What questions do you have? Make notes. Reflect on what aspects interest you the most. Think about the questions that come up during your observation.
4. Jot down any extra thoughts, no matter how random they may seem!

Throughout the process, make detailed notes of your thoughts and impressions. This is important, as you're unlikely to remember your initial thoughts further down the line, and they will help to inform what information you choose to share.

The amount of time you spend with the artwork or object is up to you, but try 5-10 minutes to start with. Dedicating time for careful observation allows you to immerse yourself in the details, intricacies, and nuances of the piece. It provides an opportunity to observe, wonder, and reflect on the artwork or object's various elements, such as composition, colour, texture, and symbolism. Spending sufficient time with an artwork or object enhances your ability to perceive and interpret meaning and potential lines of inquiry.

Afterwards, review your observations, comments and questions, and analyse which aspects of the artwork or object captured your attention the most. This helps you to identify specific elements that you want to explore further.

Organise research

The next step involves conducting thorough research, to learn as much as possible about the artwork or object. The research phase aims to find answers to your initial questions and explore other points of interest.

Begin by conducting research on the artwork or object, gathering information from various sources. Seek answers to the questions that you noted down previously, plus any additional details that pique your curiosity. Take note of information that feels particularly relevant to your theme, if you are using one.

Streamlining information using the rule of 3

During your research, you will no doubt come across a lot of interesting information about your artwork or object. However, in your programme, you can't share everything. You need to streamline your findings and decide which information is the most relevant for your programme. To do this, use the Rule of 3. This means selecting 3 main pieces of information (or 'storylines') for each artwork or object, then testing each storyline against 3 questions. The Rule of 3 principle, widely recognised in communication, makes it easier for people to follow your ideas and stay engaged throughout the programme. Having just 3 storylines to share per object avoids overwhelming your participants with excessive information and allows them to grasp the essential concepts more effectively.

After you've created your shortlist of 3 storylines related to your artwork or object, ask the following questions for each one:

1. Is this essential to the theme of the programme?
2. Is this relevant to the target audience?

3. Does this need to be said here and now?

If your storyline doesn't meet the criteria, choose a different one. After testing each storyline against these questions, you can highlight either the most generative storyline or the one that resonates with you the most.

If you answered 'yes' to all 3 questions, the information you've selected is relevant to the theme, the audience and the moment. All too often, we share information because we think it's interesting, even though it may not be relevant to the main theme of our programme or the people we're with. This is okay from time to time, as an aside, but doing this consistently will lead to cognitive overwhelm. Remember the aim is to share just enough information to make your participants curious, but not so much that they feel swamped.

It is crucial to acknowledge that individuals have limits when it comes to understanding and making sense of new information. Both the amount of information and how it is organised play significant roles in determining how well we can process and retain it. Simplifying and streamlining any information you've gathered from your research is key to facilitating understanding and maintaining engagement. To achieve this, it is essential to 'kill your darlings' – get rid of parts you might like or find interesting personally, but are not necessary or helpful to the overall theme. It's all about making tough choices to improve the quality of your programme.

By carefully curating the information you share and distilling it to find the most relevant and essential aspects, you enhance your participants' ability to process and retain the content, resulting in a more engaging and meaningful experience and less 'information-dumping'.

Structure a plan

Once you have selected your artworks and relevant information, you can focus on the final two steps – creating a plan and choosing Questioning Practices. These steps are often completed together and go hand in hand. For longer programmes that involve a variety of objects and artworks, it is essential to have a well thought out plan. Consider the following factors, to ensure that each object is effectively incorporated into your guided experience:

Placement in the programme

Determine where each artwork or object will fit within the overall structure of the programme. Consider whether it should be introduced at the beginning, middle, or end of the programme, to create a logical flow and build a coherent narrative.

Time allocation

Decide how much time you want to allocate for each object or artwork. Consider its significance, complexity, and the depth of exploration desired. Allocate a suitable time frame, based on the importance and richness of the content and the Questioning Practice and modality that you've selected.

Questioning Practice and activity selection

Select relevant and specific Questioning Practices to deepen participants' engagement and understanding.

Determine the activities or modalities that will best bring out the theme of the programme for each object. Consider how you can prompt participants to explore different aspects of the object, encourage critical thinking, or facilitate meaningful discussions via a variety of different modalities (see Chapter 4 on Multimodality).

Before you move on to the next section, have a go at working out what information to share for an artwork or object that you know well. The CHOOSE framework will help you to narrow down information choices and select only the most key pieces of information relevant to your theme.

Using the CHOOSE framework to choose what information to share

In this exercise, start by selecting an artwork or object that you are familiar with and know well. We will be using the first 4 steps of the CHOOSE framework to analyse and choose relevant information about it for your discussion. Starting with

an artwork you know well allows you to become acquainted with the process before applying it to something unfamiliar. Plus, you might even uncover new lines of inquiry and discover new aspects of the artwork that you hadn't noticed before.

Download the CHOOSE framework cheat sheet. www.theartengager.com

You can also refer back to the instructions for each of the steps written earlier in this chapter:

1. First choose an **imaginary target group**
2. **Choose a theme:** select a theme for your discussion that will provide focus and coherence.
3. **Highlight artworks/objects:** Choose something that is accessible, personally interesting, detailed and aligned with your theme.
4. **Observe:** Spend time with your artwork or object, taking note of any observations, comments, and questions that occur to you.
5. **Organise research:** research your artwork or object to learn as much as possible about it and then refine your choices using the Rule of 3.
6. **Choose:** the 3 key pieces of information to share. Write them down.

- **Test:** For each piece of information ask:
 - Is this essential to the theme of the programme?
 - Is this relevant to the target audience?
 - Does this need to be said here and now?

We'll complete the final two steps of this exercise at the end of this chapter, once we've looked at how and when to share information.

 What did you find interesting or challenging about this exercise?

How to share information

Many museum educators and guides are experts in their field, having honed their craft over the years and accumulated a vast body of knowledge about the artworks and objects featured in their programmes. It's only natural to want to share this incredible knowledge with an audience. However, it's important to recognise that having extensive knowledge alone is not enough. The ability to share that knowledge in an engaging and accessible manner requires a separate skill set.

Less is more

I always keep Olga Hubard's words (mentioned at the start of this chapter) in my head as I'm thinking about what information to use in my discussions.[5] When it comes to sharing information in museum programmes, less is definitely more. Don't default to using everything in your 'well-stocked pantry'; instead, choose the most relevant and impactful 'ingredients' that align with the goals and themes of your programme. Whilst you may want to provide the most 'value' possible, it doesn't mean overloading participants with everything you know. Be selective. Focus on the 'magic 3' described earlier - 3 key points or ideas that are clear and memorable. By sticking to these essential elements, you can ensure a more effective and engaging experience for everyone.

Present information in small chunks

To facilitate learning and processing, present new information in manageable portions, or bite-sized chunks. For every few minutes of new content, allow participants time to absorb and digest what they've learned. Steer clear of the dreaded information-dump at all costs. This is when you download the contents of your head to a group, or you start monologuing. You can visibly see the engagement dropping off with every extra minute you're talking. The longer you talk, the more your participants will start to think that their input is irrelevant or unnecessary and they will start to tune out. This can also have an impact on future participation.

Make it relevant

When the information that is shared is directly related to the participants' interests, experiences or curiosities, it becomes more meaningful and engaging. If information is relevant to their own lives, values or perspectives, it allows participants to make a personal connection to it. As a result, relevant information is more likely to be remembered. So, how can we make what we share relevant?

According to Sam H. Ham, a Professor of Communication Psychology and author of *Interpretation: Making a Difference on Purpose*, relevant information possesses two important qualities: it is meaningful and personal.[6] Meaningful information goes beyond facts and dates; it links to the participants' interests, experiences and values. It sparks curiosity, prompts reflection and enables participants to make connections and gain deeper understanding. It acknowledges the diverse backgrounds and interests within the group and recognises that different individuals may have different entry points to understanding and engaging with the artwork or object.

By incorporating both meaningfulness and personal relevance in the information you share, you can foster engaging and, quite possibly, transformative experiences as a museum educator, which resonate with your participants on a deep level. Relevant information turns the engagement switch on.

Get to know your participants

Understand the background, interests, and prior knowledge of your group. Whilst you can ask a few questions at the start of your programme to establish connection, think about how you can keep discovering who's in the group throughout.

When sharing information, it's important to gauge the level of knowledge and understanding of your group. Some may arrive with a generally sophisticated knowledge of the museum, exhibition or subject matter. Others may be starting from scratch. Others still may be composed of a mix of different levels of knowledge When dealing with mixed (in terms of knowledge and understanding) groups, it becomes important to strike a balance that accommodates everyone's needs. Don't pitch your level too high at the start. As you progress, you can gradually introduce more complex information, checking for understanding as you go. Avoid making any assumptions about prior knowledge. When participants feel that prior knowledge is not assumed, they are more likely to ask questions and seek clarification.

Begin by presenting concepts or ideas in a way that is accessible and easily comprehensible. As you progress, you can gradually introduce more complex information, ensuring that participants can follow along and engage with the content effectively. The goal is to make the information understandable and relatable to your audience, ensuring they can continue to engage with it and find it meaningful.

Use accessible language

Avoid 'industry-speak', technical terms and academic language, as these can create barriers to understanding for many participants. Strive to use everyday language that is familiar and accessible to your group. Communicating challenging ideas doesn't mean resorting to complex language or convoluted explanations. In fact, it's often more effective to convey these ideas using simple, clear sentences. If you need to use specialised terms, take the time to define them in a way that is easy to grasp, as per the advice below. Use bridges, such as examples, analogies, contrasts, similes, and metaphors to create a link with what your group already knows about.[7]

Avoid fact regurgitation

Instead of listing facts and dates, focus on conveying key concepts and ideas. Guide your participants towards understanding the *Why?* behind the information, so that they can grasp its relevance. Provide the context and background information surrounding the subject matter, so that you help participants see the bigger picture.

For example, whilst knowing the date an artwork or object was created can provide historical context, and can certainly be relevant in some discussions, it is not always essential for a meaningful and engaging experience. In most cases, participants are more likely to remember information that is personally relevant and meaningful to them, rather than specific dates.

However, when participants ask you to provide a date for an artwork or object, it often signifies their interest in understanding the significance of what they are looking at within a larger context. They are seeking connection with the cultural and historical developments that surrounded that specific point in time. In such situations, it can be valuable and enriching to provide not only the date, but also additional contextual information that helps participants grasp the wider implications and influences of the subject matter. Additionally, if the date of an artwork or historical event is crucial for understanding a sensitive topic or difficult history, it is important to share it, in order to place the object in context. In such cases, knowing the date ensures that participants do not draw incorrect conclusions or misunderstand the artwork or object's historical significance. As a rule of thumb, if the date is relevant to the context and relevant to the group's understanding of an artwork, then share it.

Different ways to share information

A 'mini share'

A mini share is a short narrative sequence that answers something the group wants to know more about. It is introduced by questions and followed up by questions. Using questions before and after the narrative sequence serves multiple purposes. It prompts participants to actively think about the topic and fosters their curiosity. The initial questions create a sense of inquiry and anticipation, whilst the follow-up questions

help reinforce the key points and allow participants to reflect on what they have learned. The before and after questions also provide an opportunity for group discussion and sharing of perspectives, fostering a collaborative and interactive environment whilst 'sandwiching' the narrative sequence.

Storytelling

Consider introducing storytelling elements into your discussion as a way of sharing information. You can share personal stories or anecdotes that are relevant to the theme, or find stories about individuals related to the information you're sharing. Again, ask questions before and after. Asking questions after sharing a story helps to reinforce key themes, enhances reflection, and supports participants in processing the information in their minds.

Questions

Use questions to spark curiosity and assess your group's prior knowledge, interests, and understanding of the subject matter. You can use questions such as *What are you wondering about?* to find out what the group would like to know more about. You could even ask a closed question like, *Is that something you're familiar with?* to check for understanding after sharing a chunk of information. *What if...?* is another question that you can use to share information that may be particularly thought provoking, powerful, surprising, or even counter-intuitive. The question immediately creates a sense of intrigue and anticipation, which may lead to an 'a-ha!' or 'wow!' moment.

A-ha! and wow! moments

An a-ha! moment is that sudden realisation, insight or understanding, when something becomes clear and meaningful. When this happens you can often see a visible change in someone's facial expressions, such as their eyes lighting up, or a smile appearing. A-ha! moments often result from the connection of new information to existing knowledge or personal experiences. Creating a-ha! moments has to do with preparation and timing. As a facilitator, you will need to have a solid understanding of the information you're sharing and know how to introduce the right information at the right moment. (Refer to the 'Make it relevant' section, above, for more on how to share relevant information.) Allowing space to process information, creating clear connections, and making it meaningful and personal is key.

Wow! moments are instances when participants experience a sense of awe, wonder, or surprise that exceeds their expectations. Use wow! moments as opportunities to share information by strategically incorporating surprising, fascinating, or awe inspiring elements into your programmes. Reveal intriguing or little known facts about an artwork or object that captivate and surprise your group. Drawing attention to surprising connections between different artworks, ideas, or time periods can spark a sense of wonder and curiosity amongst participants. By revealing unexpected relationships or patterns, museum educators can facilitate wow! moments that prompt

participants to explore and delve deeper into the subject matter. You can create these moments at any point during your programme. For example, do a mini-share or some storytelling to share some information about an artwork or object, before you go and look at it. This works really well with masterpieces and large-scale objects which always elicit a reaction from participants. By talking about the object first, without actually seeing it, you are building up curiosity and excitement. You could also work in a wow! moment during a discussion, by sharing a piece of information which radically alters the participants' thoughts about an artwork or object.

Think about moments in the past when you have seen people experiencing a-ha! or wow! moments in your museum programmes. Review what happened. What were you doing? What were the participants doing? How did you share information?

Quotes

Share quotes from artists, scholars or historical figures, to offer different viewpoints and diverse perspectives. Alternatively, select quotes or creative writing that evoke emotions related to the theme or artwork being discussed, to convey the passion, inspiration, or profound experiences of individuals connected to the subject matter.

Quotes sourced from historical documents or primary sources transport participants to specific time periods, enabling a deeper comprehension of the historical context. These quotes can help to illuminate the attitudes, beliefs, and social dynamics of the era, making the information really come to life. By intentionally choosing thought provoking quotes that raise questions or challenge commonly held assumptions, educators can foster engaging and intellectually stimulating conversations.

Supplementary materials

Supplementary materials provide additional context to any information you're sharing and serve to enrich the participants' learning experience. These materials can include handouts, visual aids, and sensory or interactive elements, such as maps, diagrams, or replicas. By incorporating supplementary materials, educators can offer tangible resources that support participant engagement with the artworks or objects being discussed. These materials can provide detailed information, historical background, or visual references that complement (or substitute for) any verbal information. Hands-on activities and interactive elements encourage active participation too.

When to share information

Assumptions

Despite evolving trends towards interactivity and the inclusion of multiple voices and perspectives, there are still

a large number of visitors who come to a museum to participate in a programme and expect that the educator, as 'the expert', will be imparting or transmitting information in the traditional style. In order to create an engaging and interactive museum or gallery programme, it is therefore crucial to proactively set expectations from the start. Introduce the programme as an interactive experience that encourages discussion, conversation, and personal engagement with the art or objects. By positioning yourself as facilitator, co-explorer or orchestrator alongside the participants, you foster a sense of shared discovery.

In my training courses, I often hear the claim that some visitors only want to listen and are not interested in interaction. These statements often stem from the person's own reluctance and resistance towards implementing more participative discussion-based approaches. It is important to move away from these assumptions and broad statements about what we think visitors want, and instead consider a range of perspectives. Based on my experience, visitors who appear unhappy to participate, or who verbally express a lack of interest in doing so, may simply be unfamiliar with the advantages of active engagement or unsure about what to expect. Their hesitation often stems from a lack of exposure, rather than a genuine disinterest. By addressing their concerns and creating a warm and welcoming environment, we can gradually introduce interactive methods. It's important to remember that visitors' preferences can change, and with patience

and effective facilitation, we can help them discover the value of taking part, making their museum experience more enjoyable and meaningful.

It is common for us to make certain assumptions about visitors. One common thought is that group participants share our values and preferences regarding art, museums, and learning. We might assume that they have a similar level of knowledge or appreciation for the subject matter. Additionally, we might assume that visitors approach the museum experience with the same goals and expectations as we do. However, it is important to remember that the participants in your programmes come from diverse backgrounds and have their own unique perspectives, interests and motivations. By recognising and challenging these assumptions and adopting a more open-minded approach, we can better understand and cater to the varied needs and preferences of our visitors, creating a more inclusive and enriching experience for all.

Integrate information at key points

The integration of information at key points means strategically incorporating relevant and meaningful information at specific moments throughout the programme. Instead of delivering a continuous stream of information, this approach involves carefully selecting and timing the presentation of information to enhance the overall experience and engagement of participants.

What constitutes a key point? Consider asking yourself these two simple questions:

1. Will sharing this information help participants understand the artworks or objects better?
2. Does the current moment feel like a natural fit for sharing the information?

The first question evaluates the relevance and impact of the information, helping you to determine whether adding information here adds value. The second question considers the flow and structure of the discussion, aiming to identify moments where sharing information aligns seamlessly with the ongoing conversation or takes it in a new direction. This can involve trusting your intuition, drawing from past experiences, and observing the level of engagement closely.

To create a lasting impact with the knowledge you have, consider experimenting with *when* you share it. One way is to experiment with sharing it at different times during a discussion. Treat it as a scientific experiment, and observe the group closely for their reactions and responses each time you share the information, then take note of what happened. Rather than overwhelming and burdening people with your knowledge, approach it as a tool that you can playfully explore. Find creative ways to share it. Remember that you don't always have to share the same information at the same key point. As your groups change, key moments and opportunities will too.

By adopting a playful mindset, you can transform your knowledge into a dynamic tool and observe its effects on the group. Notice their reactions, engagement levels, and the overall impact on their learning experience. Make comparisons between sharing the information at the start, in the middle, or at the end, and take note of the outcomes. This perspective allows you to view information as a tool for engaging your audience, keeping them actively learning and discovering alongside you.

When the group goes quiet

Another good moment to share information is when the group becomes quiet. Pay attention to the dynamics of the discussion and notice when there is a lull or pause in the conversation. This silence can indicate that the participants are processing what has been discussed, or that they are ready for new insights. You can use these moments to introduce relevant information that can deepen their understanding or spark new discussions. Ask an open-ended question that prompts their curiosity or encourages them to think deeper. For example, you could say, *I noticed there's a moment of quiet reflection here. Let's explore the mood in this artwork further. In this painting, the artist deliberately chose vibrant hues to represent different emotions. What effect do the colours have on the atmosphere?*

When the group is stuck or going round in circles

If you find yourselves going round in circles, or remaining stuck at the same point of the discussion, it can be a

suitable time to introduce new information. Recognise when the group seems to be in a loop, or facing challenges in progressing the conversation. Use this as an opportunity to share relevant insights or perspectives that can help break the cycle and move the discussion forward.

Information can spark ideas that may inspire the group to think differently and explore new avenues of understanding. Use the phrase, *What if I was to tell you...* to introduce new information, followed by a question about its impact, such as, *Does knowing this information change your thinking?* This approach encourages participants to reflect on the impact of the shared information on their perception and emotional response to the artwork, fostering a more immersive and thought provoking experience.

When observation is not enough

In instances where answers cannot be found through observation alone, it is important to share supplemental information to support the group in going beyond surface-level understanding. As a facilitator, actively promote and value the process of discovery through observation as the core approach. However, if answers remain elusive through sustained looking, it is always worth sharing relevant information. Consider if providing additional information would enhance participants' understanding and help them delve deeper into the subject matter.

Withholding information can lead to frustration and potential misconceptions, particularly when dealing with historically or culturally sensitive topics. In these cases, it is crucial to share any necessary context before misinformation arises, and to strike a balance between fostering discovery and providing essential information.

In response to questions

Foster curiosity within the group by encouraging active observation and inquiry. Prompt them to ask questions and engage in discussions, allowing the group to take a more prominent role in the conversation, whilst you facilitate. By creating a community of inquiry that promotes and values inquiry, you can seize opportunities to share relevant information in response to participants' questions.

This approach encourages active participation, empowers the group to drive the learning experience, and ensures that shared information aligns directly with their interests and curiosities. You can proactively engage the group in this way by regularly asking thought provoking questions, such as *What are you wondering about?* or *What can I help you understand?* throughout your programme. By inviting their reflections and inquiries, you create opportunities for participants to share their points of curiosity and/or confusion. This approach not only encourages active thinking and engagement, but also allows you to address participants' specific needs and concerns, by sharing relevant information that directly addresses what they are most keen to know.

Use a Questioning Practice

Because of the way they are structured, Questioning Practices allow information to be shared with your group in small amounts and at appropriate times. They allow you to break down the information into smaller, manageable portions and share it at different moments, rather than overwhelming participants with an information dump.

As we'll see in the next chapter (on design and structure), by selecting Questioning Practices beforehand, you establish a structured framework for discussion. This helps you plan when and how much information to share. You can determine whether to provide some context at the beginning or save it for later stages, or in response to participant inquiries. Preparing with Questioning Practices allows for a more thoughtful and strategic approach to information sharing, enhancing the overall learning experience for your group.

Complete the CHOOSE framework by determining how and when to share information about your artwork or object, the amount of time you will spend with it, its place within your overall programme, and the Questioning Practices you plan to use.

1. **Create a plan:**

 Placement: Consider where this artwork/object will fit into the programme as a whole.

 Time: Decide how long you will spend with this artwork/object. Take into account where this artwork/object is placed within the programme arc, the richness of the content and any possible Questioning Practices you are going to use.

2. **Questioning Practices and activities:**

 Choose Questioning Practices and activities for your artwork or object and the theme. Ensure that your activities incorporate a variety of modalities.

 Consider how you might share each of the 3 storylines that you defined in the earlier exercise in this chapter.

 Think about:
 - How can you make it *meaningful* and *personal*?
 - What format you will choose:
 - Mini share
 - Questions
 - A-ha! or wow! moment
 - Quote
 - Storytelling

> ○ Supplementary materials
> ○ Some other way...?

Finding the right balance is key when it comes to using information intentionally as a tool for engagement. Information can play a vital role in deepening participants' understanding, allowing them to engage with works on a deeper level, beyond initial impressions. However, it's important to recognise that not all artworks and objects require the same level of interpretation. Historical and cultural sensitivity should guide our approach. Likewise, each and every group is unique, and it's crucial to consider all the variables at play when sharing information. Being attentive and adaptable is crucial, as is knowing when to introduce certain ideas and when to save them for later. Ultimately, using information intentionally requires practice, skill, and experience.

 How do you feel about sharing information now? What are your next steps going to be?

Notes

1 Patterson Williams, "Object-Oriented Learning in Art Museums", Round-table Reports 7, no. 2 (1982): 12–15.

2 Leslie Schenk and Martin Tucker, "Attention Spans", World Literature Today 72, no. 1 (2015): 141.

3 "Captive and Non-Captive Audiences - a Story about How I Arrived at the Idea and What I Mean by It", last modified September 1, 2005, https://interpat.mx/wp-content/uploads/2020/05/Captive-captive-and-Non-_SH2005.pdf.

4 Sam H. Ham, *Interpretation: Making a Difference on Purpose* (Golden, Colorado: Fulcrum, 2016).

5 Olga M Hubard, *Art Museum Education: Facilitating Gallery Experiences* (Basingstoke, Hampshire: Palgrave Macmillan, 2015), 93.

6 Ham, *Interpretation: Making a Difference on Purpose*, 31

7 Ham, *Interpretation: Making a Difference on Purpose*, 31

9
Deliberate design

'A designed experience flows like a river,
pausing and at times rushing forwards, but
always with rhythm and a guiding purpose.'

– Andy Sontag

W e touch on a variety of design and structure elements throughout this book. In Chapter 5 (Creating a Community of Collaboration) where we explore the 3 phases of group formation, and in Chapter 8 (Intentional Information), where we learn to design discussions either with or without information. This chapter aims to bring all of these elements together and tie up any loose ends around designing for participation and engagement in the Thinking Museum® Approach.

Designing guided experiences in museums involves creating the right conditions, environment and structure to facilitate meaningful and engaging experiences for participants. Thoughtful advance planning, attention to detail and understanding the needs and desires of the participants are all important design elements.

In this chapter, we'll explore the design and structure of a guided experience itself. This includes the overarching framework, objectives, and components of the entire experience, as well as how to design an individual discussion. For the former, this includes defining the desired outcome, identifying the target audience, and determining the sequence of artworks. We'll also discuss how to find a flow, or a sense of rhythm and purpose in your museum programmes, allowing for moments of pause and acceleration, whilst maintaining an overall guiding direction. A well designed programme will be created with the participants in mind. It will also be guided by the 'arc' of

programme design and the 3 phases (Entry, Exploration and Exit). It will also prioritise the perspectives, needs, preferences and interests of the participants over those of the educator. Participant-centred design means designing experiences that actively involve participants in the learning process, by encouraging their engagement and active participation. Your role is to facilitate and guide the learning experience, adapting your approach based on participant input and interests.

In contrast, educator-centred design places the educator at the centre of the programme. Here, the focus is primarily on the educator's knowledge, interests and teaching style. Everything is designed around the educator's expertise and what they consider important or interesting, without necessarily taking into account the specific needs and interests of the participants.

Within the programme itself you will also need to plan the design and structure of each discussion around an artwork or object. This involves considering the Discussion Cycle (discussed at the end of this chapter), the amount of time you'll spend there, and the Questioning Practices, activities and modalities that will bring it to life.

Whilst participant-centred programme design sets the context and overall structure, the design of individual discussions ensures that each conversation within the programme is purposeful, engaging, and participative. Both aspects are important for creating a successful experience;

the overall design provides a framework for coherence and progression, whilst the design of individual discussions allows for meaningful and focused interactions within that framework.

We'll start by exploring the design of a participant-centred guided experience.

Designing a participant-centred guided experience

Theme, audience, duration, type

Deciding on a theme forms the foundations of your museum or gallery programme and helps to guide the design process. In Chapter 8, we explored how themes (even loose ones) provide focus and coherence and help the programme become a 'rounded whole', rather than just a collection of artworks and objects. The chosen theme informs the selection of artworks, objects, activities, supplementary materials, and any other elements incorporated into the programme. It ensures that everything works harmoniously to support and enhance the overarching story or message being conveyed. Even in open discussions without preset limits or contextual information, a flexible theme gives the programme shape and substance, providing a unifying thread that ties everything together. By

363

using a theme, a guided experience gains structure, depth, and a meaningful flow that engages visitors.

Knowing the demographic of your audience is also essential to making informed choices about the content and design of your participant-centred programme. Whether the group is predetermined or considered during the design stage, understanding their characteristics and preferences enables you to create a more tailored and impactful experience for them. Demographic information about your intended audience directly impacts various aspects of your programme design, including the selection of artworks, objects, Questioning Practices, activities, and the types of questions you might ask.

However, there are also many instances where educators find themselves working with unfamiliar groups, such as with impromptu guided tours where participants sign up on the spot and have no prior acquaintance with one another. When working with groups that we know little or nothing about, it becomes even more important to employ adaptable and inclusive approaches and to gather as much information as possible about the group at the start of and throughout the programme, in order to personalise the experience.

Finally, consider the length of the programme and the type of experience you'll be offering. There's a significant distinction between a highlights tour at one end of the

spectrum, where you cover many artworks or objects in a shorter time frame, and a slow looking experience at the other end of the spectrum, where you may focus deeply on a single artwork. The two approaches vary in depth, duration, and the number of pieces discussed. Highlights tours are (generally) faster-paced, whilst a slow looking experience allows for more leisurely exploration. We'll delve more deeply into the topic of pace later.

Desired outcome

Before making decisions about content, it is crucial to have a clear vision of what you want to achieve in your guided experience. Attempting to choose artworks, objects or Questioning Practices without first thinking about your objectives or outcome is like planning the interior design of a house before building its walls. Just as the walls provide the structure and framework for a house, a well-defined outcome serves as the foundation that guides and informs the creative process. Without this solid base, the decisions and choices made can lack coherence and direction. By knowing your desired outcome upfront, you can make better decisions that align with that end goal. This 'back-to-front' approach starts with the end in mind, helping you to stay focused and purposeful when designing your programme.

The design process usually begins with considering both the desired outcome and the theme. Whilst there is no

one-size-fits-all approach, different institutions may prioritise different aspects of the planning process. However, in most cases, it is important to have both a clear vision of what you want to achieve (your desired outcome) and the theme you want to convey to your participants at the start. The specific process, i.e. whether the theme or outcome is decided first - may vary.

The following three questions serve as a useful framework for determining the desired outcome of a guided experience. Note: it is not always necessary to answer all three questions in every scenario. The relevance and applicability of each question may vary, depending on the specific context and goals of the programme.

What is your desired outcome?

1. *What do you want participants to learn or take away from the programme?*
Define the educational or informative purpose, by focusing on the specific knowledge, information, or understanding you want participants to gain.

2. *What do you want participants to feel or experience during the programme?*

Define the emotional or transformative purpose, by considering any desired feelings, connections or impact you want participants to experience.

3. *What action or behaviour change do you want participants to exhibit after the tour?*
Define the practical or behavioural purpose, by considering the actions, behaviours, or attitudes you want participants to engage in as a result of the programme.

Play with the pieces

Brainstorm a long list of artworks or objects that might be suitable for the theme of the guided experience. Come up with many more than you actually need. I like to write each option on a sticky note, so that I can 'play with the pieces' and move them around whilst I consider how each object fits with the theme, which ones fit together and which ones I might get rid of. I mark a few 'key pieces' with a star, to use at the midpoint of the programme, and I add any ideas I have for Questioning Practices and/or modalities or activities to each sticky note.

If an artwork you love doesn't really fit into the theme, don't include it. You can use it another time. It's better to have fewer relevant works than many slightly off-tangent ones.

Whittle down your options, by analysing whether each one fits the theme, but don't forget to consider the location or the environment around the object too. All too often I've had to remove an artwork or object because there isn't enough space around it to comfortably fit a group, or it's too far away from the rest of the choices. Be prepared to kill a few of your darlings in the process too (see Chapter 8 for more on letting go of personal favourites).

Design the flow

Once you have all the artworks shortlisted, you can more easily envisage how they are going to fit together and how you might make links from one to the next. If you can't find a 'flow', move the order around until each artwork or object naturally links to the next. Come up with a few options for your route, then walk it at several different times of day. This helps you to see how the flow works in reality, rather than just on paper.

Now that you have a draft flow, you can consider the Questioning Practices you've chosen (or written down as suggestions on your sticky notes), and how they will flow from one object to the next. Think carefully about which Questioning Practices you will use to start your programme, when participants are new to each other and the museum, which Questioning Practices would be best placed at the midpoint to stimulate deeper understanding, and which ones will work at the end to foster reflection. Think about

how the Questioning Practices flow within the programme. By strategically placing these QPs at different points, such as the Entry, Exploration and Exit phases, participants are prompted to think critically, make connections, and deepen their understanding of the artworks or objects they encounter.

The 'arc' of participant-centred guided experiences

Let's use an arc to visualise what a participant-centred programme will look like and to help structure the flow of the design.

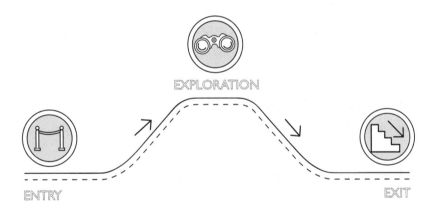

The Entry phase is at the beginning of the arc, where you are setting the context and introducing participants to the museum, the programme, each other and you. The middle of the arc (the Exploration phase) is where the programme builds up momentum, offering deeper engagement and perhaps also more challenging discussions with a few key pieces. This is the heart of the programme, where

369

participants actively interact, discuss and explore. It's the part of the programme where you and the participants may feel a sense of flow, and you can plan and design your artworks, objects, activities and modalities accordingly.

Finally, the end phase (Exit) of the arc is the culmination and reflection point. Participants have the opportunity to reflect on what has just happened, make personal connections, and leave the programme with a sense of closure and fulfilment. Just like an arc, a participant-centred guided experience has an upward trajectory, building to a peak moment, followed by a gradual descent or resolution. This shape implies a sense of growth, development, and a journey that reaches its 'peak point' before winding down. Visualising the programme as an arc keeps the programme participant-centred as you design it. It also serves as a reminder to prioritise the needs, interests, and engagement of the participants throughout the entire experience. Let's look at each of these phases in detail.

The 3 phases of a guided experience

The arc of participant-centred guided experiences, illustrated on the previous page, shows 3 distinct phases: Entry, Exploration, and Exit. In addition to these 3, the overall experience design can incorporate pre-entry and post-exit phases, to bookend the main experience and provide valuable opportunities for participant engagement and follow up. Let's delve into each of the core phases:

Entry

The Entry phase includes anything that happens once your group has arrived in the building (or online), up until the first artwork or object in the Exploration phase. For the most part, this incorporates the introduction to your programme where for 5-10 minutes you are setting the scene, and making connections and introductions. It may also involve what happens before the group meets you, the physical entry process and any strategies to make the group's transition from the front door to you as smooth and efficient as possible, minimising any potential delays or confusion. These opening minutes are as crucial to engagement as the Exploration phase, as a good Entry phase builds trust, rapport and connections.

Introduction

As you start your programme, your introduction will literally set the stage for the ensuing participation and interaction. An introduction is where participants find out what to expect, how the programme will unfold, and what is expected of them in terms of participation and behaviour. It serves as a guide, providing orientation and clarifying any logistics, so that participants feel prepared and informed. Beyond practicalities, introductions are instrumental in establishing a positive group dynamic. By fostering connections and intentionally creating a welcoming environment at the start, participants feel comfortable and more willing to participate once you arrive at your first artwork or object. In addition, the introduction helps to build rapport,

creating a feeling of camaraderie and shared purpose. The principle of 'connection before content' (see Chapter 5) enhances the whole experience, as participants feel more at ease, more open and more engaged with the discussions that follow.

Use your introduction as a tool for setting expectations and encouraging interaction. There are 4 elements to a great introduction:

- Introduce yourself
- Introduce the organisation - museum/company
- Learn about and help the participants to connect
- Introduce the programme and its goal

Introducing yourself

When introducing yourself, focus on who you are and what your role is as the facilitator. Sharing a bit about yourself helps to establish a personal connection with the participants, allowing them to see you as a relatable and approachable figure. This personal connection lays the groundwork for building trust, which is essential for creating an environment of psychological safety.

In addition to sharing information about yourself, clearly state your role as facilitator. Explain that your purpose is to guide the group through the experience, foster meaningful interactions, and ensure that everyone feels included and valued. By highlighting your role as facilitator,

you set the stage for participants to understand that you are there to support their exploration and encourage their active engagement.

This combination of sharing personal information and clarifying your role helps to create an atmosphere of trust and psychological safety. When participants feel comfortable and trust you, they're more likely to share their thoughts, ask questions and actively participate. This, in turn, makes the experience more enjoyable and engaging for everyone. Actively and intentionally building this initial connection and trust during the introduction sets a positive tone for the entire experience and enhances the overall interaction within your programme.

Write an introduction to yourself

1. Who are you? Quickly answer the following questions with the first thoughts that come to mind:
 a. What would you like to be known for?
 b. What do you love about what you do?
 c. What are your superpowers?
2. What is your role? What word (or title, even?) best describes what you do and what does it mean? E.g. orchestrator, facilitator, guide-on-the-side, connector, co-pilot, mediator

3. Form 1-2 sentences to summarise your answers. Say them aloud and edit words that don't scan well when spoken. The tone should be conversational and friendly. Go beyond your job title and qualifications - you don't want it to sound like a resumé. Keep in mind that this is about forming connections with people.

In your introduction to yourself you are trying to convey what makes you uniquely you, in order to connect with your participants. It should be enough to get people curious about who you are and why you do what you do, so that they feel safe in your hands for the rest of the programme.

Introducing the organisation

The second part of your introduction, if applicable, is to introduce the museum, gallery or organisation that you work for or that you're representing. The organisation itself may have a standard way of stating their mission and values and, if at all possible, this should be incorporated into your introduction, but put into your own words. Think about: what drew you to work for this organisation in the first place?

Learning about and connecting the participants

The third stage of a good introduction allows you to understand the individuals in the group, their motivations

for being there and what they are specifically interested in seeing or doing. By gathering this information, you can tailor the programme to meet their expectations and create a more meaningful experience. At this point, engaging in conversation and asking some initial fact-finding questions helps you gather relevant information without overwhelming the participants. Asking a few (not too many!) closed questions here helps to break the ice and provides the first opportunity for participants to interact with you and each other, without requiring too much effort.

Introduction to the programme

The final stage of the introduction is to provide an overview of the programme itself. You can share the theme or focus of the tour, as well as a few hints about what participants can expect to see and how long the programme will last. You can also share some statements about the type of programme participants can expect. For a guided experience, it's crucial to convey that the experience will be interactive and that you will be discovering things together. By setting these expectations upfront, you establish a framework for active participation and engagement, instead of passive listening. Ensure that participants know that they will be encouraged to contribute, share their thoughts and take an active role in the journey.

Depending on the type of programme, you may also want to establish some guidelines about behaviours you

would like to encourage (for an in-depth look at this, see Chapter 5). For instance, you might want to emphasise that all questions are welcome, regardless of how simple they may seem. Or, you may want to highlight the importance of listening respectfully to others and avoiding making assumptions. Or you could encourage participants to contribute by emphasising that there are no 'right' or 'wrong' answers. You could also say, *participation is always encouraged, but never required*. By highlighting that participation is voluntary, you create an inclusive, non-pressurised environment. Participants may choose to actively participate in discussions, ask questions and share their perspectives. At the same time, those who prefer to listen and observe can feel at ease knowing that their presence is valued and respected, and that they won't be called upon at a moment's notice to find an answer. This guideline fosters a sense of autonomy and allows participants to engage in a way that aligns with their comfort level and preferences.

After providing this information, open the floor for questions, before transitioning to the main body of your programme: the Exploration phase.

Exploration

The Exploration phase includes the discovery and exploration of one or more artworks or objects. Artworks and objects should be selected according to their relevance to the theme, and their accessibility and suitability for slow, careful observation.

Begin the Exploration phase with an engaging, low-threshold activity or discussion. This warm-up helps to capture participants' attention, spark curiosity and create positive momentum from the beginning. It also gets the group acclimatised to the space and each other, whilst at the same time building trust and forming connections. For more about warm-ups, see Chapter 5.

As participants progress through the Exploration phase of your programme, it's important to maintain their engagement and energy levels. Introduce a mix of activities and exhibits that provide a balance between active and reflective experiences (see Chapter 4, Multimodality). The midpoint of the Exploration phase, when the group is fully acclimatised and energised, is an ideal opportunity to introduce longer discussions or specific activities, allowing participants to delve deeper into the content and express their thoughts and interpretations.

If you are new to using Questioning Practices, this would be a good time to explore how they might work in your programmes. For more experienced facilitators, the midpoint is a good time to experiment with more complex Questioning Practices and/or activities (such as movement, or embodiment), deeper discussions and thought-provoking conversations. It's also a time to consider exploring key pieces of the collection or visually striking or impressive artworks that create a wow! moment for your participants. The midpoint serves as a pivotal moment to capitalise on the group's

collective momentum and curiosity, fostering a richer and more transformative experience for everyone involved.

Towards the end of the Exploration phase, explore artworks or objects with discussions or activities that allow for a sense of closure and reflection. Consider incorporating opportunities for participants to consolidate their learning, share their insights or experiences with others, or engage in a culminating activity that ties back to the overarching theme or objectives of your programme. This helps participants to reflect on their journey and solidify their understanding. It also makes for a more memorable experience.

Exit

Just like the Entry phase, the last few minutes of a programme are equally important in shaping participant memories of the experience. Even if you are running out of time, you should always round off the programme well. The Exit phase is where you wrap everything up, tie up loose ends, and leave participants wanting more.

In *The Art of Gathering*, Priya Parker explains why closings matter: 'I once had an improv teacher, Dave Sawyer, who told us that you can tell the difference between good actors and great actors not by the way they enter a stage…, but how they exit'.[1] Here are my 3 steps to ending well, adapted from Parker's anatomy of a closing: the last call, looking inward, and turning outward.

The last call

First, you will need to signal the ending as you approach it. This prepares participants for the actual conclusion, allowing them to mentally transition and anticipate the end of the event. At your last stop you might want to signal that this will be the last artwork or object of the programme, mention that this is the last discussion, or say that you're taking the last few comments for today's programme. This 'soft close', as Parker calls it, subtly provides a mental cue that the programme is winding down.

When you are planning your sequence of artworks or objects, think about which of them would be a good choice for the last object. When you go to a concert, the band will choose their last song carefully, to leave you on a high and wanting an encore. This last song signals that the end of the concert is nigh, but if you play your cards right, you'll get a few bonus songs to finish with - that's how you want your participants to feel too.

After you have signalled the end, find a good space for the actual conclusion. Think about where you will stand, so that you have your participants' attention and they are not automatically thinking about what happens beyond the museum's exit doors. Whatever you do, don't do it by the cloakroom, as this sends a signal to your participants that the programme is already over and they switch off from the conclusion, eager to grab their coats and move on.

Looking inward

The looking inward part of your conclusion involves reflecting on the shared experience and connecting with the group one last time. You might want to do a summary or quick review of what you've done together, what you've experienced, the highlights of what you've seen, maybe even repeat back some of the words the participants said.

By reviewing what you have done and experienced, you create a sense of cohesion one last time, and reinforce the significance of your programme. In my programmes I like to do a quick summary of where we've been or what we've discussed. I also like to remind participants (if true) that they didn't know each other at the outset, or that they've spent 15 minutes with an artwork or object. I then ask them to reflect back on the experience. This may take the form of a Questioning Practice such as 321 Reflection: 3 new things they've learned, 2 things they're going to remember, and 1 question they have. Sometimes I ask participants for one word to sum up how they feel about a particular artist or theme, or even how they are feeling right now.

These reflective prompts foster a deeper connection with the material and each other, encouraging everyone to process the experience and solidify any learning. It also helps to create a sense of closure and personal meaning.

Turning outwards

The last part of the Exit phase is focused on asking participants to consider what they will take away from the programme: their 'exit ticket'. This is an opportunity for them to reflect on the most meaningful or surprising aspects of the experience and articulate what they will carry with them. Using an exit ticket question, such as *What's one thing you will take away from today?* or prompting them to complete a statement like *I was surprised by...* or *The most powerful thing was...* encourages participants to summarise their key insights or highlights. For school children, you can ask them what they are most excited to share when they get home.

Don't let your parting words be about logistics. Instead, end on a memorable note that relates to the content of the programme. You want the closing to leave a lasting memory of what participants have seen, discussed, or discovered. Consider how you can design the ending to create those lasting memories and ensure that the participants' final impression is tied to the substance of the experience.

By structuring the conclusion in this way, you provide participants with an opportunity to reflect on their personal takeaways and solidify their learning, whilst also leaving them with a memorable, meaningful close to their experience.

Pace and flow

Pace is a crucial factor to consider when designing the flow of your guided experience. The pace refers to the speed or rhythm at which participants move through the programme and engage with the artworks or objects. A well-paced museum experience ensures that your participants stay engaged, attentive and receptive throughout their journey. By carefully managing the rhythm and flow of stops, activities and information, you can create a balance that keeps your participants engaged, without overwhelming or exhausting them.

Less is more

In the context of designing guided experiences, 'less is more' is a guiding principle. It suggests that by intentionally selecting and presenting a smaller quantity of content, activities, or objects, we can create more impactful and meaningful experiences for participants. Essentially, less is more is about choosing quality over quantity. It's about prioritising the most relevant and impactful content, and ensuring that each element has a purpose and contributes to the overall goals of the programme. It invites us to create experiences that are powerful, focused, and leave a lasting impression on visitors, rather than overwhelming them with an abundance of information or distractions.

Streamline your content

It's important to streamline your content. Time is a precious resource for any guided experience. Instead of attempting to cover everything, it's important to focus on the key messages and themes you wish to convey and a carefully-curated selection of artworks and objects. Having a smaller number of high-impact objects allows visitors to engage more deeply with each one, and this leads to more engaging and memorable experiences that go beyond surface level. If you feel that there is always too much to cover on your programmes, then it's time to reassess your strategy, as your participants will likely be feeling that too. Covering too many objects, or too much information, will leave you and your participants feeling exhausted.

Balance

Find the right balance between providing enough time for participants to engage with each artwork or object and ensuring that the programme progresses at a reasonable pace. The type of pace you choose will be dependent on the type of programme you are creating. Avoid rushing participants through the programme, as it can hinder their ability to appreciate and reflect upon the pieces. On the other hand, overly prolonged periods at each point may lead to disengagement or boredom.

Variety

Create a diverse and engaging experience by incorporating different paces. Participants have varying attention spans and preferences and, as facilitator, you can cater to a group's needs by offering a range of experiences.

A varied and dynamic pace keeps participants engaged, by offering a mix of different rhythms, transitions, and levels of interaction. This prevents monotony and enhances the overall experience. You don't want to be spending the same amount of time at every object.

Bear in mind the arc of your programme and pace it accordingly. For example, participants are most warmed-up in the middle of a programme, so you could plan for a longer stop in the middle, whereas at the end people are more tired, and this may call for either shorter bite-sized stops or a slower winding down exercise, depending on the group and how you want to finish the programme. Lastly, be mindful of the Entry, Exploration and Exit phases when considering pace.

Invisible structure

Designing a guided experience with an invisible structure involves guiding participants seamlessly through a well-thought-out experience, without them being explicitly aware of any underlying structure. Instead of signalling each phase or transition, or announcing each Questioning

Practice or activity, the programme flows naturally, allowing participants to focus on engaging with the objects.

By carefully curating the content, designing the flow, and considering the pacing and sequencing of activities, the programme develops naturally, enabling participants to immerse themselves in the experience without feeling constrained by a visible structure. The goal is to create a programme where participants feel a sense of discovery, autonomy, and connection, allowing them to effortlessly engage with the museum's offerings in a deeper way.

Thoughtful and deliberate transitions help maintain a sense of flow and cohesiveness throughout the experience. By carefully considering the relationships between different pieces, facilitators and their participants can create meaningful connections, through thematic similarities, historical contexts, or aesthetic elements. Instead of feeling like a long list of objects, the programme allows each object to connect to the previous one or the next, like links in a chain. The questions you ask will be instrumental to this. The way you summarise and synthesise key themes or thoughts that participants have mentioned will help to create this rounded whole.

Designing individual discussions

When designing individual discussions within a museum programme, we want to make sure each conversation

has a purpose and keeps participants engaged. Whilst the programme design sets the structure, each individual discussion focuses on specific artworks or objects, to explore their meaning and significance. By planning the flow of the conversation, allocating enough time, and using effective techniques, we can make each discussion purposeful and engaging. This allows participants to dive deeper into the artworks or objects, ask questions, share their perspectives, and reflect on their insights.

Getting started

Here are a few questions to ask yourself when you are designing an individual discussion, either within a larger programme or as a standalone conversation:

8 starter questions for designing engaging discussions:

Answer any or all of these questions, to get more clarity on the design of your individual discussion:

1. What is the purpose of your discussion or dialogue? Does it relate to the overall theme and desired outcome (and curriculum, where necessary)?

2. Who thinks the artwork or object is relevant? The target group, the museum curators, the educators, or you?

3. What is the role of the artwork? Is it there to inspire/challenge or inform?

4. How will you create motivation for participation and ensure that you get everyone involved?

5. Does your individual discussion design have a good structure, with room for flexibility and variation?

6. Is there a balance in your design between the sharing of knowledge and group participation? How can you create space for the group to share their experience of the artwork or object?

7. What Questioning Practices are you choosing for this artwork or object? Are you investigating the formal features or technique? Or the historical context? Be conscious of your approach at the start. Don't try to cover everything.

8. What activities and modalities can you include to boost the learning experience. Are you including enough variety to appeal to different preferences and interests in your group?

The Discussion Cycle

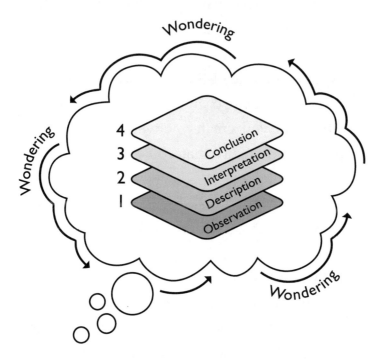

Use the Discussion Cycle structure as a guide for individual discussions around an artwork or object. Knowing the structure of a discussion will not only help you to plan which Questioning Practice to use, it will also free up mental headspace, allowing you to be more creative with your groups in the moment. The first two stages - **observation** and **description** - set the stage for the interpretation that follows. Engaging in careful observation and noticing the details of the artwork or object is essential for a more nuanced and informed interpretation. By dedicating time to seeing and noticing, participants can develop a solid foundation for their subsequent analysis and interpretation.

When we take the time to observe and truly see the artwork or object, we allow ourselves to go beyond the superficial or initial impressions. When we spend time observing, we are able to move beyond initial impressions or assumptions. It encourages us to approach the artwork or object with a curious and attentive mindset, seeking to uncover layers of meaning and engage in deeper critical thinking.

The **interpretation** stage is where you may or may not spend the most time (depending on what you would like to achieve at the artwork or object, working within the goals of your theme). Interpretation can take many forms, but it may involve building explanations, making connections, and exploring different perspectives to delve deeper into an artwork or object's meaning and significance.

Wondering is not limited to a specific stage within the structure; it can occur throughout the entire discussion. Wondering involves posing questions, expressing curiosity, and exploring different possibilities and interpretations.

Use this framework to structure your discussions and to select Questioning Practices to achieve your goals. Understanding the Discussion Cycle helps you to design and facilitate more engaging discussions within your programmes.

Notes

1 Priya Parker, *The Art of Gathering: How We Meet and Why It Matters.* (Riverhead Books, 2020), 248.

Conclusion

As we reach the end of this book, let's pause for a moment and reflect on the practical guidance, techniques and tools we've explored together.

From the very beginning, we embarked on a journey to discover how the Thinking Museum® Approach creates engaging, participant-centred discussions with art and objects in the museum or heritage environment.

In Part One (*The Foundations*) we discussed what engagement is and why it matters. We explored the importance of the 3 Foundations of the Thinking Museum® Approach – observation and noticing, shared visual inquiry, and personal discovery – and how they are the key ideas and building blocks for designing and facilitating engaging guided experiences.

In Part Two (*The Practices*) we examined the power of Questioning Practices as catalysts for meaningful discussion. We explored the importance of creating an inclusive and welcoming environment, and facilitating multimodally, with care and attention. We also discussed how practice, coaching and personal reflection are key to our professional growth and development. We debated the value of sharing information as an intentional tool to engage (rather than overwhelm) our participants, by looking at practical suggestions on when, how, and if to share information, as well as guidance on being intentional about the information we share. In the last chapter we delved into deliberate

programme design and learned how to craft engaging guided experiences. We saw how each of the 8 Practices is crucial to creating and sustaining engagement.

Now you're probably full of ideas and possibilities. But you may also be wondering, 'Where do I begin?' The answer is simple: begin by taking action. It is through action that we transform ideas and possibilities into tangible outcomes and it is through practice that we refine our skills. Each step you take towards implementing these ideas into your practice, no matter how small, will bring rewards in terms of engagement. View any setbacks or challenges as opportunities for growth and learning. Remember, everyone has to start somewhere. Action and persistence help us hone our craft.

When I first started facilitating inquiry-based discussions in the museum, I used to feel completely drained afterwards. I hadn't realised how much energy I was investing in spinning all the plates and keeping all the balls in the air. Experienced facilitators made it look so easy and effortless. But when you're beginning to adopt a new approach, you will physically feel the mental effort of what you are doing (rest assured, it gets so much easier with time and experience).

When you start out implementing the ideas in this book, you will also be much more deliberate in your approach, you will take time to carefully plan what you are going to

do and how you are going to do it. You'll use the Questioning Practice you've chosen exactly as it is written - in a structured and formal way, moving from one step to the next without much improvisation or deviation from your plan. This methodical approach is typical of someone starting out with inquiry-based teaching, as you get used to what it feels like to use questioning to facilitate discussion around art and objects. It may even feel quite unnatural at first. You may forget to reflect back some of the participant comments or make connections between different threads of the conversation. You might feel unconfident and awkward.

It is a process. Learning a new approach unfolds as a continuum, with distinct stages of growth and development that unfold gradually over time and with experience. With each stage, you gain new insights and skills, steadily advancing along the continuum. At the beginning, focus on implementing and grasping the foundational concepts – observation and noticing, sharing visual inquiry and personal discovery – into your guided experiences. Refer back to this book regularly, to build a solid understanding of the key concepts at play in this approach.

Invest time and effort in carefully planning your programmes and individual discussions. Work with just one Questioning Practice at this stage, and take time to methodically work through the sequence of questions on your own in advance and anticipate potential responses

from participants. This deliberate planning will help you to gain confidence and structure in your facilitation. Reflection, practice, and coaching play crucial roles during this initial phase, supporting your learning and growth. And if there are any missteps or wobbles along the way, remember to view them as valuable learning opportunities.

As you gain more experience in trying out the approach in different settings, with diverse groups and various objects or artworks, you'll grow in confidence. In this intermediate phase, you'll have a solid understanding of the 8 Practices and you will have started to integrate them into your facilitation approach. You will start to work with more Questioning Practices and become more adept at selecting and adapting them to suit different contexts and objects. Nuanced questioning techniques and core facilitation skills - like clarifying, asking for evidence, and summarising - will become second nature to you.

Developing your reflective practice, a positive attitude to practice and actively seeking feedback are important for refining your skills and expanding your repertoire at this stage. Using these three practices together will contribute to your growth as a facilitator, allowing you to fine-tune your techniques and deepen your experience in implementing the Thinking Museum® Approach.

As you continue your journey, you will begin to internalise the foundations and practices, using them instinctively

and naturally. At the advanced stage you'll feel that you have a recognisable facilitation style that is unique to you; that is both intuitive and responsive. You will be able to seamlessly adapt your approach in real time, tailoring and personalising discussions to the needs and interests of participants. Your facilitation will flow naturally and effortlessly.

At this stage, you may also want to share your expertise with others, providing guidance, coaching and support to educators who are newer to the approach. Even as a seasoned facilitator, you are committed to lifelong learning, staying informed about new developments in the field and seeking ways to deepen your understanding of facilitation and questioning techniques. You will continue to engage in reflection and innovation, evaluating your facilitation experiences, experimenting with new ideas, and pushing the boundaries of your practice. You will always be on the lookout for ways to enhance participant engagement and promote meaningful discussion.

Becoming a practitioner is the culmination of your journey through the 4 phases of development. At this stage you will have years of experience in designing and facilitating inquiry-based discussions, combining a wealth of knowledge and practical experience in navigating diverse contexts with confidence. You embody the core foundations of observation and noticing, shared inquiry, and personal discovery, infusing every aspect of your practice with

a participant-centred approach. By fostering an environment that encourages discussions, active participation, and deep thinking, you ensure that participants remain at the heart of the guided experience. You are keen to share your experience and insights with others, challenging them to embrace new approaches. Lastly, you have a commitment to community-building, fostering collaboration, empowering others, and offering guidance and coaching to people on their journeys. Ultimately, you're part of a global network of practitioners dedicated to facilitating enriching and engaging guided experiences in museums.

In the final stage, inquiry-based teaching becomes deeply ingrained as a way of being. It becomes part of your professional identity and permeates your approach. It won't happen overnight but, over time the approach will shape your thoughts, actions and interaction in the museum and beyond. Throughout the continuum, there will be subtle shifts in your mindset, as the core concepts of the approach become part of your practice and identity as an educator. You will develop new habits, attitudes, and perspectives that align with these principles, without even realising it.

Real change rarely comes from the outside. It is often the result of internal shifts, personal revelations, and a heightened sense of self-awareness. This book and the Thinking Museum® Approach are the catalysts for these 'inside to outside' changes. While I am here to cheer you on and

provide guidance along the way, ultimately the responsibility to get started lies with you. You now have all the tools and guidance you need to get started. Your journey begins now.

Bibliography

Aguilar, Elena. "Active Listening: The Key to Transforming Your Coaching (Opinion)." Education Week, April 28, 2014. https://www.edweek.org/education/opinion-active-listening-the-key-to-transforming-your-coaching/2014/04.

Ashby Butnor. "Critical Communities: Intellectual Safety and the Power of Disagreement." Educational Perspectives 44, no. 44 (January 1, 2012): 29–31.

Baba, Trevor, "The Importance of Intellectually Safe Classrooms for Our Keiki." Educational Perspectives 51, no. 1 (2019): 28–30.

Barrett, Terry. *Interpreting Art: Reflecting, Wondering, and Responding*. Boston: Mcgraw-Hill, 2003.

Benne, Kenneth D., and Paul Sheats. "Functional Roles of Group Members." Journal of Social Issues 4, no. 2 (April 1948): 41–49. https://doi.org/10.1111/j.1540-4560.1948.tb01783.x.

Block, Peter. *Community: The Structure of Belonging*. Berrett-Koehler Publishers, 2009.

Bown, Claire. "See Think Wonder: Integrating Thinking Routines into an International Primary School Programme." MA, 2011. https://thinkingmuseum.com/wp-content/uploads/2023/06/Final-Thesis-Claire-Bown.pdf.

Burnham, Rika, and Elliott Kai-Kee. *Teaching in the Art Museum: Interpretation as Experience*. Los Angeles: J. Paul Getty Museum, 2014.

Covey, Stephen R. *7 Habits of Highly Effective People*. 1989. Reprint, Simon & Schuster Ltd, 2013.

Dweck, Carol S. *Mindset: Changing the Way You Think to Fulfill Your Potential*. London: Robinson, 2017.

Feldman, Edmund B. *Varieties of Visual Experience*. Prentice Hall Art History, 2002.

Felix, Cynthia, Caterina Rosano, Xiaonan Zhu, Jason Flatt, and Andrea Rosso. "Greater Social Engagement and Greater Gray Matter Microstructural Integrity of Aging Adults." Innovation in Aging 4, no. Supplement_1 (December 1, 2020): 794–94. https://doi.org/10.1093/geroni/igaa057.2879.

Fredrickson, Barbara L. "Extracting Meaning from Past Affective Experiences: The Importance of Peaks, Ends, and Specific Emotions." Cognition & Emotion 14, no. 4 (July 2000): 577–606. https://doi.org/10.1080/026999300402808.

Grand Valley State University. "Feldman's Model of Art Criticism." Accessed June 19, 2023. https://www2.gvsu.edu/hipshean/resources/Feldman's%20Model%20Crit.pdf.

Ham, Sam. "Captive and Non-Captive Audiences- a Story about How I Arrived at the Idea and What I Mean by It," September 1, 2005. https://interpat.mx/wp-content/uploads/2020/05/Captive-captive-and-Non-_SH2005.pdf.

Ham, Sam H. *Interpretation: Making a Difference on Purpose*. Golden, Colorado: Fulcrum, 2016.

Harvard Graduate School of Education. "Artful Thinking." Project Zero. Accessed June 3, 2023. https://pz.harvard.edu/projects/artful-thinking.

Harvard Graduate School of Education. "Project Zero's Thinking Routines Toolbox." Project Zero. Accessed June 4, 2023. https://pz.harvard.edu/thinking-routines.

Harvard Graduate School of Education. "See / Think / Wonder." Project Zero. Accessed June 7, 2023. https://pz.harvard.edu/sites/default/files/See%20Think%20Wonder.pdf.

Harvard Graduate School of Education. "Visible Thinking." Project Zero. Accessed June 12, 2023. https://pz.harvard.edu/projects/visible-thinking.

Harvard Graduate School of Education. "What Makes You Say That?" Project Zero. Accessed June 7, 2023. https://pz.harvard.edu/sites/default/files/What%20Makes%20You%20Say%20That_0.pdf.

Hubard, Olga M. *Art Museum Education: Facilitating Gallery Experiences*. Basingstoke, Hampshire: Palgrave Macmillan, 2015.

Hunter, Dale. *The Art of Facilitation*. Penguin Random House New Zealand Limited, 2012.

Igdalova, Aleksandra, Safiyyah Nawaz, and Rebecca Chamberlain. "A View Worth Talking About: The Influence of Social Interaction on Aesthetic Experience and Well-Being Outcomes in the Gallery," May 1, 2024.

International Coaching Federation. "Updated ICF Core Competencies," 2019. https://coachingfederation.org/app/uploads/2021/07/Updated-ICF-Core-Competencies_English_Brand-Updated.pdf.

K. Anders Ericsson, Ralf T. Krampe, and Clemens Tesch-Römer. "The Role of Deliberate Practice in the Acquisition of Expert Performance." Psychological Review 100, no. 3 (1993): 363–406. https://doi.org/10.1037//0033-295x.100.3.363.

Kline, Nancy. *Time to Think: Listening to Ignite the Human Mind*. London Cassell Illustrated, 2016.

Lansley, Harry. "The Seven Universal Facial Expressions." The Emotional Intelligence Academy. The Emotional Intelligence Academy, April 16, 2018. https://www.eiagroup.com/facial-expressions-explored.

Lieberman, Matthew D. *Social: Why Our Brains Are Wired to Connect*. Oxford: Oxford University Press, 2015.

Lipmanowicz, Keith McCandless, Henri. "Liberating Structures - Liberating Structures Menu." www.liberatingstructures.com, n.d. https://www.liberatingstructures.com/ls/.

Lorenz-Spreen, Philipp, Bjarke Mørch Mønsted, Philipp Hövel, and Sune Lehmann. "Accelerating Dynamics of Collective Attention." Nature Communications 10, no. 1 (April 15, 2019): 1–9. https://doi.org/10.1038/s41467-019-09311-w.

Magsamen, Susan, and Ivy Ross. *Your Brain on Art: How the Arts Transform Us*. New York: Random House, 2023.

Maister, David H, Charles H Green, and Robert M Galford. *The Trusted Advisor*. London; New York: Simon & Schuster, 2002.

Maslow, Abraham H. *Religions, Values, and Peak-Experiences*. Harmondsworth, Eng.; New York: Penguin Books, 1994.

McDonald, Joseph P., Nancy Mohr, and Alan Dichter. *Power of Protocols: An Educator's Guide to Better Practice*. New York: Teachers College Press, 2015.

New London Group. "A Pedagogy of Multiliteracies: Designing Social Futures." Harvard Educational Review 66, no. 1 (April 1996): 60–93.

Parker, Priya. *The Art of Gathering: How We Meet and Why It Matters*. Riverhead Books, 2020.

Salen, Katie, and Eric Zimmerman. *Rules of Play: Game Design Fundamentals*. Cambridge, Mass. The Mit Press, 2004.

Sample, Ian. "Blow to 10,000-Hour Rule as Study Finds Practice Doesn't Always Make Perfect." The Guardian, August 21, 2019. https://www.theguardian.com/science/2019/aug/21/practice-does-not-always-make-perfect-violinists-10000-hour-rule.

Schenk, Leslie, and Martin Tucker. "Attention Spans." World Literature Today 72, no. 1 (2015): 141. https://doi.org/10.2307/40153617.

Schoenfeld, Alan H. "How We Think: A Theory of Human Decision-Making, with a Focus on Teaching." The Proceedings of the 12th International Congress on Mathematical Education, 2015, 229–43. https://doi.org/10.1007/978-3-319-12688-3_16.

Schön, Donald A. *The Reflective Practitioner: How Professionals Think in Action.* London: Temple Smith, 1983.

Simpson, John, Edmund Weiner, and Edmund Weiner. *Oxford English Dictionary.* Oxford University Press, USA, 2000.

Starr, Julie. *The Coaching Manual: The Definitive Guide to the Process, Principles and Skills of Personal Coaching.* 5th ed. Pearson Business, 2021.

TeachThought. "Learning Styles vs. Multimodal Learning: What's the Difference?" January 21, 2022. https://www.teachthought.com/learning/learning-styles-multimodal-learning/.

Technical University of Denmark. "Abundance of Information Narrows Our Collective Attention Span." EurekAlert! April 15, 2019. https://www.eurekalert.org/news-releases/490177.

Vance, Jessica. *Leading with a Lens of Inquiry.* Elevate Books EDU, 2022.

Vengoechea, Ximena. *Listen like You Mean It : Reclaiming the Lost Art of True Connection.* 1st ed. New York: Portfolio, 2021.

Visual Thinking Strategies. "Home." Visual Thinking Strategies (VTS). Accessed April 4, 2024. https://vtshome.org/.

Williams, Patterson. "Object-Oriented Learning in Art Museums." Roundtable Reports 7, no. 2 (1982): 12–15. https://sjmusart.org/sites/default/files/files/object-oriented-learning-in-art-museums.pdf.

About the author

Author photo: Rudi Wells

Claire Bown is a museum educator, trainer, facilitator, and podcast host, who is from the UK and is currently based in the Netherlands. With over 25 years of experience in the field of museum and heritage education, and a strong background in designing and facilitating guided programmes, Claire founded Thinking Museum® in 2013. Her expertise lies in consulting, designing, and leading professional learning opportunities for museum educators, guides, docents, and volunteers, encompassing a wide range of facilitation and engagement techniques.

Driven by her belief that museums and heritage should be accessible to all, Claire's mission is to share tools and techniques to help everyone enjoy art and museum objects more fully, without necessarily needing recourse to any specialist, in-depth knowledge or skills. She takes great joy in teaching people the secrets of facilitating engaging experiences with art and objects, and sharing techniques to help everyone to engage and connect with museums, art, objects and ideas.

Claire is fascinated by what makes a perfect art or museum guided experience, as well as the qualities required to facilitate engaging discussions about art and ideas. She is committed to making museum and gallery programmes truly participant-centred, and strongly believes that observation and noticing, shared visual inquiry and personal discovery can foster curiosity, help us discover hidden details, and deepen our understanding.

She is also fascinated by the role that information plays in art or object discussions, and how we can use contextual knowledge to engage and stimulate participants on our programmes. All of these passions have been poured into *The Art Engager: Reimagining Guided Experiences in the Museum*. In this book, Claire outlines the necessary steps to confidently design and lead engaging participant-centred, discussion-led experiences around art and objects in the museum.

Claire hosts her own podcast, *The Art Engager*, where she shares a diverse array of easy-to-learn and flexible techniques and tools that foster participant-centred, inquiry-driven experiences, breathing life into art and objects. Claire is also an ILM accredited coach (Level 5 in Effective Coaching and Mentoring) and holds a Master of Museology from the Reinwardt Academy in Amsterdam.

Connect with Claire

⊕ thinkingmuseum.com
✉ claire@thinkingmuseum.com
ⓕ @thinkingmuseum
⊙ @thinkingmuseum
ⓘⓝ Claire Bown

Made in the USA
Thornton, CO
12/13/24 06:29:20